LOVE MANIFESTO

I have taken the Unabomber's manifesto
(that he had several newspapers print or he would strike again)
and re-arranged its sequence of words and letters
to read as a very strange love poem.
I then mailed this poem anonymously to people I know.
It starts out, "This is not a letter of physical harm...."

1997
Dimensions variable

First edition, 2008

© 2008 The Frances Young Tang Teaching
Museum and Art Gallery, Skidmore College
ISBN: 0-9765723-6-2

Distributed by
University of Washington Press
P.O. Box 50096
Seattle, Washington 98145-5096
www.washington.edu/uwpress/

This book was set in Amalia, Fantabular, and
Trade Gothic by Heavy Meta

Printed and bound in Italy

Library of Congress Cataloging-in-Publication Data
Dunbar, Elizabeth.
 Dario Robleto : alloy of love / Elizabeth Dunbar;
with essays by Michael Duncan, Jennifer Michael
Hecht, Robin Held; dialogue with Dario Robleto by Ian
Berry; edited by Ian Berry. —1st ed.
 p. cm.
Catalog of an exhibition at the Frye Art Museum,
May 17–Sept. 1, 2008 and at the Frances Young
Tang Teaching Museum and Art Gallery at Skidmore
College, Sept. 27, 2008–Jan. 25, 2009.
 Includes bibliographical references.
 ISBN 0-9765723-6-2 (alk. paper)
 1. Robleto, Dario, 1972— Themes, motives—
Exhibitions. I. Berry, Ian, 1971– II. Charles and Emma Frye
Art Museum. III. Frances Young Tang Teaching Museum
and Art Gallery. IV. Title.
 N6537.R5745A4 2008
 709.2—dc22 2008011158

This book is made possible in part with support from
The Mattsson-McHale Foundation.

ALLOY of LOVE

DARIO ROBLETO

Elizabeth Dunbar

with essays by
Michael Duncan, Jennifer Michael Hecht, Robin Held
Dialogue with Dario Robleto by Ian Berry

Edited by Ian Berry

The Frances Young Tang
Teaching Museum and Art Gallery at Skidmore College
Saratoga Springs, New York

Frye Art Museum
Seattle, Washington

In association with
University of Washington Press

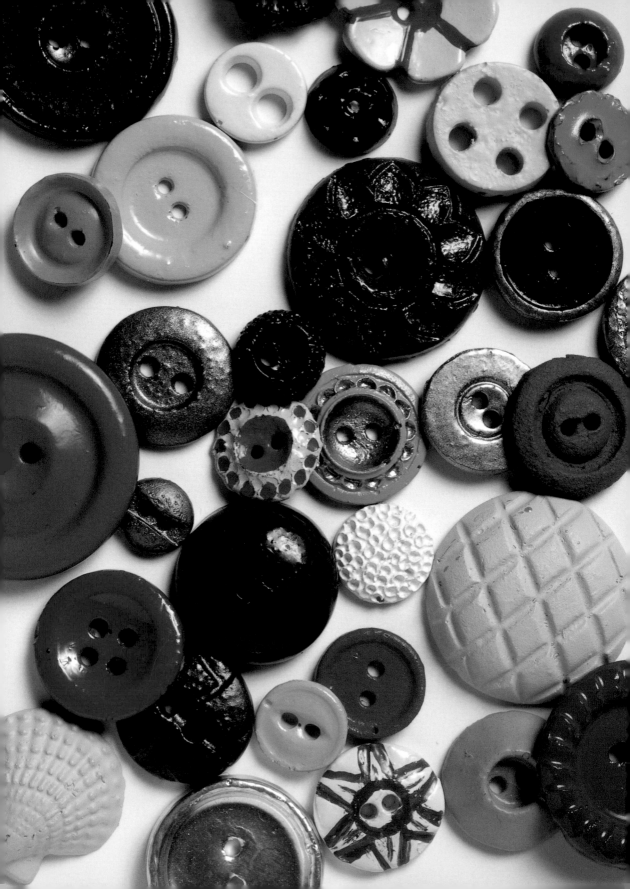

For more than a decade, Dario Robleto has been composing a love song to America, an extended meditation on longing and loss, spirituality and healing. Both elegiac and redemptive, his sculptures and assemblages reflect an engagement with an impressive range of sources, from popular music and military history to the natural sciences and forgotten craft traditions. Music, especially, guides Robleto's creative processes. He compares his methods to those of a DJ, digging through the dusty record bins of history, searching for the perfect moment, memory, or material—one to sample, splice, or mix with others to create something that is indeed the sum of its parts, but also much more.

Robleto's project is part memorial, part rescue mission: it seeks to resuscitate the material wreckage of our shared past, mixing and transforming historically-loaded artifacts and elements into regenerative works that reveal the fragments of hope embedded within. Fashioned from a lengthy roster of arcane and sometimes unbelievable materials—including melted and pulverized vinyl records, shrapnel and bullets excavated from battlefields, medicinal herbs and homebrewed tonics, and even prehistoric fossils and the dust of human bones—these works speak volumes about history and nostalgia, even as they address concerns for the present condition of our world and its future.

Alloy of Love surveys ten years of work by Dario Robleto, from his first investigations of vintage record albums as embodiments of emotions to more recent explorations of the impact of war on the domestic sphere. Early works witness Robleto improving found objects by investing them with new, hidden meanings, as in *Sometimes Billie Is All That Holds Me Together*, a set of buttons crafted from melted Billie Holiday records and used to impart new life to articles of thrift-store clothing. In recent years Robleto has turned his attention to darker themes of war and destruction, using the techniques of alchemists and apothecaries to transform the materials of war into healing remedies. New works, like *No One Has a Monopoly Over Sorrow*, reclaim the mourning arts of past eras—the love letters, the hair wreaths, the wax-preserved flowers—to make ameliorative gestures that recognize the survival of the past in objects and the poetic potential of materials.

WE'LL DANCE OUR WAY OUT
OF THE WOMB

Thirty-six 120 watt light bulbs, neighborhood

Over the course of a month,
I secretly exchanged the existing light bulbs from the front porch
of every house in the neighborhood block I grew up on
with a higher-wattage light bulb, thereby
making the whole block significantly brighter at night.

1997
Dimensions variable

TONIGHT I'M GONNA PARTY
LIKE IT'S 2099

A library, whiteout, ink

In an effort to buy us all a little more time,
on January 26, 1996, research was begun in the University library,
searching for all references to the end of the world.
The dates were then whited-out and Armageddon was delayed
by writing in an additional 100 years to these predictions;
for example, 1999 became 2099.
The piece will continue indefinitely or until
I am satisfied all references have been changed.

1996-present
Dimensions variable

UNTITLED (NO FLOW)

*Purchased and unpackaged pens,
disassembled, filled with ink and plaster mixture,
reassembled and repackaged*

1996
8 x 4½ x ¼ inches
Collection of the artist, San Antonio, Texas

UNTITLED

Purchased and unpackaged fax paper,
unwound, turned inside out, ends reversed, re-rolled,
repackaged in reverse order and returned to store

1996
9 x 7 x 4½ inches
Collection of the artist, San Antonio, Texas

UNTITLED
(SWEETNESS I WAS ONLY JOKING)

*Purchased and unpackaged gum, chewed until sugarless,
re-shaped into original form and repackaged*

1997
11 x ½ x 4 inches
Collection of Don Mullins, Austin, Texas

DARIO'S SHREDDED LOVE LETTERS

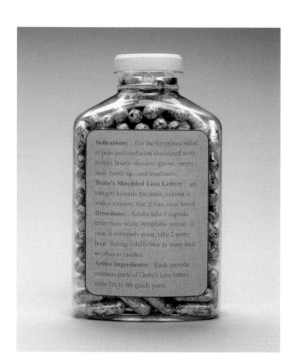

Pill bottle, pill capsules,
shredded love letters from 7th through 9th grade years,
homemade labels

1997
4 ¼ x 2 x ½ inches
Collection of Gregory Higgins, Dallas, Texas

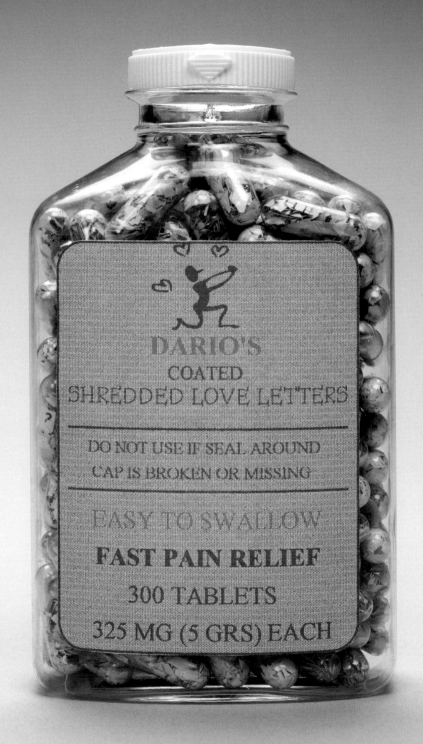

DEEPER INTO MOVIES
(BUTTONS, SOCKS,
TEDDY BEARS & MITTENS)

Baby blanket, spools of thread

The thread from my first baby blanket was completely unraveled.
Various lengths of this extracted thread
were then seamlessly spliced into thread purchased from
various fabric stores, thrift stores, etc.
The united threads were then re-spooled and returned to the
shelves from which they were purchased.

1997
Dimensions variable
Private Collection

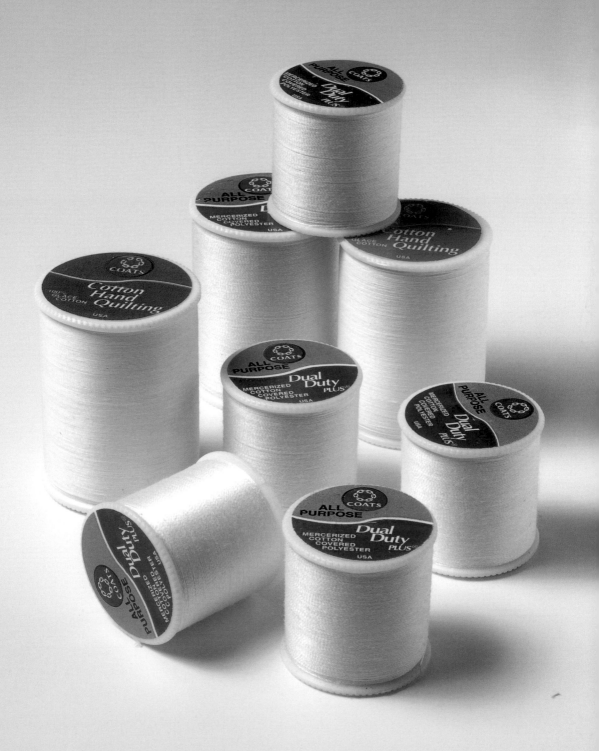

THE SAD PUNK
(NAMED EXTINCTION)

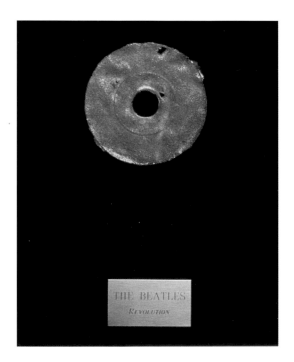

Cast 45 rpm and 12-inch singles
made from hand-ground fossil dust of a Discoscaphites gulosus
(Cretaceous period), polyester resin, velvet,
frames, brass labels

1998
Six parts, Each 24 x 30 inches
Private Collection, Paris

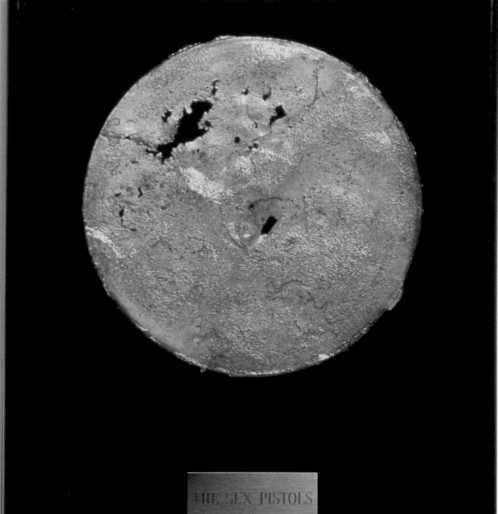

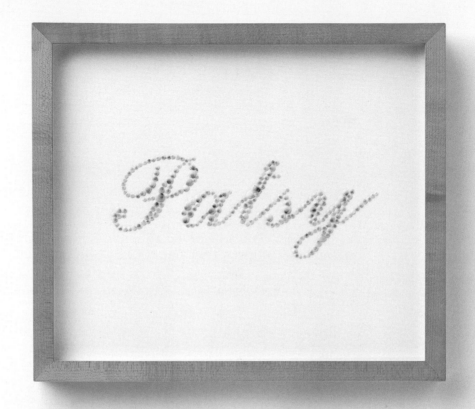

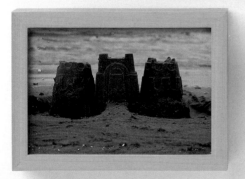
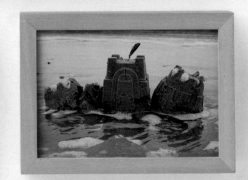

I WISH THE OCEAN
SOUNDED MORE LIKE PATSY CLINE

Seashells, altered sound of seashells

*A collection of seashells were grouped into a series of pairs.
Each couple was then serenaded with a
different Patsy Cline song for 48 hours at a time.
Each seashell's partner was then either returned to the shore
or used to make sand in* The Words To All The Love Songs
Start Making Sense When You've Gone Away.

1998
Dimensions variable

B | W

THE WORDS TO ALL THE LOVE SONGS
START MAKING SENSE
WHEN YOU'VE GONE AWAY

*Photos, seashells, indigenous rocks, fish bones,
crab shells, various debris*

*Various seashore items were collected,
hand-ground and sanded into homemade sand.
The sand was returned to the shore,
constructed into a sand castle, and left to collapse
and be added back to the sea floor.*

1998
Dimensions variable

Collection of the Austin Museum of Art,
gift of anonymous

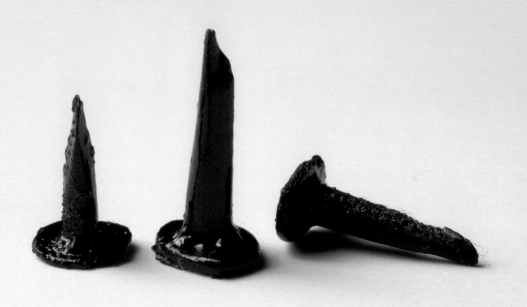

WE MISS SID!

Melted vinyl record, resin

Ordinary tacks made from the Sex Pistols' 1996,
20-year reunion tour live album, Filthy Lucre Live

1998
Dimensions variable
Private Collection

I fall to pieces
Each time I see you again
I fall to pieces
How can I be just your friend?

You want me to act like we've never kissed
You want me to forget, pretend we've never met
And I've tried and I've tried but I haven't yet
You walk by and I fall to pieces

I fall to pieces
Each time someone speaks your name
I fall to pieces
Time only adds to the flame

You tell me to find someone else to love
Someone who'll love me, too, the way you used to do
But each time I go out with someone new
You walk by and I fall to pieces

You walk by and I fall to pieces

"I Fall To Pieces"
Lyrics by Hank Cochran and Harlan Howard

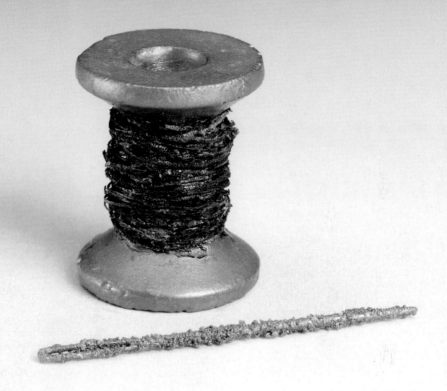

UNTITLED

Vinyl record, iron pyrite (fool's gold), glue

*Patsy Cline's "I Fall To Pieces" 45 rpm vinyl record
was slowly sliced along outer rim until reaching center
then connected into one long thread and spooled.*

1998-1999
1½ x 1 x 1 inches
Collections of Peter Norton and Eileen Harris Norton,
Santa Monica, California

THERE'S AN OLD
FLAME BURNING IN YOUR EYES,
OR, WHY HONKY TONK
LOVE IS THE SADDEST KIND OF LOVE

Altered matches, matchbox, hand-ground and melted vinyl records, paint

*Vinyl records by Patsy Cline, Conway Twitty, Hank Williams,
Tammy Wynette, and others, were ground into powder,
then melted and coated onto the head of each match.
Boxes of these altered matches were laid on bars in several
honky tonks around town,
waiting for their chance to go out in flames.*

1998
½ x 2 x 1 inches
Private Collection, Austin, Texas

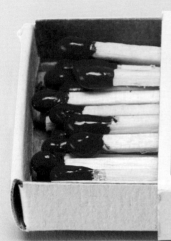

ROSEBUD
STRIKE ON BOX

MATCHES

KEEP AWAY FROM CHILDREN
UNIVERSAL MATCH. MINNEAPOLIS. MN 55416
A DIVISION OF DIAMOND BRANDS

MADE IN
THE U.S.A.

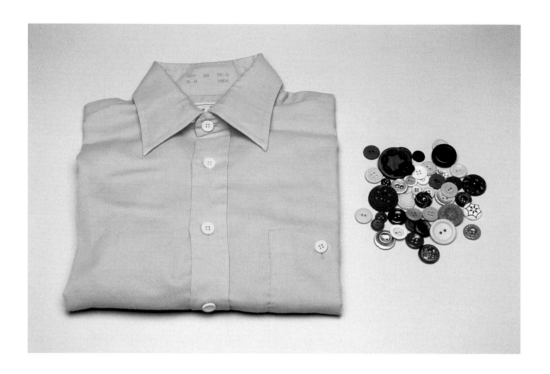

SOMETIMES BILLIE IS ALL THAT
HOLDS ME TOGETHER

Hand-ground and melted vinyl records, various clothing, acrylic, spray paint

*Several new buttons were crafted from melted Billie Holiday records
to replace missing buttons on found, abandoned, or thrift-store clothing.
After the discarded clothing was made whole again,
it was re-donated to the thrift stores
or placed back where it was originally found.*

1998-1999
Dimensions variable
Collection of Rebecca and Alexander Stewart,
Seattle, Washington

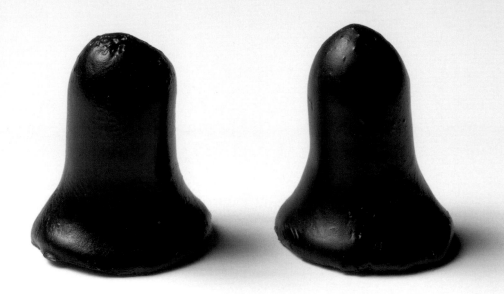

IT SOUNDS LIKE THEY
STILL LOVE EACH OTHER TO ME

Melted vinyl records, resin

Left ear plug: Nirvana's From The Muddy Banks Of The Wishkah
Right ear plug: Hole's Live Through This

1998
Each 1 x 1½ inches
Private Collection

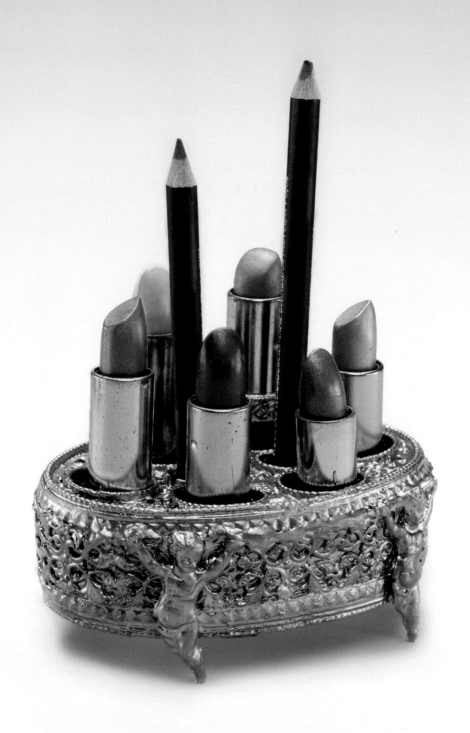

I'VE KISSED YOUR MOTHER TWICE AND NOW I'M WORKING ON YOUR DAD

*Cast of an antique lipstick holder
made with melted vinyl records (David Bowie's "Rock 'n' Roll Suicide,"
The New York Dolls' "Trash," The Sex Pistols' "God Save The Queen"),
antique lipstick containers,
stolen cheap lipstick and lip liner, spray paint*

1998
5 x 4 x 3 inches
Collection of Gregory Higgins, Dallas, Texas

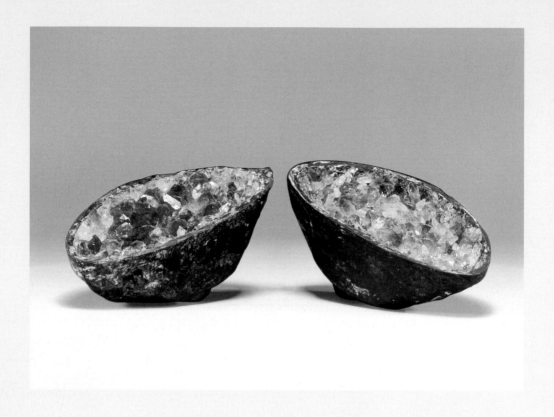

JIMMIE, YOUR CHEEKS
WILL NEVER LOSE THEIR LUSTER

Dissolved magnetic audiotape, resin, hand-set amethyst crystals, paint

*Geode rock created from a dissolved magnetic
audiotape recording of Jimi Hendrix's guitar distortion
sampled from his track "Purple Haze"*

1998
Each rock 2½ x 4½ x 1½ inches
Collection of Denby Auble, Houston, Texas

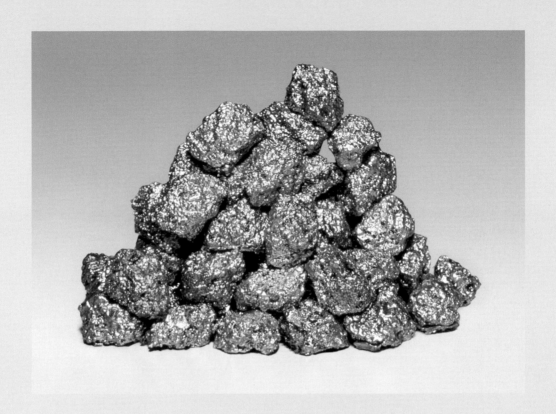

I SAW A POP IDOL SNEER
AT A DYING KID

Melted vinyl record, resin, spray paint

A used, thrift-store copy of Michael Jackson's album Thriller
was melted down and shaped into nuggets of iron pyrite (fool's gold)

1998
6½ x 4½ x 5½ inches
Collection of Nancy Delman Portnoy, New York

I WISH I COULD GIVE ARETHA
ALL THE R.E.S.P.E.C.T. SHE WILL EVER NEED

Cast of found and thrift-store trophy parts
made with melted Aretha Franklin 45 rpm records
("You Make Me Feel Like a Natural Woman," "Prove It," "Chain of Fools"),
resin, spray paint, engraved silver label

1999
8 x 3 x 2 inches

I WISH I COULD GIVE KRAFTWERK
ALL THE SOUL THEY WILL EVER NEED

Cast of found and thrift-store trophy parts
made with melted Kraftwerk vinyl records
(Computer World, The Man-Machine, Trans-Europe Express),
resin, spray paint, engraved chrome label

1999
12 x 6 x 3 inches

I WISH I COULD GIVE MARIA
ALL THE SOUL SHE WILL EVER NEED

Cast of found and thrift-store trophy parts
made with melted Maria Callas vinyl records
(*live recordings of* Norma, Madame Butterfly, Tosca)
resin, spray paint, engraved brass label

1999
11 x 3 x 3 inches

All collection of the artist, San Antonio, Texas

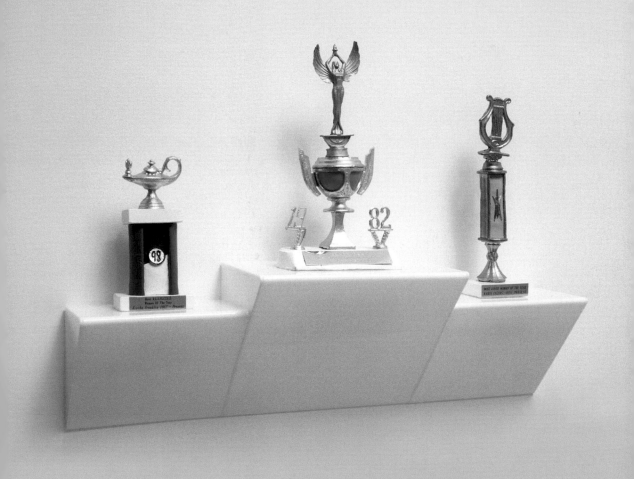

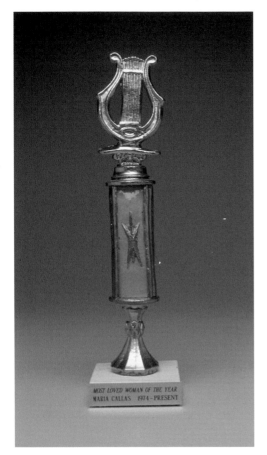

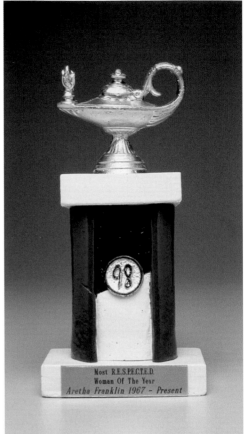

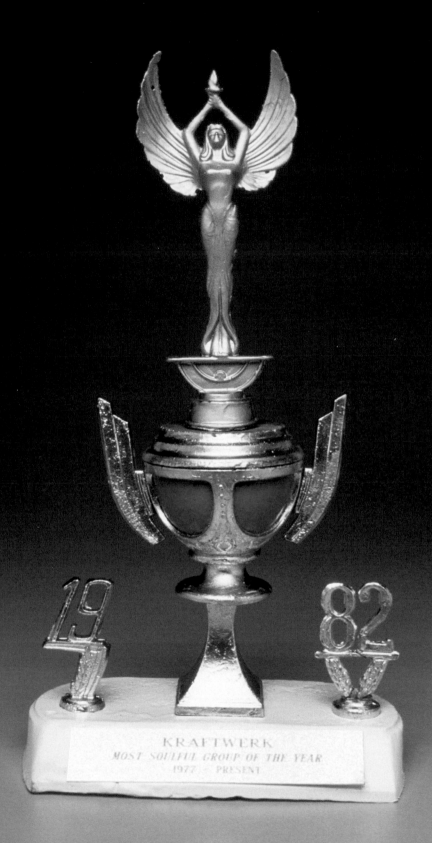

KRAFTWERK
MOST SOULFUL GROUP OF THE YEAR
1977 - PRESENT

MOURNING AND REDEMPTION
(AT THE GATES
OF THE DANCE FLOOR)

Crystal Disco Ball: *Homemade blue crystals
(monoammonium phosphate, water, dye); polyester resin*
Various artifacts: *Melted 45 rpm and 12-inch records, oil and acrylic paints,
spray paint, syringes, resin, acrylic shelf; objects on the left side
of runway dance floor made with Crystal Gayle's "Don't It Make My Brown Eyes Blue";
duplicate objects on right made with Gloria Gaynor's "I Will Survive"*

Shotgun shells: *For Kurt, 1994*
Arrowheads: *For Atahuallpa, 1532*
Syringes: *For Basquiat, 1988*
Coal: *For the coal miner's daughter's father, 1959*
Scaled-down version of an O-Ring: *For the* Challenger, *1986*
Medallion: *For Freddie Mercury, 1991*
Weight loss pill: *For Karen, 1983*
Impression of dinosaur skin: *For the dinosaurs, 60 million B.C.*
Thimble: *For the weaver's rebellion (The Triangle Shirtwaist Company), 1909*
Lily: *For Oscar Wilde, 1990*

1999
Dimensions variable
Private Collection

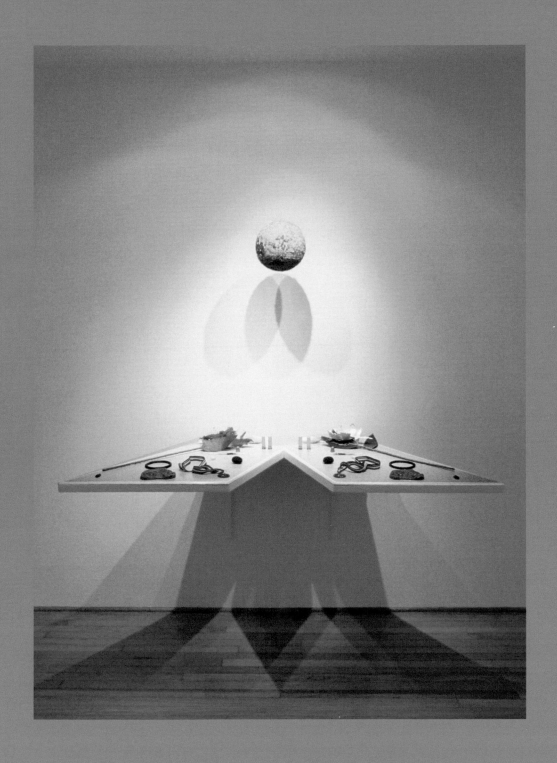

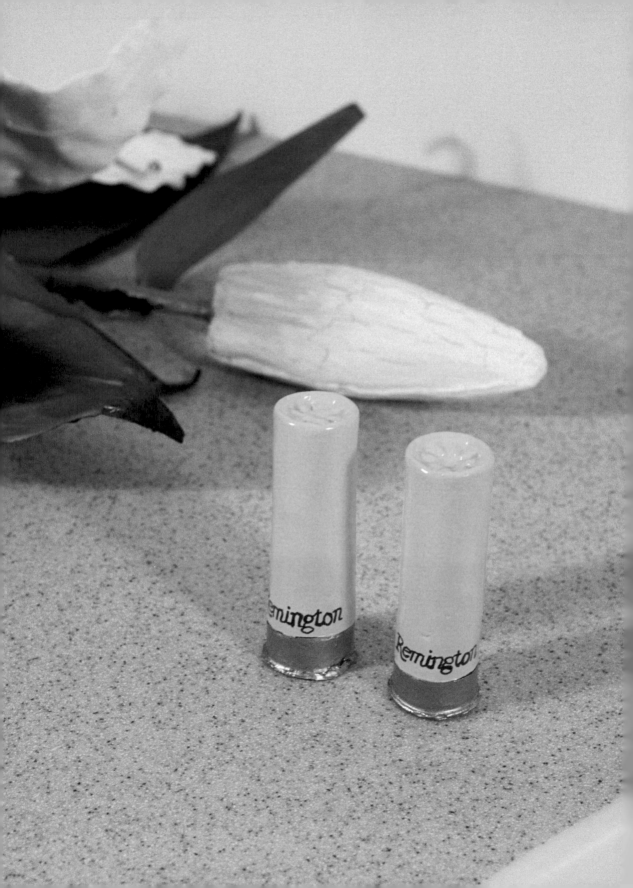

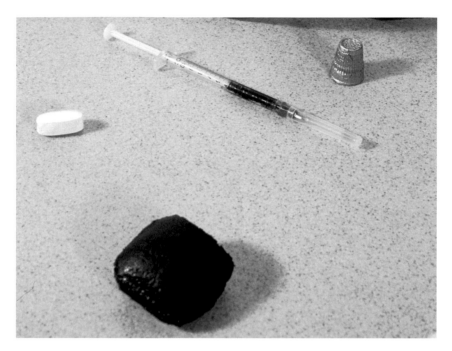

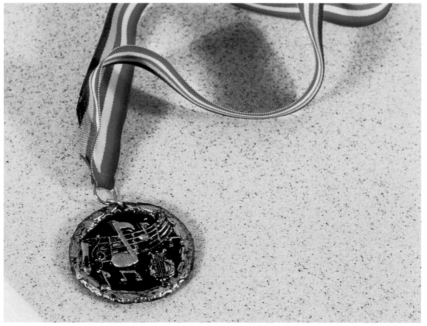

I ♥ EVERYTHING ROCK 'N' ROLL
(EXCEPT THE MUSIC)

Grocery bags that flew into my front yard,
songs I wrote for them,
spray paint, acrylic, pencil, pastel, frame

1999
42 x 44 inches
Collection of Nancy Delman Portnoy,
New York

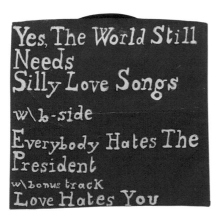

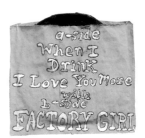

EVERYBODY HATES THE PRESIDENT

Lunch bag that flew into my front yard,
songs I wrote for it,
spray paint, acrylic, pastel, frame

1999
7 x 9 inches
Collection of Nancy Delman Portnoy,
New York

FACTORY GIRL

Beer can bag that flew into my front yard,
songs I wrote for it,
cardboard, spray paint, frame

1999
6 x 6 inches
Collection of Nancy Delman Portnoy,
New York

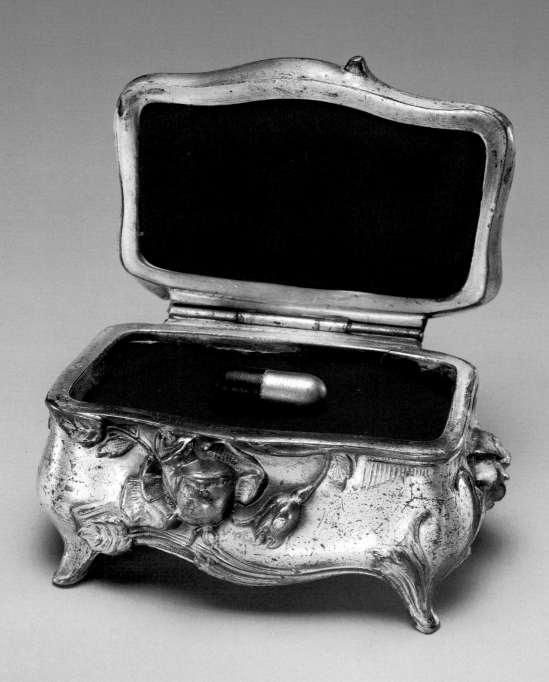

WHEN YOUR HEARTSTRINGS BREAK
I CAN MEND THEM BACK
(THE SUPREME SOLUTION)

Melted vinyl
from every Diana Ross and The Supremes Top 40 record released,
gold dust, silver dust, antique pill box, velvet

1998-2000
3½ x 3½ x 3 inches
Collection of Carlos Bacino, Houston, Texas

GIRL SINGING IN THE WRECKAGE
(DUSTY'S BLACK BOX RECORDER)

Melted Dusty Springfield vinyl records ("You Don't Have To Say You Love
Me," "Wishin' and Hopin'," "What Have I Done To Deserve This?"),
resin, protective concrete, paint,
a voice retrieved from the wreckage

2000
6 x 8 x 11 inches
Collection of Lombard-Freid Projects, New York

When I said I needed you
You said you would always stay
It wasn't me who changed but you
And now you've gone away

Don't you see
That now you've gone
And I'm left here on my own
That I have to follow you
And beg you to come home?

You don't have to say you love me
Just be close at hand
You don't have to stay forever
I will understand
Believe me, believe me
I can't help but love you
But believe me
I'll never tie you down

Left alone with just a memory
Life seems dead and so unreal
All that's left is loneliness
There's nothing left to feel

You don't have to say you love me
Just be close at hand
You don't have to stay forever
I will understand
Believe me, believe me

You don't have to say you love me
Just be close at hand
You don't have to stay forever
I will understand
Believe me, believe me, believe me

"You Don't Have To Say You Love Me"
Lyrics by Vicki Wickham and Simon Napier-Bell

I could have loved you, girl, like a planet
I could have chained your heart to a star

But it really doesn't matter at all
No, it really doesn't matter at all, life's a gas

I could have built the house on the ocean
I could have placed your love in the sky

But it really doesn't matter at all
No, it really doesn't matter at all, life's a gas

I could have turned you into a priestess
I could have burned your fate in the sand

But it really doesn't matter at all
No, it really doesn't matter at all, life's a gas

But it really doesn't matter at all
No, it really doesn't matter at all, life's a gas

"Life's A Gas"
Lyrics by Marc Bolan

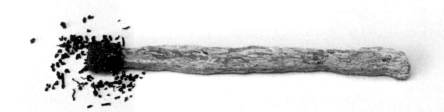

A DARK DAY FOR THE DINOSAURS
(RADIO EDIT)

Hand-carved dinosaur bone fragment,
melted and powderized vinyl record of T. Rex's "Life's A Gas"

2000-2001
⅛ x 1½ x ⅛ inches
Private Collection

IF WE DO EVER GET ANY CLOSER AT CLONING OURSELVES PLEASE TELL MY SCIENTIST-DOCTOR TO USE MOTOWN RECORDS AS MY CONNECTING PARTS

Melted Motown records from mother's record collection, hand-scratched and powderized Motown records, polyester resin, altered turntable, dissolved audiotape, vinyl letters, cast vinyl skulls, cast vinyl brains, bacteria from vinyl records, petri dishes, soy agar (5.0 % defibrinated sheep blood, 4.5g pancreatic digest of casein, papaic digest of soybean meal 5.0g, sodium chloride 5.0g, agar 14.0g, Growth Factors 1.5g), my blood sample, predigested protein, butterflies (lemon butterfly, pansy butterfly), homemade red, blue, green and yellow crystals (monoammonium phosphate, water, dye), crystal-inlaid 12-inch woofers, amino acids, carbon, amethyst crystals, sulphur, iron pyrite (fool's gold) potassium iodide, B-12, calcium hydroxide, hemlock, gold dust, dinosaur dust (dicophites gulosus), tryptophan, methylene, rose quartz, amber, shrimp eggs, sea salt, rock salt, slides with various prepared Motown vinyl samples, slide boxes, test tubes, test tube rack and grabber, microscopes, beakers, various glass and plastic vials and bottles, ceramic mortar, scalpel, tweezers, glass and plastic droppers, magnifying glass, glass stirring rod, eye goggles, gelatin pill, Styrofoam, dead wood, chopped drumsticks, fake flowers, Plexiglas and rods, electrical parts, electrical wiring, acrylic paint, spray paint, homemade labels

B|W

THE POLAR SOUL

Homemade blue crystals, microphones, soundtrack, video monitor, Plexiglas, plastic tubes, pedestals, Formica, vinyl lettering

1999-2000
Installation dimensions variable
Originally commissioned by Artpace, San Antonio, Texas
Collection of the artist

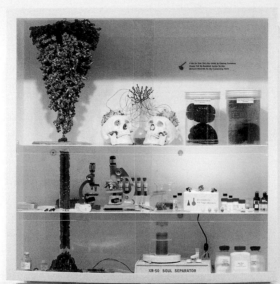
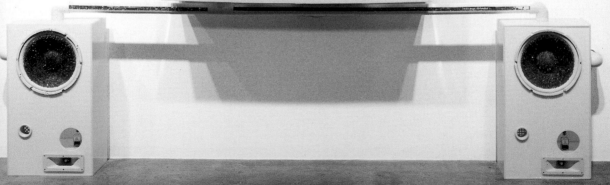

XR-50 SOUL SEPARATOR

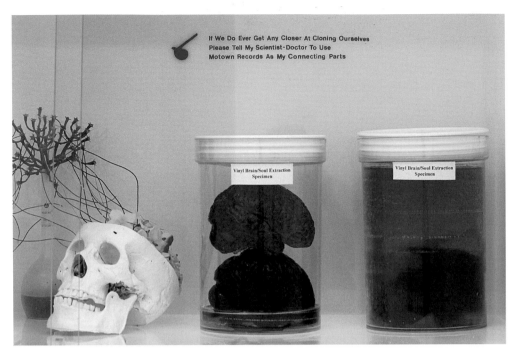

If We Do Ever Get Any Closer At Cloning Ourselves
Please Tell My Scientist-Doctor To Use
Motown Records As My Connecting Parts

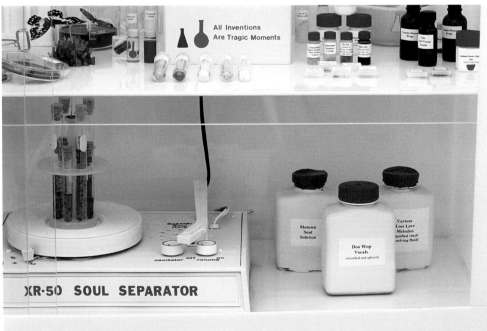

Dario Robleto

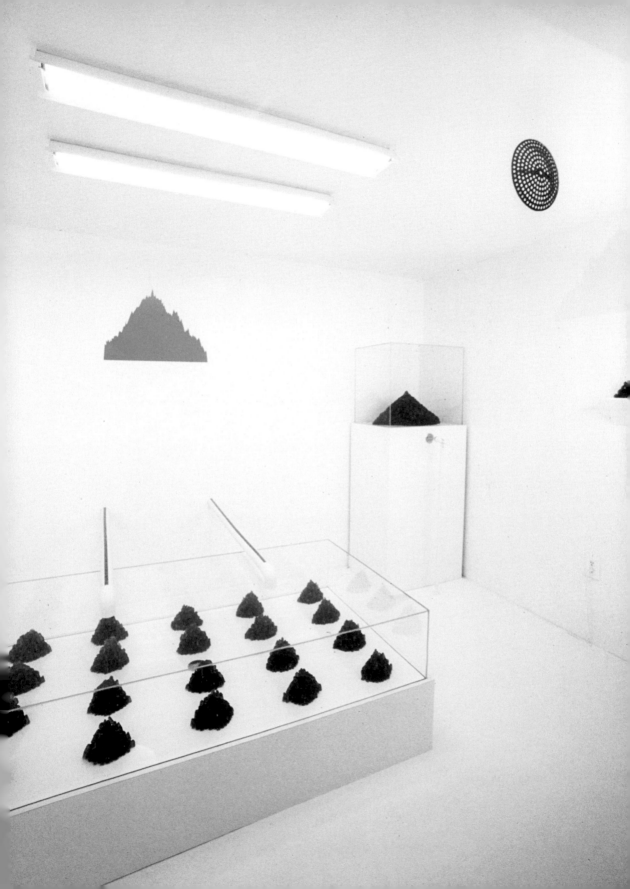

I MISS EVERYONE WHO HAS EVER GONE AWAY (THE SUITE)

Twelve screen prints on paper

Miles Davis–Live Around The World
Marlene Dietrich–Live In London
Maria Callas–Carmen
Jimi Hendrix–NYC '68 (Live)
Buddy Rich and Max Roach–Rich Versus Roach
Sun Ra–Live At The Village Vanguard
Ella Fitzgerald and Billie Holiday–Live at Newport (top left)
Charles Mingus–The Complete Town Hall Concert (top right)
Nirvana–From The Muddy Banks Of The Wishkah (bottom left)
Edith Piaf–Live In Lausanne (bottom right)
The Plastic Ono Band–Live Peace In Toronto 1969
Patsy Cline–Live At The Grand Ole' Opry

2000
Each 17 x 14 inches
Collection of Chris Mattsson and John McHale,
Austin, Texas

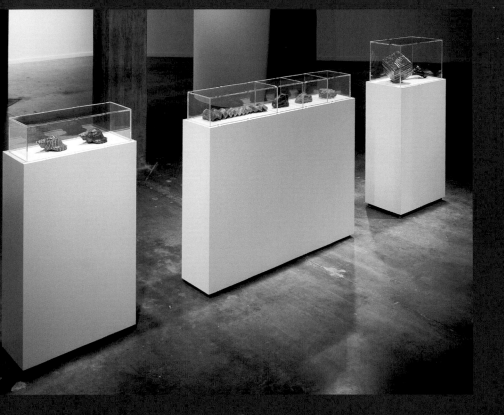

THE PAST IS MADE OF GOLD,
THE FUTURE IS MADE OF COAL

IT WAS YOUR AGE, IT'S OUR RAGE

TREBLEDOWN BASSUP

1999
Collection of Don Mullins, Austin, Texas

Installation view
Contemporary Arts Museum, Houston, Texas

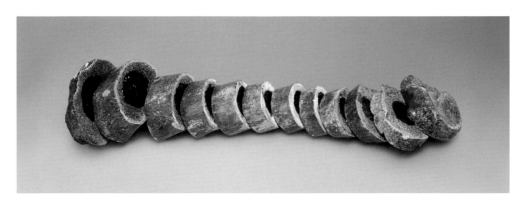

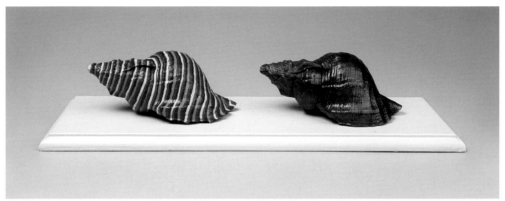

IT WAS YOUR AGE, IT'S OUR RAGE
(detail)

Bone: *Prehistoric* Bison antiquus *bone (Pleistocene period,*
2 million to 10,000 B.C.), herbivore, sliced and hollowed out,
filled with melted vinyl record of Bob Dylan's "The Times They Are A Changin'"

1999
48 x 52 x 8 inches (with pedestal)

THE PAST IS MADE OF GOLD,
THE FUTURE IS MADE OF COAL

Gold seashell: *Melted vinyl record (Patti Smith's Horses),*
iron pyrite (fool's gold), carbon, polyester resin
Rainbow seashell: *Sawdust from hand-ground acoustic guitar,*
polyester resin, spray paint

1999
48 x 36 x 8 inches (with pedestal)

SOMETIMES THE TOP 40 MAKES ME FEEL LIKE AN EMPTY, MAINE COASTAL COTTAGE IN THE DEAD OF WINTER

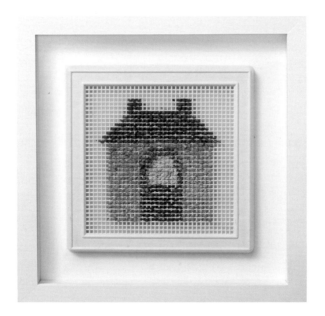

Cottage and landscape: *Various melted vinyl records from the Top 40 of the past 28 years, polyester resin, fake snow, spray paint*
Storm cloud: *Dust from record grooves, lint, various debris collected from used record bins where records were found, wire*
Knitting: *Painted spider webs and dust collected from used record bins where records were found*
Record bin: *Record sleeves, wood, paint*

1979-2001
Dimensions variable
Collection of the artist, San Antonio, Texas

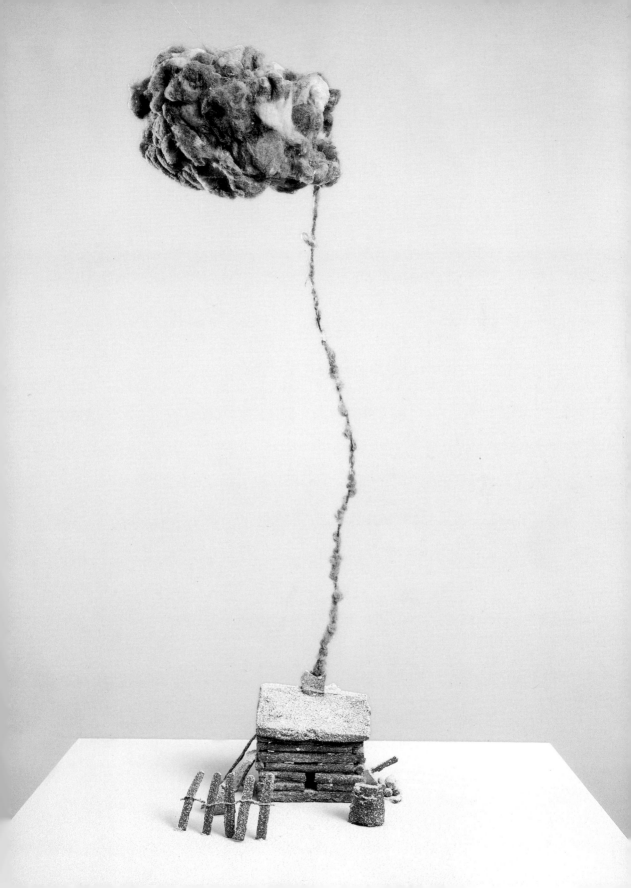

SOME MEMORIES ARE SO VIVID
I'M SUSPICIOUS OF THEM

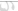

Wood, cloth, glue, cardboard, paper, melted vinyl record, paint

*A miniature reproduction bedroom was constructed
based on my mother's general memories of her room when she was a
teenager. The record on the record player is the sole copy
of an original composition I wrote for her,
imagining what she may have liked as a young girl
and what she might like today,
entitled "I Thought I Knew Negation Until You Said Goodbye"*,
which was recorded, pressed to vinyl, ground into powder, melted
and cast into a miniature record.*

*Production assistance by Justin Boyd

2000-2001
55 x 22½ x 20½ inches (with pedestal)
Collection of Nancy Delman Portnoy, New York

REQUIEM WRITER
(WORLD WAR ODES)

Pencil, ink, colored pencil, marker on paper

*All drawings based on album cover designs from
my grandmother's record collection.*

2001
Sixteen individual works
Each 14 x 14 inches

Top left: Collection of Abby Messitte and Derek Eller, New York
Top right and bottom right: Private Collection
Middle left: Collection of Nicole Klagsbrun, New York
Middle right and bottom left: Collection of Nicole D. Liarakos, New York

the u.s.ofa. and the angels Sing
the new radio airplay hit single
Though It's Not Love It's Means Something

Golden Things To Remember
The 40s
HiROSHiMA
presents
the
lost hymnal
It's Times Like This My
Funk Is Completly Useless

THE DRILL SERGEANTS
LIBERTY
39¢
golden moments
SUPER SURROUND SOUND
Marbyrden (That's What I'm Reaching For) Remix (1961)
Kar, Sweet Potato, Crystal and Stone (1966)
You Have Erased The Fundamental Me (1959)
Requien Writers League (1958)

Scientist Caught In The Belly Of A Whale !
Surround
Sound
bobby oppenheimer
and the turkish vacuum ice
Surround
Sound

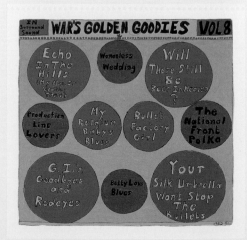

IN Surround Sound
WAR'S GOLDEN GOODIES VOL 8
Echo In The Hills (My Name Is Waiting There?)
Womanless Wedding
Will There Still Be Beer In Heaven?
Production Line Lovers
My Belgium Babys Blues
Bullet Factory Girl
The National Front Polka
G.I.'s Goodbyes and Redeyes
Betty Lous Blues
Your Silk Umbrella Won't Stop The Bullets
1953 G.

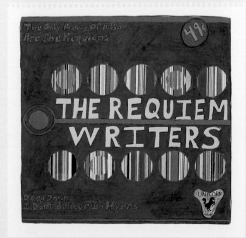

The Only Beauty Of A War Are The Requiems
49¢
THE REQUIEM WRITERS
Deep Down I Don't Believe In Hymns
UNICORN

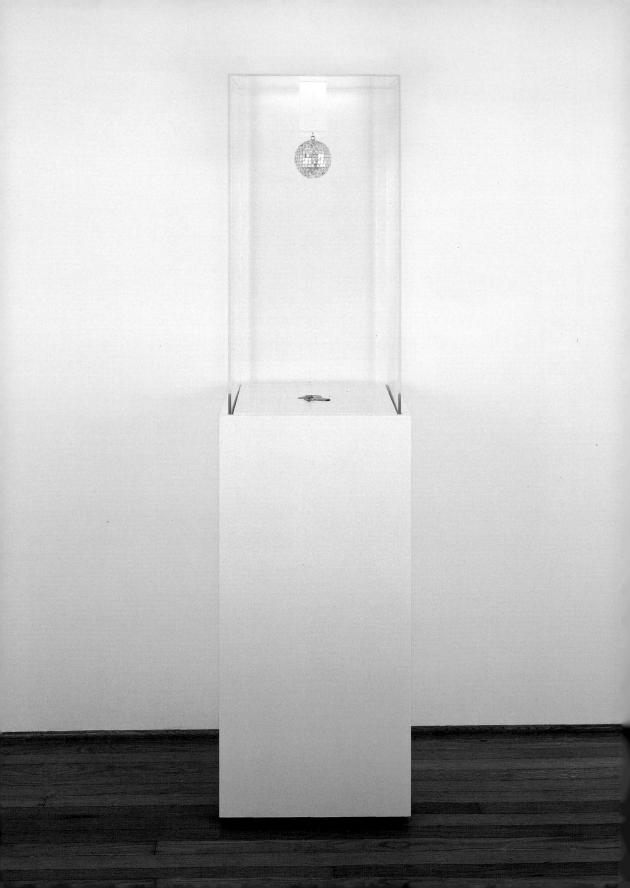

WE'LL DANCE OURSELVES
OUT OF THE TOMB

Pedestal, Plexiglas, motor, lights

Disco ball: *Glass and hand-ground impact glass*
(glass formed from a meteorite strike when heat from blast
melts sand surrounding impact site),
polyester resin, Styrofoam, paint
Pendant: *Melted vinyl record of T. Rex's "Cosmic Dancer,"*
50,000 year old meteorite fragment (nickel, iron),
homemade crystals (monoammonium phosphate, water, dye), spray paint
Puddle: *Homemade crystals, amino acids, carbon, polyester resin*

2000-2001
33 x 6½ x 6½ inches
Private Collection

YOUR MOONLIGHT
IS IN DANGER
OF SHINING FOR NO ONE

*Custom-made oak box, glass and hand-ground trinitite
(glass formed during the first atomic test explosion from
Trinity test site, c. 1945, when heat
from blast melted sand surrounding impact site),
quartz, velvet, engraved brass label*

2000-2001
5 x 17 x 5 inches
Collection of Denby Auble, Houston, Texas

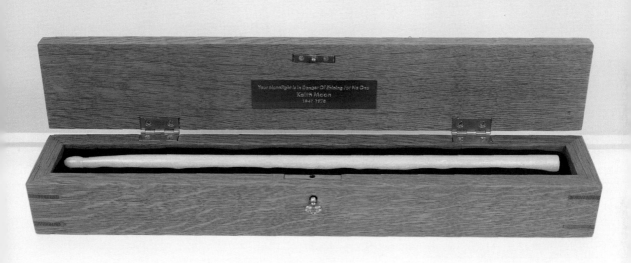

Your Moonlight Is In Danger Of Shining For No One
Keith Moon
1947 1978

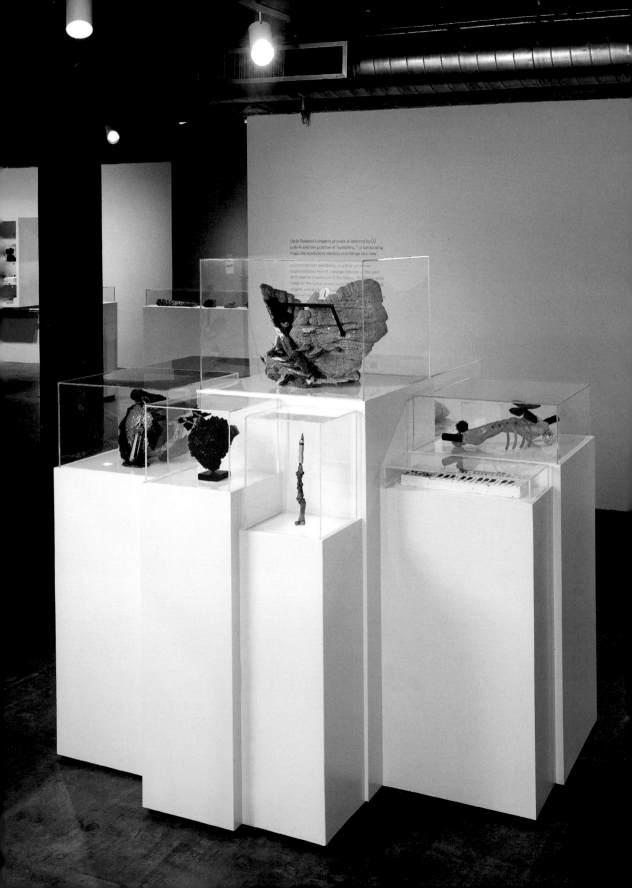

Dario Robleto's creative process is inspired by DJ culture and the practice of "sampling," or compositing music by combining existing recordings into new

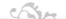

POPULAR HYMNS
WILL SUSTAIN US ALL
(END IT ALL)

2000-2001
69 x 70 x 63½ inches
Whitney Museum of American Art, New York;
purchase with funds from the
Contemporary Painting and Sculpture Committee
and Cecily E. Horton, 2004.19a-vv

Installation view
Contemporary Arts Museum, Houston, Texas

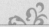

A DARK DAY
FOR THE DINOSAURS

Prehistoric cave bear digit, wire

Lighter: *Dissolved 8-track recording of Black Sabbath's "Iron Man"*
Flame: *Melted vinyl record of T. Rex's "Life's A Gas," spray paint*

2000-2001
40 x 19 x 9 inches (with pedestal)
Whitney Museum of American Art, New York; purchase with
funds from the Contemporary Painting and Sculpture Committee
and Cecily E. Horton, 2004.19a-vv

Dario Robleto

FALSETTO
CAN BE A WEAPON

Hand-carved fossilized mammoth ivory,
each tip laced with melted vinyl from Tammy Wynette's record
"Stand By Your Man," hand carved driftwood, leather pouch, twine

2000-2001
49 x 10 x 10 inches (with pedestal)
Whitney Museum of American Art, New York; purchase with
funds from the Contemporary Painting and Sculpture Committee
and Cecily E. Horton, 2004.19a-vv

A candy-colored clown they call the sandman
Tiptoes to my room every night
Just to sprinkle stardust and to whisper,
Go to sleep. everything is all right

I close my eyes, then I drift away
Into the magic night
I softly say
A silent prayer, like dreamers do
Then I fall asleep
To dream my dreams of you

In dreams I walk with you
In dreams I talk to you
In dreams you're mine
All of the time we're together
In dreams, in dreams

But just before the dawn
I awake and find you gone
I can't help it, I can't help it, if I cry
I remember that you said goodbye

It's too bad that all these things
Can only happen in my dreams
Only in dreams
In beautiful dreams

"In Dreams"
Lyrics by Roy Orbison

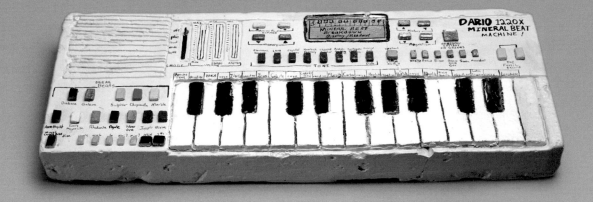

THIS MINERAL I CALL A BEAT

Silver ore, olivine, Apache tear, calcite, copper ore,
onyx, fluorite, unakite, rhodonite, ivory, magnesite, zinc, carbon,
amino acids, iron pyrite, hemlock, sulfur, cubic zirconia,
obsidian, yellow jasper, rose quartz, mica, amethyst, diabase, marble,
chrysorolla, lepidolite, galena, plaster, melted vinyl,
dissolved audio tape and powderized compact disc recordings
of Roy Orbison's "In Dreams," spray paint, marker

2000-2001
46 x 19 x 9 inches (with pedestal)
Whitney Museum of American Art, New York; purchase with
funds from the Contemporary Painting and Sculpture Committee
and Cecily E. Horton, 2004.19a-vv

Whoa, oh mercy, mercy me
Oh, things ain't what they used to be
No, no, where did all the blue skies go?
Poison is the wind that blows
from the north and south and east
Whoa mercy, mercy me

Ah, things ain't what they used to be, no, no
Oil wasted on the ocean
and upon our seas
Fish full of mercury, oh ah

Oh, mercy, mercy me
Oh, things ain't what they used to be, no, no
Radiation underground and in the sky
Animals and birds who live nearby are dying

Oh, mercy, mercy me
Oh, things ain't what they used to be
What about this overcrowded land
How much more abuse from man can she stand?

Oh, no, no, my sweet lord
No, no, my sweet Lord
No, no, my sweet Lord

"Mercy, Mercy Me (The Ecology)"
Lyrics by Marvin Gaye

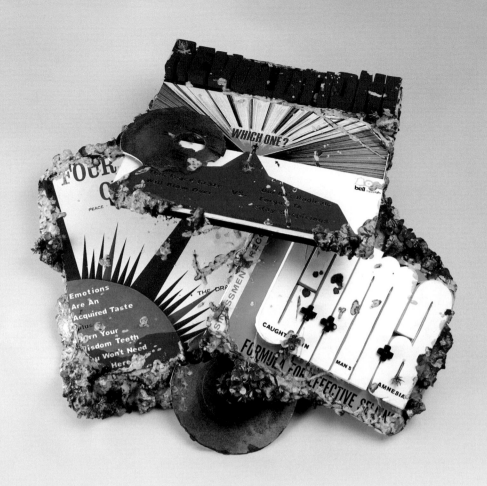

A PAIR OF SPINNING
POP STARS TETHERED BY A RIBBON
OF GAS AND DUST (LUST)

Sulfur-coated beeswax, amethyst, Columbian amber,
homemade crystals, altered album covers, paper, foamcore, glue,
prehistoric whale bone dust, melted vinyl records of Nirvana's "In Bloom"
and Marvin Gaye's "Mercy, Mercy Me (The Ecology),"
gunpowder, antibiotics, polyester resin, typeset, spray paint

2000-2001
52 x 22 x 22 inches (with pedestal)
Whitney Museum of American Art, New York; purchase with
funds from the Contemporary Painting and Sculpture Committee
and Cecily E. Horton, 2004.19a-vv

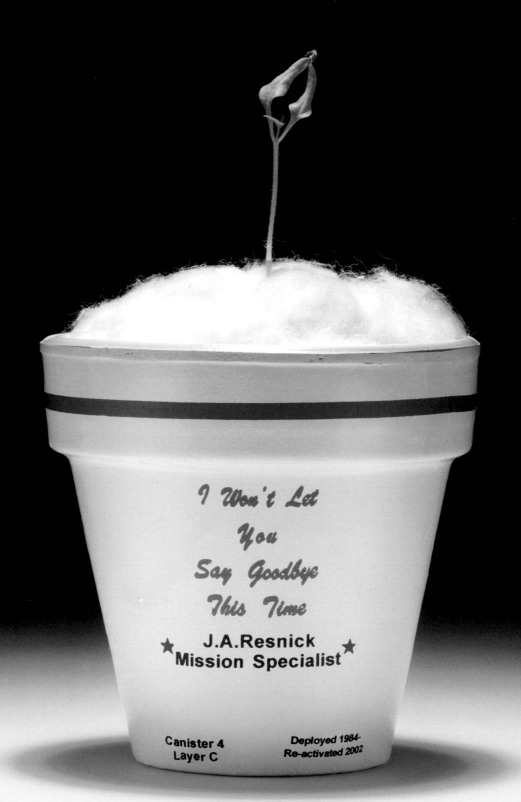

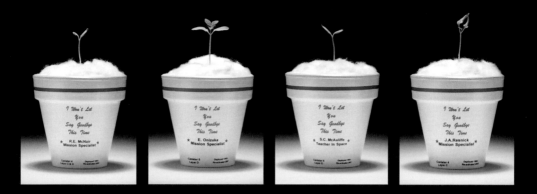

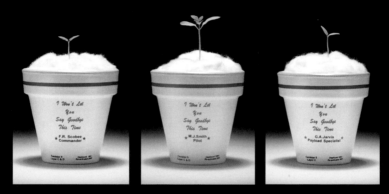

I WON'T LET YOU SAY GOODBYE THIS TIME

Suite of seven digital Chromogenic photographs

Re-activated NASA "Space Seeds"
(tomato seeds flown in space and launched on a probe from
the space shuttle Challenger, 1984, retrieved on the Columbia, 1990),
cotton, dirt, custom-made porcelain cups,
dust made from fragments of shuttle ceramic heat shields, typeset

2001-2003
Each 12 x 9 inches
Collection of Federal Reserve Bank of Dallas, Houston Branch

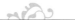

MEN ARE THE NEW WOMEN

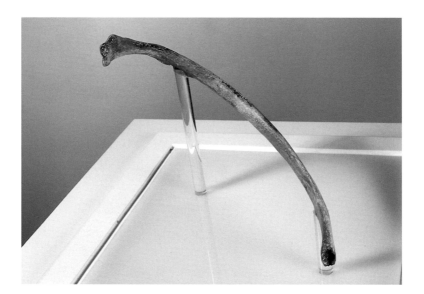

Bone dust, carbon, water extendable resin, pigments, dirt,
engraved Plexiglas, polyurethane, wood, light

A female ribcage bone was ground to dust
then recast and carved as a male ribcage bone.

2002
50³⁄₄ x 15 x 15 inches
Courtesy of the Linda Pace Foundation, San Antonio, Texas

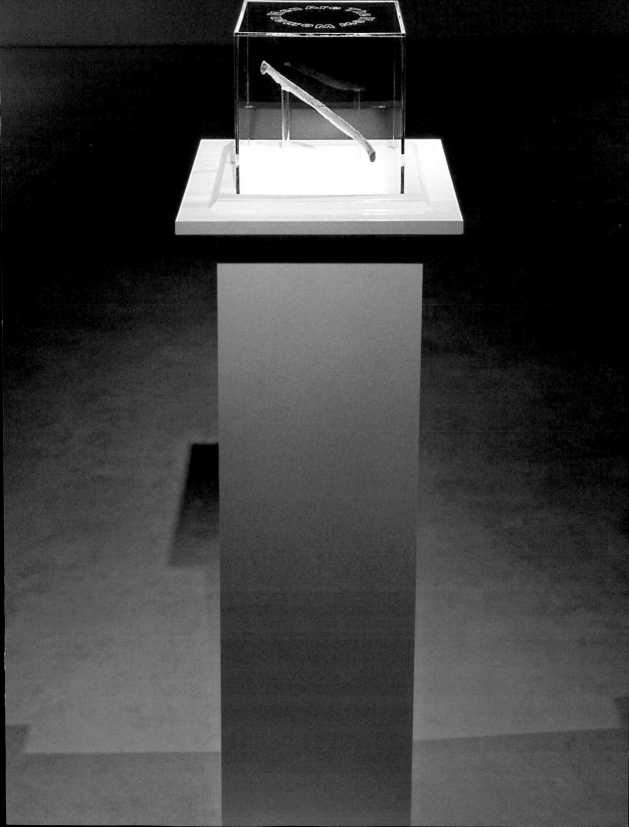

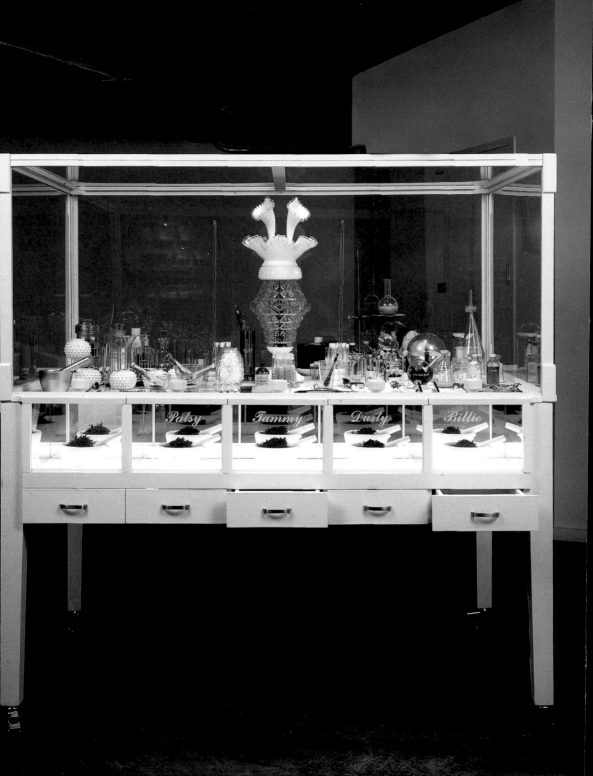

THE DIVA SURGERY

Various antique laboratory glassware (beakers, rods, test tubes,
bottles, funnels, mortars and pestles, pipettes),
magnifying glass, lab burner, glass breast pump, glass syringe,
antique milk glass, antique powder box, vintage surgical equipment,
tracheal extractor, scalpels, tweezers, scissors,
glass beads, porcelain mortars and funnels, 45 rpm records,
ground, spliced, and melted vinyl records of various Diva vocals,
audiotape, dissolved magnetic audiotape,
various laboratory chemicals, sulfur, carbon, amino acids,
crushed cubic zirconium, homemade crystals (monoammonium phosphate,
water, dye), Novocain, sugar, honey, ocean water, oil,
hummingbird and butterfly nectar, beeswax, polyester resin,
mirrors, lights, wood, Plexiglas, typeset, vinyl lettering, paint

2000-2001
77 x 81 x 56 inches
Collection Museum of Contemporary Art San Diego,
Museum Purchase, International and Contemporary Collectors Funds

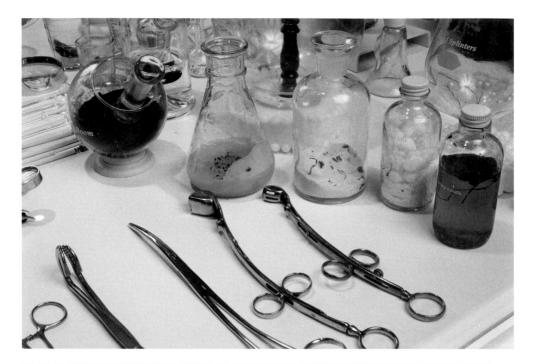

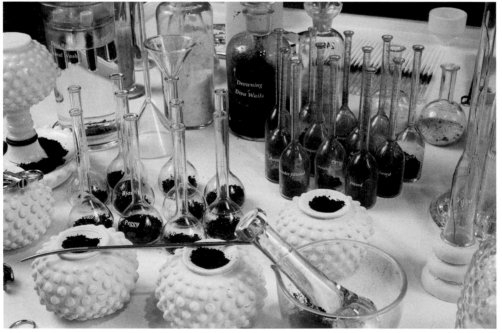

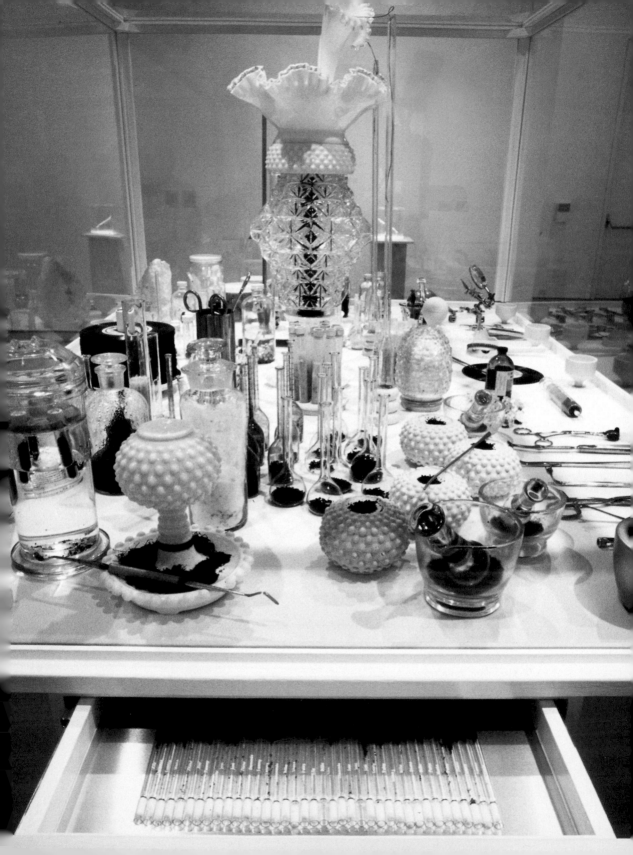

DEEP DOWN
I DON'T BELIEVE IN HYMNS

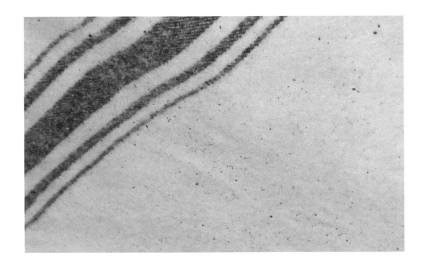

Military-issued blanket (American-Indian Wars, c. 1862)
infested with hand-ground vinyl record dust
from Neil Young and Crazy Horse's "Cortez the Killer,"
and Soft Cell's "Tainted Love"

2001
4 x 21 x 17 inches
Private Collection

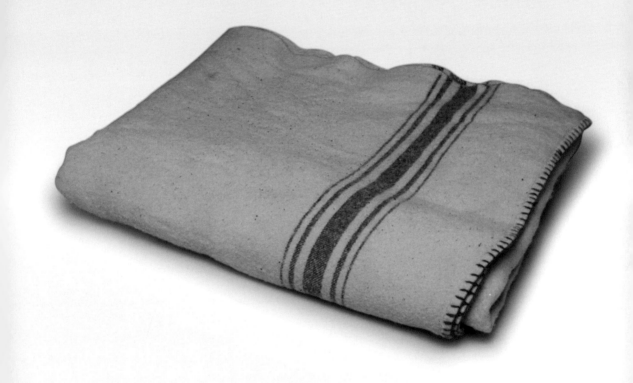

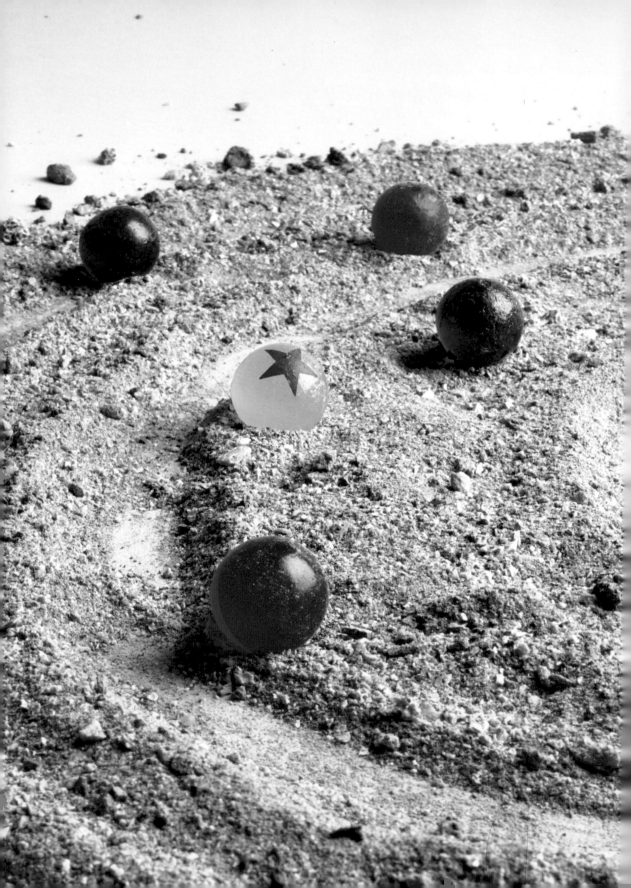

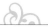

IF A METEORITE
FALLS ON YOUR HEAD THEN
GOD WAS AIMING

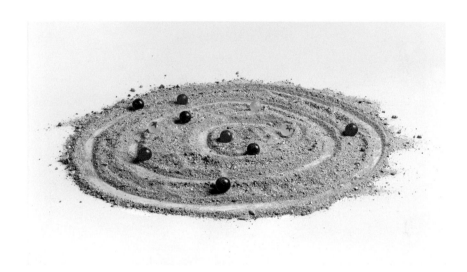

Marbles made from impact glass
(glass produced when meteorite strikes earth and melts surrounding sand),
hand-ground dinosaur dust from femur bone

2002
Dimensions variable
Collection of Ernst Siegel, Arlingon, Vermont

CHEMISTRY IN THE CHURCH

Colored paper, colored pencil, ink, glue

The Methodist Mayhem/Professor Leinsdorf's Bone Flute Orchestra
LovePeaceJoy/The Symphonies of Botany
Gospel Grandeur/The Bio-Ethicist Boys
Chemistry and the Church/Scientists For The Ethical Treatment Of Scientists
God's Barnyard/Evolutionary Psychology
Lutheran Lunacy/A Tribute to A.I.
Holy Roman Inquiry on Nanotechnology/Lab Sampler
The Power and the Glory/String Theory Melody (above and right)
Vicars For The De-Romanticizing of Astronomy/Tonight We Count and
Classify Stars

2002
Suite of nine diptychs, each 12 x 12 inches
Private collection

Dario Robleto

records **ROME IS ON TO US** tapes

STRING
THEORY
MELODY

CORAL

Dot RECORDS

STEREOPHONIC

FEATURING

THE COLD and CALCULATED
GLORIFIED DICE THROWERS ·
ABACUS DON'T FUCK WITH US ·
I COULD LOVE YOU RANDOMLY
AT BEST · · THE REFRESHING SECURITY
of MATHEMATICS and SCIENCE TO AN
INSECURE and SENSITIVE YOUTH · · ·
WHEN YOUR HEARTSTRINGS BREAK
I CAN MEND THEM BACK · · PLUS ∞ × 0

AUTOBIOGRAPHOPHOBIA

Ink, cut paper, glue

2002
21 x 19¾ inches
Private Collection

COSMOLOGY OF CONSTANT SORROW

Polyurethane on panel

2002
72 x 48 inches
Collection of Marcia Goldenfeld Maiten and Barry David Maiten,
Los Angeles, California

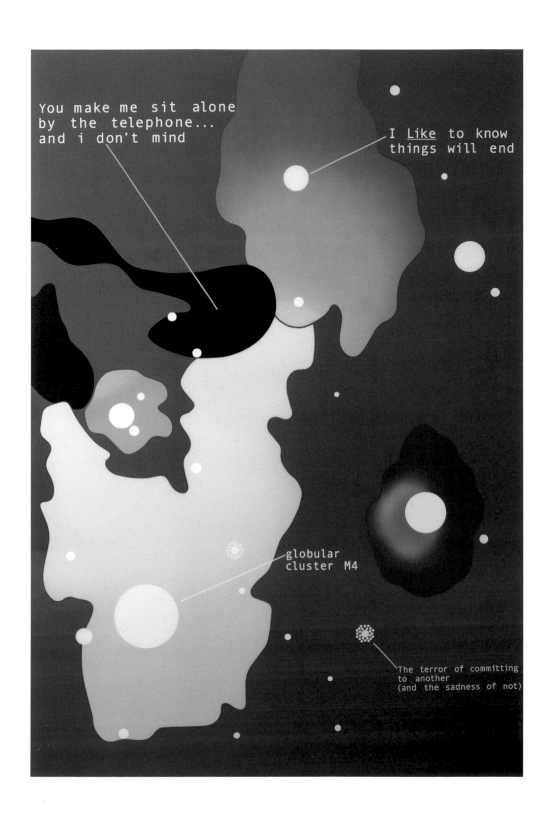

ROSES IN THE HOSPITAL

*Cut paper, colored pencil,
metal and plastic trophy parts,
foamcore, glue*

2002
Dimensions variable
Collection of Brad Nagar and Reid Sutton

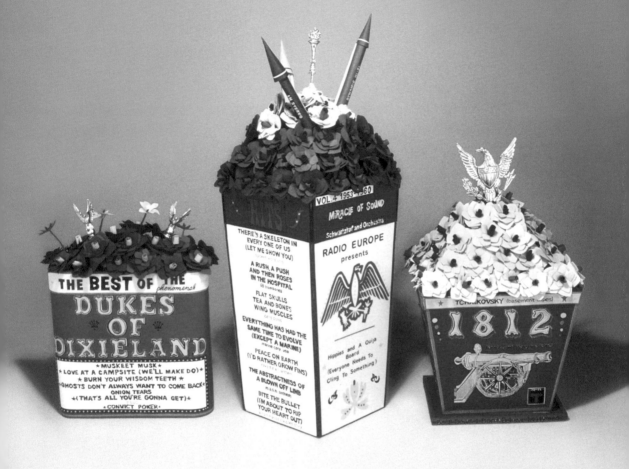

THE BEST OF THE *phenomenal*

DUKES
OF
DIXIELAND

* MUSKEET MUSK *
* LOVE AT A CAMPSITE (WE'LL MAKE DO) *
* BURN YOUR WISDOM TEETH *
* GHOSTS DON'T ALWAYS WANT TO COME BACK *
* ONION TEARS *
* (THAT'S ALL YOU'RE GONNA GET) *
* CONVICT POKER *

VOL. 4 1953 — 60
MiRACLE of SOUND
Schwartzlof and Orchestra

RADIO EUROPE
presents

THERE'S A SKELETON IN
EVERY ONE OF US
(LET ME SHOW YOU)

A RUSH A PUSH
AND THEN ROSES
IN THE HOSPITAL
(6 trombones)

FLAT SKULLS
TEA AND BONES
WING MUSCLES

EVERYTHING HAS HAD THE
SAME TIME TO EVOLVE
(EXCEPT A MARINE)
Marine Corps solo

PEACE ON EARTH
(I'D RATHER GROW FINS)

THE ABSTRACTNESS OF
A BLOWN OFF LIMB
U.S.S. anthem

BITE THE BULLET
(I'M ABOUT TO RIP
YOUR HEART OUT)

Hippies and A Ouija
Board
(Everyone Needs To
Cling To Something)

★ TCHAIKOVSKY (basement tapes) ★
1812

THOUGHTS ON US

There's A Skeleton In Everyone Of Us (Let Me Show You)
*Homemade paper and envelope made from cotton and bone dust
from every bone in the body, wheat starch, written message,
embossed text, ink, cold cast copper and ribcage bone dust frame*

The Terror Of Committing To Another (And The Sadness Of Not)
*Homemade paper and envelope made from cotton and bone dust
from every bone in the body, wheat starch, written message,
embossed text, ink, cold cast brass and ribcage bone dust frame*

A Human Being Unpeeling *(illustrated at left)*
*Homemade paper and envelope made from cotton and bone dust
from every bone in the body, wheat starch, written message,
embossed text, ink, cold cast bronze and ribcage bone dust frame*

You Will Out Live The One You Are Used To Loving
*Homemade paper and envelope made from cotton and bone dust
from every bone in the body, wheat starch, written message,
embossed text, ink, cold cast copper and ribcage bone dust frame*

Humans Are Just Things Which Happen From Time To Time
*Homemade paper and envelope made from cotton and bone dust
from every bone in the body, wheat starch, written message,
embossed text, ink, cold cast brass and ribcage bone dust frame*

The Universe Could Care Less
*Homemade paper and envelope made from cotton and bone dust
from every bone in the body, wheat starch, written message,
embossed text, ink, cold cast copper and ribcage bone dust frame*

2001-2002
Six parts, overall dimensions variable
Collection of Janet and Richard Caldwell, Houston, Texas

NOWADAYS
I ONLY LOOK UP TO PRAY

*Custom-made kaleidoscope, wood, brass,
mirrors, hand-ground trinitite
(glass produced during the first Atomic test explosion
from Trinity test site, c. 1945,
when heat from blast melted surrounding sand),
antique wood and brass tripod*

2001-2002
28 x 28 x 55 inches

B | W

THE ABSTRACTNESS OF
A BLOWN OFF LIMB

*Handmade clay and lead marbles used by soldiers
from the Civil War, American-Indian Wars and Mexican-American War,
human and dinosaur dust from femur bones*

2002
14 inches diameter

Collection of Christopher Vroom and Ilya Szilak

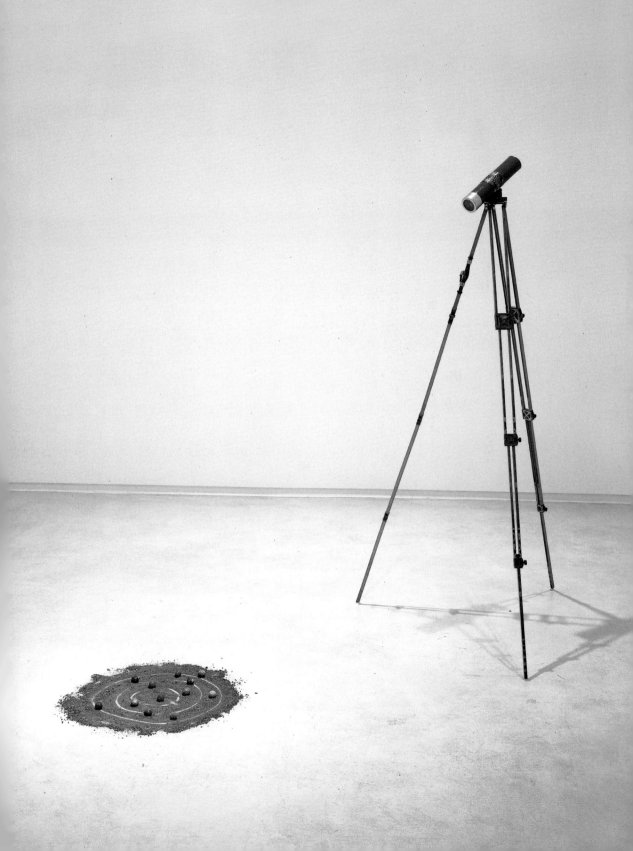

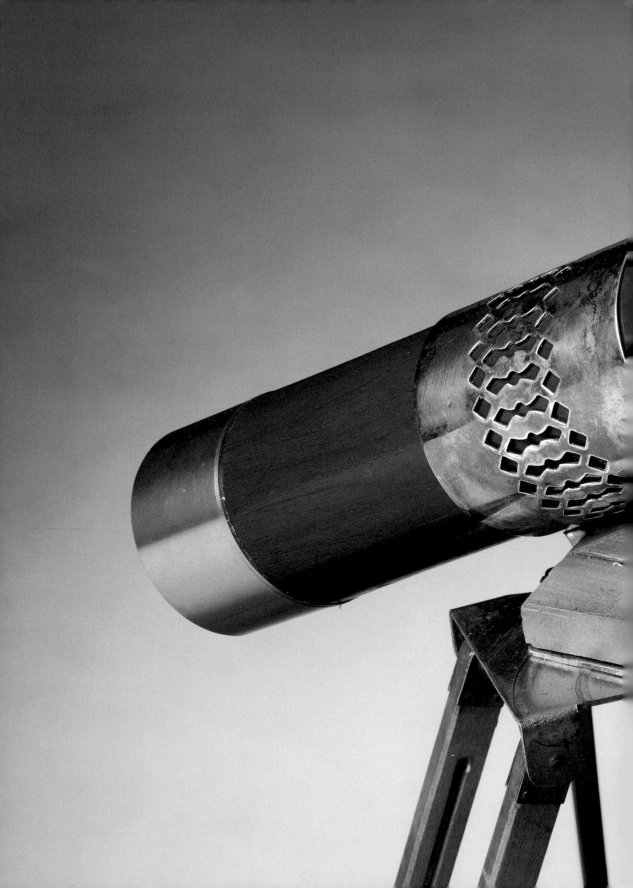

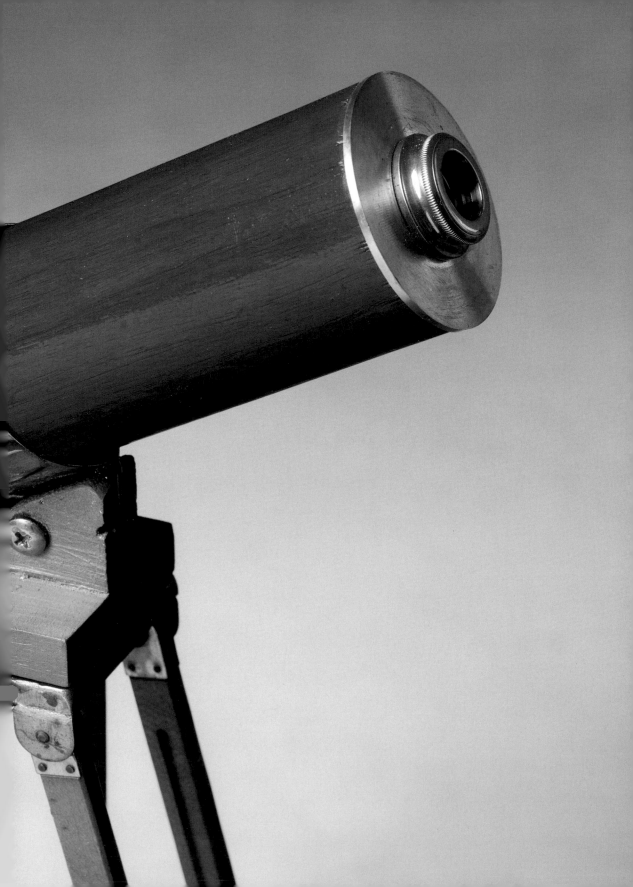

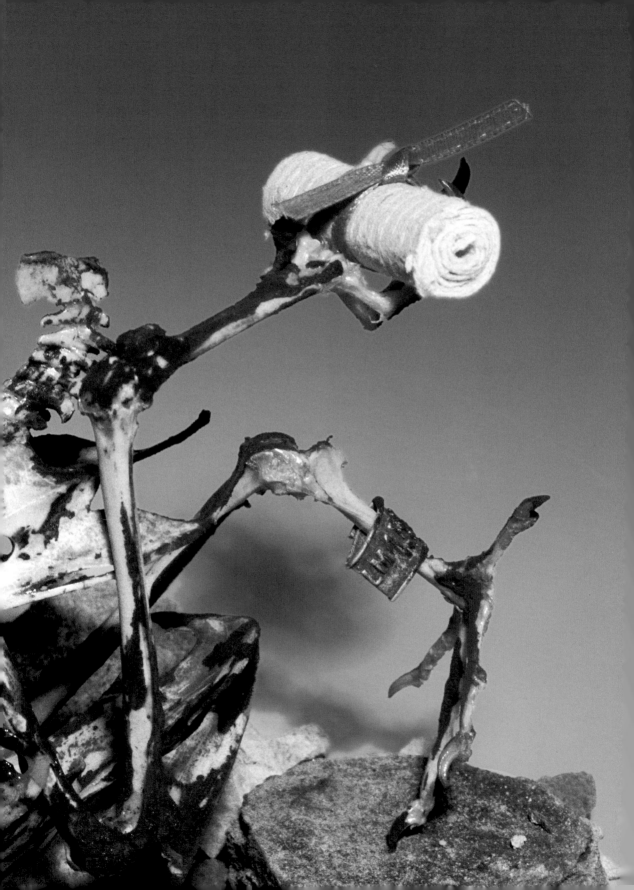

WAR PIGEON WITH A MESSAGE
(LOVE SURVIVES THE DEATH OF CELLS)

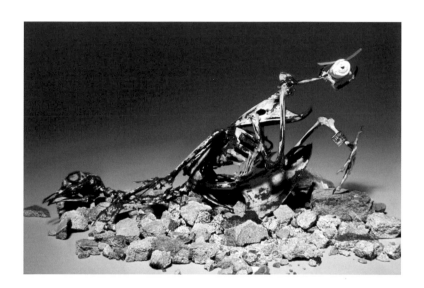

*Pigeon skeleton, WWII-era pigeon I.D. tag,
homemade paper (pulp made from human ribcage bone dust
and a Civil War-era letter that a Union soldier's wife wrote to
a Confederate General pleading for the release and
return of her P.O.W. husband), WWI bullet, ribbon, rose petals,
rust, dirt, rubble from the Berlin Wall*

2002
8 x 11 x 5½ inches
Collection of Garret Siegel, Arlington, Vermont

AT WAR WITH THE ENTROPY OF NATURE/GHOSTS DON'T ALWAYS WANT TO COME BACK

Cassette: Carved bone and bone dust from every bone in the body, trinitite (glass produced during the first atomic test explosion, from Trinity test site, c. 1945, when heat from blast melted surrounding sand), metal screws, rust, typeset
Audiotape: An original composition of military drum marches, various weapon fire, and soldiers' voices from battlefields of various wars made from E.V.P. recordings (Electronic Voice Phenomena: voices and sounds of the dead or past, detected through magnetic audiotape)

2002
2½ x 3¾ x ⅝ inches
Collection of Julie Kinzelman and Christopher Tribble

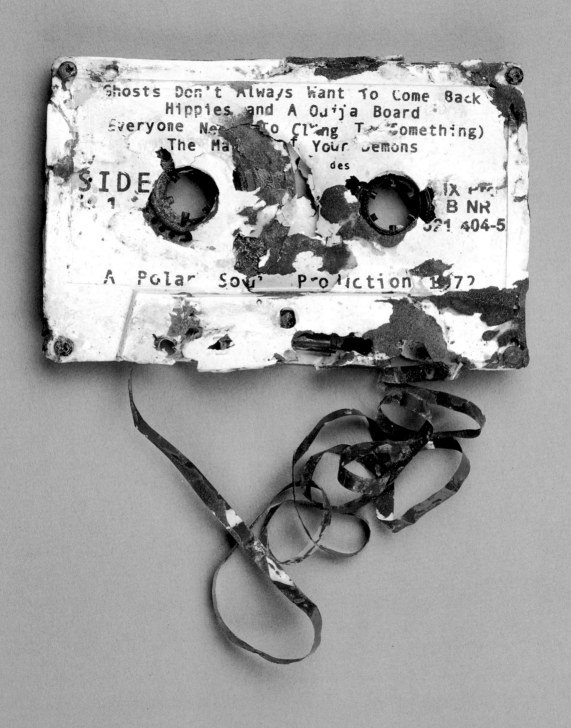

OUR SIN WAS IN OUR HIPS

Hand-ground and powderized vinyl records,
melted vinyl records, male and female pelvic bone dust,
polyester resin, spray paint, pigments,
dirt, concert spotlight.
Female pelvis made from mother's Rock 'n' Roll 45 rpm records,
male pelvis made from father's Rock 'n' Roll 33 rpm records.

2001-2002
12 x 9 x 9 inches
Collection of Peter and Linda Zweig, Houston, Texas

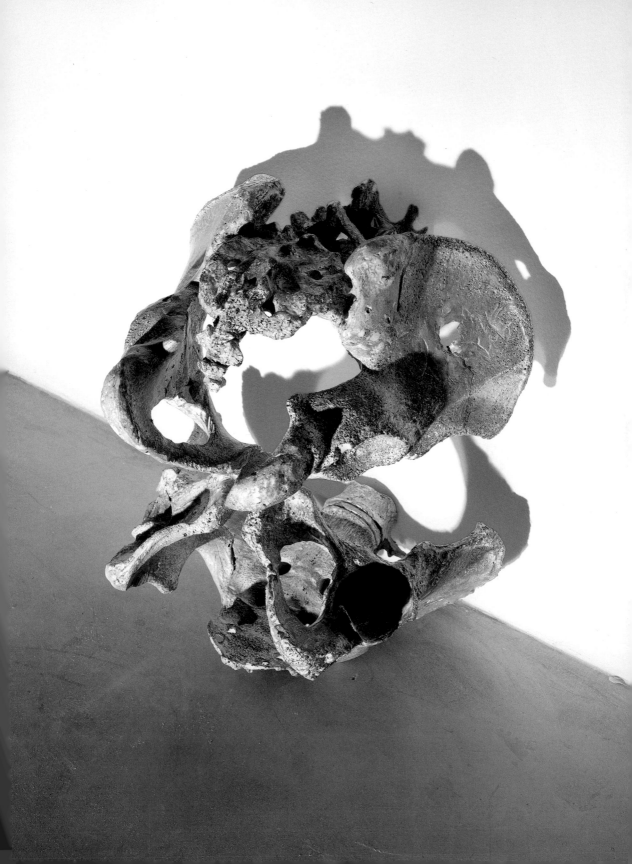

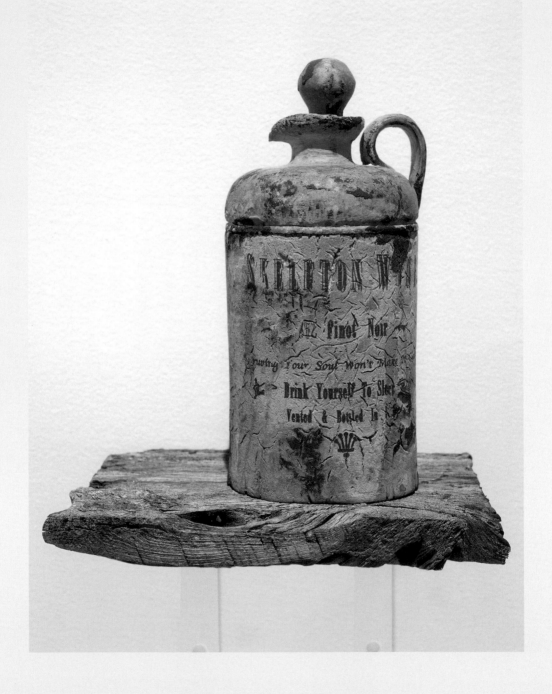

SKELETON WINE

*Cast and carved bone, bone dust from every bone in the body,
ground wisdom teeth, homemade wine (water, sugar, fermented grapes,
black cherries, plums, red raspberries, yeast,
gelatin, tartaric acid, pectinase, sulfur dioxide, oak flavoring)
fortified with calcium, potassium, creatine, zinc, iron,
nickel, tin, copper, boron, vitamin K, crushed amino acids, glutamine,
chromium, sodium, magnesium, colostrum, phosphorus,
iodine, microcrystalline cellulose, quartz,
rust, water extendable resin, typeset, driftwood shelf*

2002
12 x 5 x 5 inches
Private Collection

ATHEIST WITH A TWIST
(I'M NOT SURE ABOUT MAGIC)

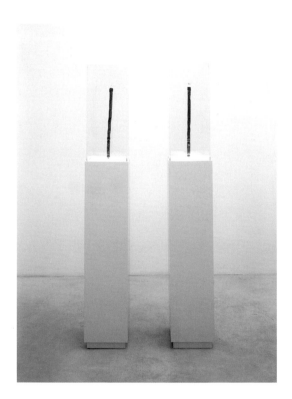

Carved pine, quartz, amethyst, leather,
spell, UV filtering Plexiglas, lights, pedestals

A custom-made wand was commissioned from
a practicing witch and a duplicate wand was made by
the artist mimicking the witch's.

2001-2002
Each 64 x 10 x 10 inches
Collection of Helen Hill Kempner, Houston, Texas

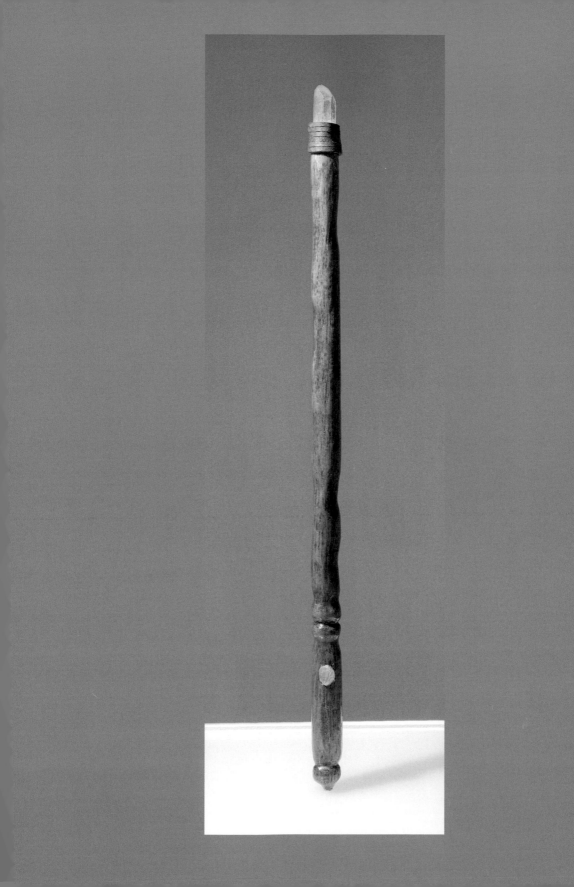

DIARY OF A RESURRECTIONIST
(I'LL BE WAITING FOR YOU)

B|W

A MOURNER LEARNS
TO RELINQUISH THE LOST

Photo albums: *Cast and carved bone dust, dehydrated bone calcium,*
crushed amino acids, melted vinyl records of Jackie Wilson's "Lonely Teardrops"
and Irma Thomas's "Time Is On Our Side / Anyone Who Knows What Love Is
(Will Understand)," homemade paper made from cotton and bone dust
from every bone in the body, fragments of soldiers' personal mirrors
from various wars, spirit of ammonia, myrrh resin, copper, mica,
water extendable resin, rust, pigments, velvet, bone glue, typeset
Photographs and tintypes: *Antique "spirit photographs"*
(detection of a ghost or spirit disturbance on photographic film)

2004
15 x 11 x 7 inches
Collection of Robin Wright and Ian Reeves

DIARY OF A RESURRECTIONIST

Antique daguerreotype of man with Rieger's Syndrome
(malformed iris which prevents light from entering pupil to retina),
ground trinitite (glass produced during the first atomic test explosion,
from Trinity test site, c. 1945, when heat from blast melted surrounding sand),
dehydrated and de-carbonized bone dust from every bone in the body,
black amber, mortician's powder, nickel, iron, collodial silver, rust, velvet,
homemade paper (pulp made from cotton, military sheet music,
crushed chrysanthemums, amino acids and bone dust from every bone in the body),
Civil War-era inkwell, Civil War soldier's personal mirror,
American porcupine quill, walnut, glass

2003-2004
70 x 20 x 20 inches (with pedestal)
Private Collection

NOT ALL DEAD
RATHER BE LIVING

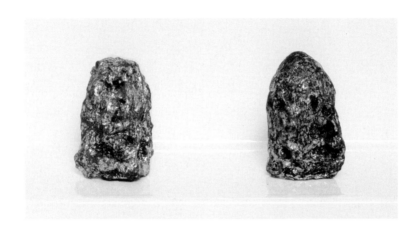

Casts of Civil War-era "pain bullets"
(bullets used by soldiers to bite on during surgery)
made from melted vinyl records, nickel, silver,
painted porcelain and MDF shelf

Bob Marley—"I Shot The Sheriff"
Marvin Gaye—"Sexual Healing"
Kurt Cobain—"Lithium"
Tupac Shakur—"Hit 'em Up"
Sam Cooke—"Someone Have Mercy"
Del Shannon—"Runaway"
John Lennon—"Happiness Is A Warm Gun"

2001-2002
3 x 12 x 3 inches
Collection of Michael Bastasch,
San Francisco, California

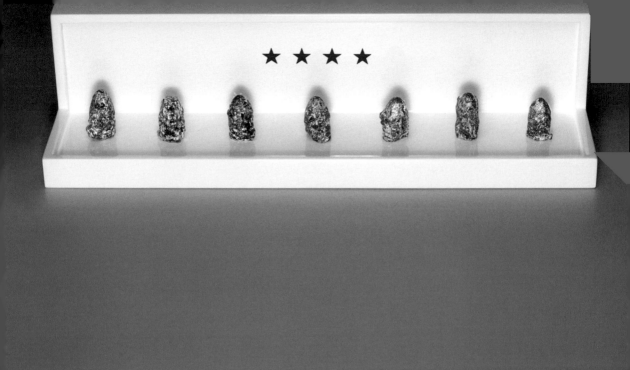

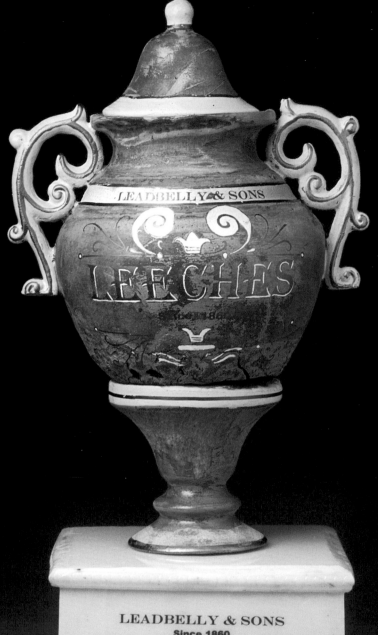

LEADBELLY & SONS
Since 1860

SCRUBBIN' YOUR SOUL WON'T MAKF IT CLEAN
USE LEADBELLY & SONS LEECHES FOR PURIFYING

FRESH MELTED VINYL LEECHES IN A MIXTURE OF
BONE CALCIUM, BONE DUST, SWAMP SALT, SWAMP ROOT,
BEESWAX, IRONIZED YEAST, BRIMSTONE,
SPIRIT OF AMMONIA AND
DIATOMACEOUS EARTH
LIKE A MOSQUITO SUCKING ON A MUMMY

MY SOUL
IS RARELY WITH ME ANYMORE

Cast dehydrated bone calcium, bone dust from every bone in the body,
swamp salt, swamp root, beeswax, ironized yeast, brimstone,
witch hazel leaf, spirit of ammonia, diatomaceous earth, sawdust,
leeches made from Muddy Waters' "Rollin' Stone" and
The Rolling Stones' "Sympathy for The Devil" melted vinyl records,
water extendable resin, typeset

2003
19 x 9 x 7 inches
Private Collection

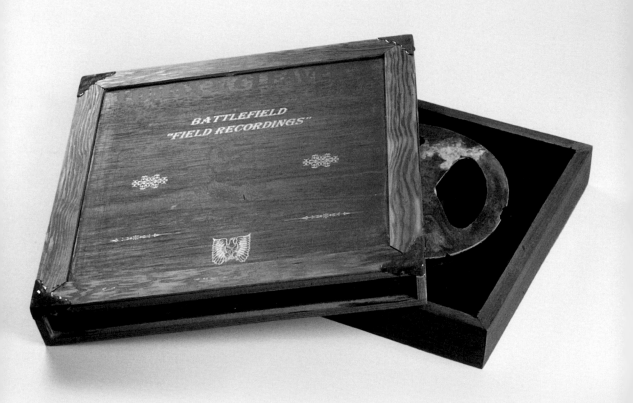

A PHANTOM ATTEMPTS TO SING
AS SHE ONCE DID ON EARTH

Carved de-carbonized bone dust from every bone in the body,
dehydrated bone calcium, ground amino acids, reel-to-reel audio loop
of a female ghost humming a lullaby made from an E.V.P. recording
(Electronic Voice Phenomena: voices and sounds of the dead or past,
detected through magnetic audiotape) recorded at Gettysburg on a Civil War
reenactment date, melted bullet lead, rust, velvet, mahogany, fir,
water extendable resin, typeset

2004
2¼ x 11½ x 11½ inches
Collection of Michael Bastasch, San Francisco, California

THE LAST LOST SHIPMENT
OF AN UNTESTED LIFE POTION

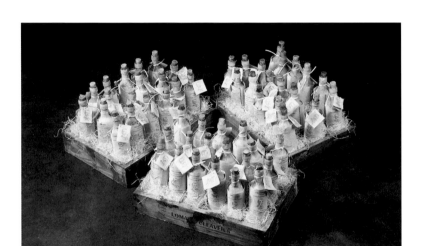

Cast and carved bone dust from every bone in the body,
sulfur, homemade moonshine (potato-derived alcohol),
wine elixir (water, sugar, fermented black cherries, yeast, gelatin,
tartaric acid, pectinase, sulfur dioxide, oak flavoring;
fortified with: aged holy water, angelica root, rosary vine, temple bells,
Bishopwort, myrrh resin, prayer plant, fig leaf, immortal root,
carbon, chlorophyll, spirulina, brimstone, Devil's backbone,
Devil's shoestring root, ground venomous snake bone, Virginia snakeroot,
Devil's club leaf, bee venom, Dead Sea salt, hemlock, blood root,
tare, melted vinyl record droplets from Peggy Lee's "Is That All There Is"
and Roy Orbison's "In Dreams"), homemade paper, pine, moss,
rust, ribbon, water extendable resin, typeset

2003-2004
Dimensions variable
Collection of Julie and John Thornton, Austin, Texas

HIPPIES AND A OUIJA BOARD
(EVERYONE NEEDS
TO CLING TO SOMETHING)

Suitcase: *Cast and carved dehydrated bone calcium and bone dust
from every bone in the body, microcrystalline cellulose,
cold cast iron and brass, rust, antique syringe, crushed velvet,
leather, thread, water extendable resin, typeset*
Ouija board, bottles, and medicine: *Cast and carved dehydrated bone calcium
and bone dust from every bone in the body, typeset, homebrewed moonshine
(potato-derived alcohol), homemade wine health tonics
(water, sugar, fermented black cherries, yeast, gelatin, tartaric acid,
pectinase, sulfur dioxide, oak flavoring; fortified with: 100-year
old hemlock oil, Devil's Claw, witch hazel bark, swamp root,
powdered rhubarb, pleurisy root, belladonna root, white pine tar, coal tar,
dandelion, sarsaparilla, mandrake, mullein, skullcap, cramp bark,
elder, ginseng, horny goat weed, tansy, sugar of lead, mercury with chalk and
tin-oxide, calcium, potassium, creatine, zinc, iron, nickel, copper,
boron, vitamin K, crushed amino acids, home-cultured antibiotics, chromium,
magnesium, colostrum, ironized yeast, ground pituitary gland,
ground wisdom teeth, ground seahorse, shark cartilage, coral calcium,
iodine and castor oil)*
Records: *Various 1960s 45 rpm records
cast in prehistoric whale bone dust, typeset*

2003-2004
42 x 23 x 19 inches
Blanton Museum of Art, The University of Texas at Austin,
Purchase through the generosity of The Brown Foundation,
the Michener Acquisitions Fund,
and the Blanton Contemporary Circle, 2004

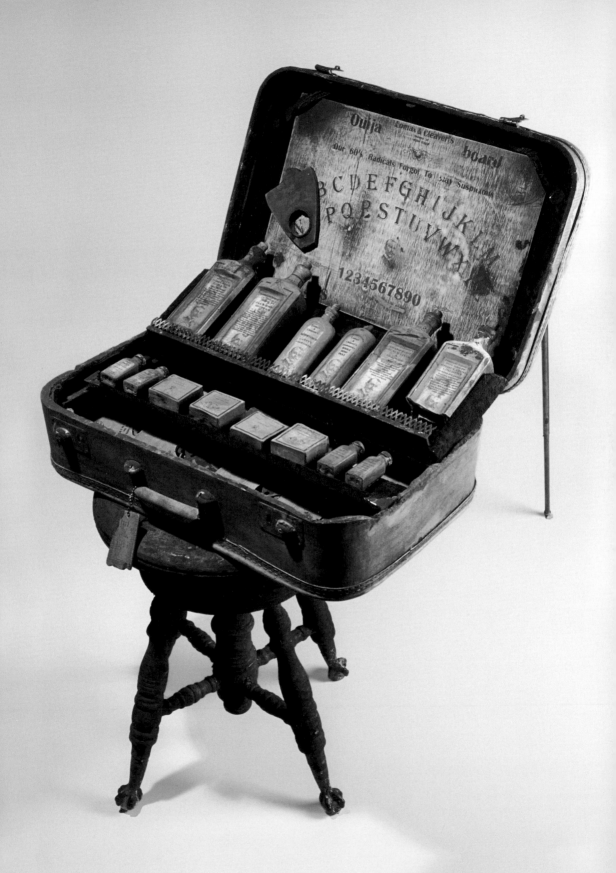

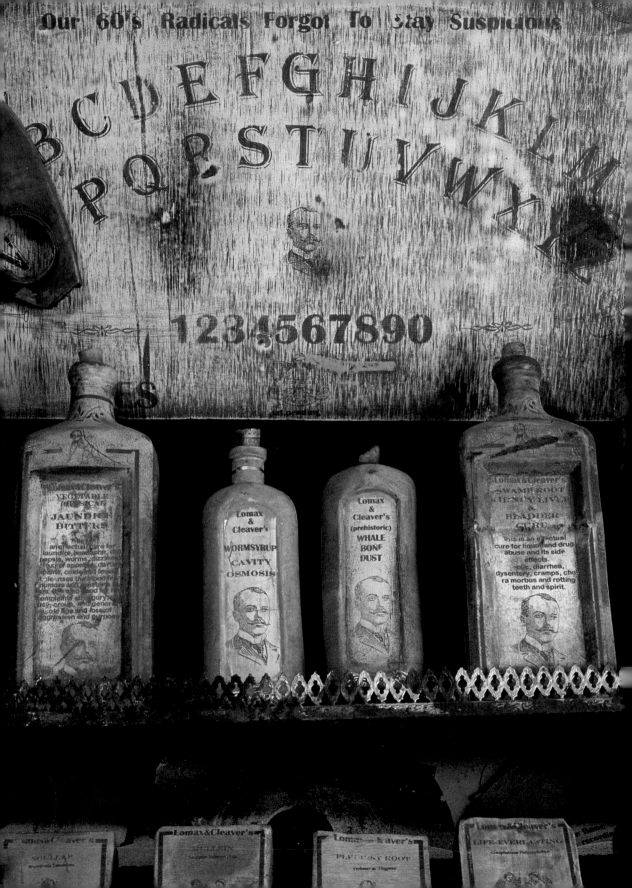

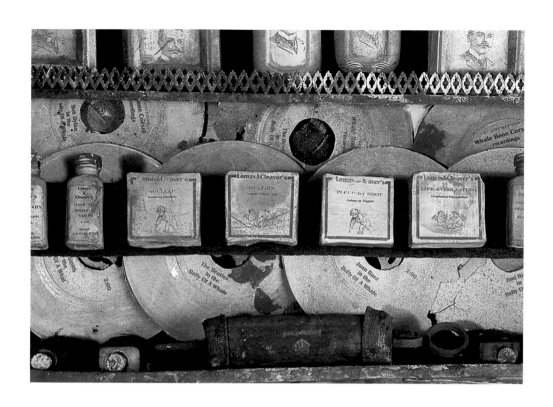

OUR 60s RADICALS
FORGOT TO STAY SUSPICIOUS

Cast of homemade paper (pulp made from cotton, military sheet music
from American wars, and bone dust from every bone in the body),
dehydrated bone calcium, bone charcoal, ground trinitite
(glass produced during the first atomic test explosion,
from Trinity test site, c. 1945, when heat from blast melted surrounding sand),
wheat starch, cold cast steel, nickel, zinc, melted bullet lead,
rust, shatter-proof Lexan, typeset

2003-2004
25 x 21 x 2 inches
Collection of Blake Byrne, Los Angeles, California

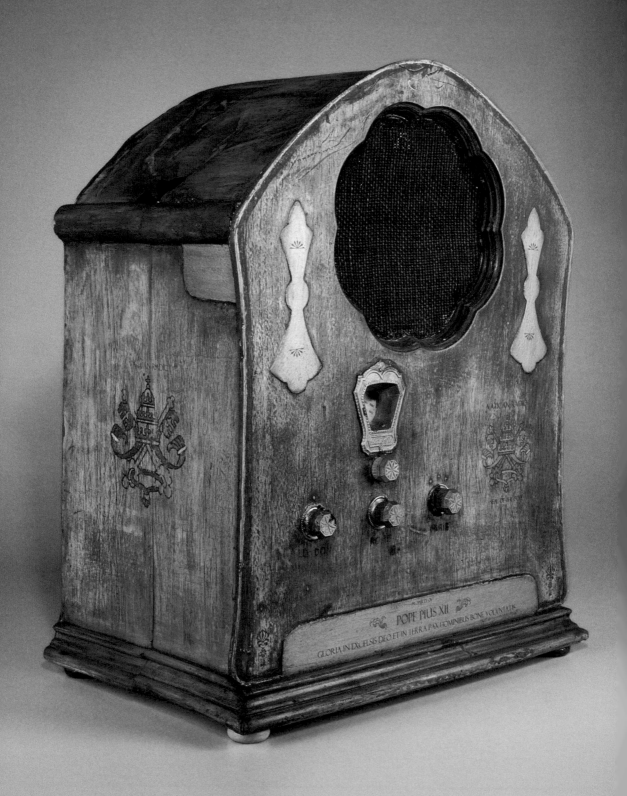

VATICAN RADIO

Radio: *Cast and carved bone charcoal and melted vinyl records*
of U.S. presidents addressing or declaring war, sulfur,
dehydrated bone calcium, cold cast zinc, silver and nickel,
melted bullet lead, pigments, dirt, rust,
water extendable resin, typeset, speaker
Soundtrack*: *Loop of the radio broadcast of the first number being called*
in the draft lottery of WWII (October 29, 1940),
Marvin Gaye's "Sexual Healing," church bells and choirs

*Production assistance by Justin Boyd

2003
20 x 15½ x 10 inches
Ulrich Museum of Art, Wichita State University, Wichita, Kansas

A DEFEATED SOLDIER
WISHES TO WALK HIS DAUGHTER
DOWN THE WEDDING AISLE

Cast of a hand-carved wooden and iron leg
that a wounded Civil War soldier constructed for himself made
from melted vinyl records of The Shirelles' "Soldier Boy"
and femur bone dust, fitted inside a pair of WWI military cavalry boots made from
melted vinyl records of Skeeter Davis's "The End Of The World,"
oil can filled with homemade tincture (gun oil, rose oil, bacteria cultured
from the grooves of Negro prison songs and prison choir records, wormwood,
goldenrod, aloe juice, resurrection plant, Apothecary's rose and bugleweed),
brass, rust, dirt from various battlefields,
ballistic gelatin, white rose petals, white rice

2004
21 x 20 x 80 inches
Los Angeles County Museum of Art,
purchased with funds provided by Tina Petra, Ken Wong, and Gibson Dunn

Dario Robleto

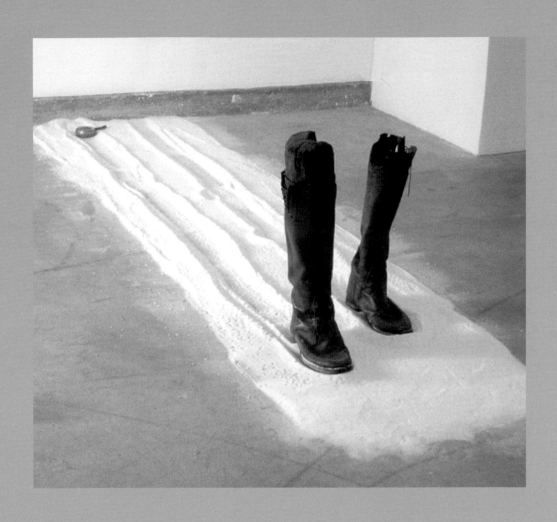

Soldier boy
Oh, my little soldier boy
I'll be true to you

You were my first love
And you'll be my last love
I will never make you blue
I'll be true to you
In the whole world
You can love but one girl
Let me be that one girl
For I'll be true to you

Wherever you go
My heart will follow
I love you so
I'll be true to you
Take my love with you
To any port or foreign shore
Darling, you must feel for sure
I'll be true to you

Soldier boy
Oh, my little soldier boy
I'll be true to you

"Soldier Boy"
Lyrics by Luther Dixon and Florence Greenberg

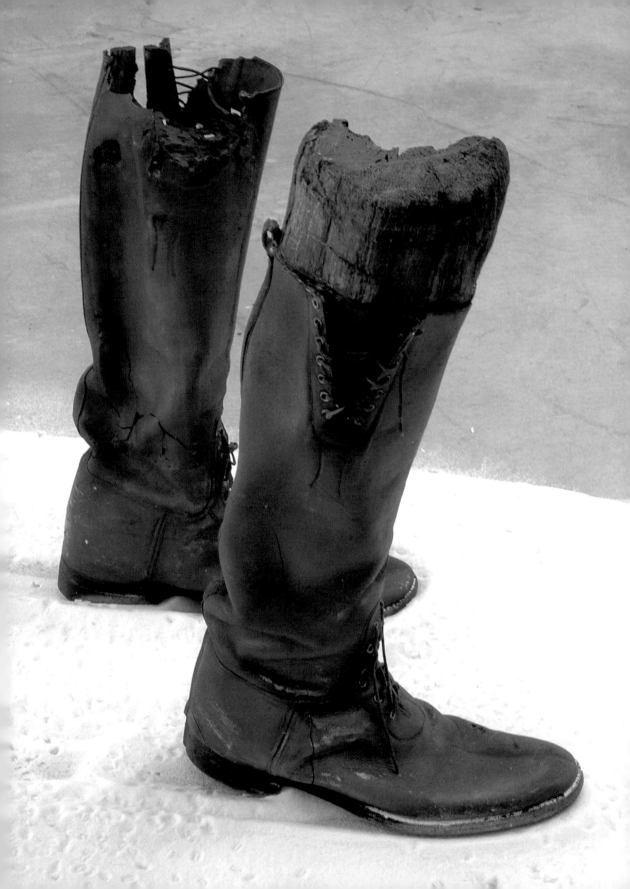

THE MELANCHOLIC REFUSES
TO SURRENDER

*Cast and carved bone charcoal
and melted vinyl record of Lead Belly's "The Titanic,"
broken male hand bones, ground coal,
horse hair, dirt, pigments,
lead salvaged from the sea, string, rust*

2003
14 x 11 x 5 inches
Collection of Nancy and Stanley Singer

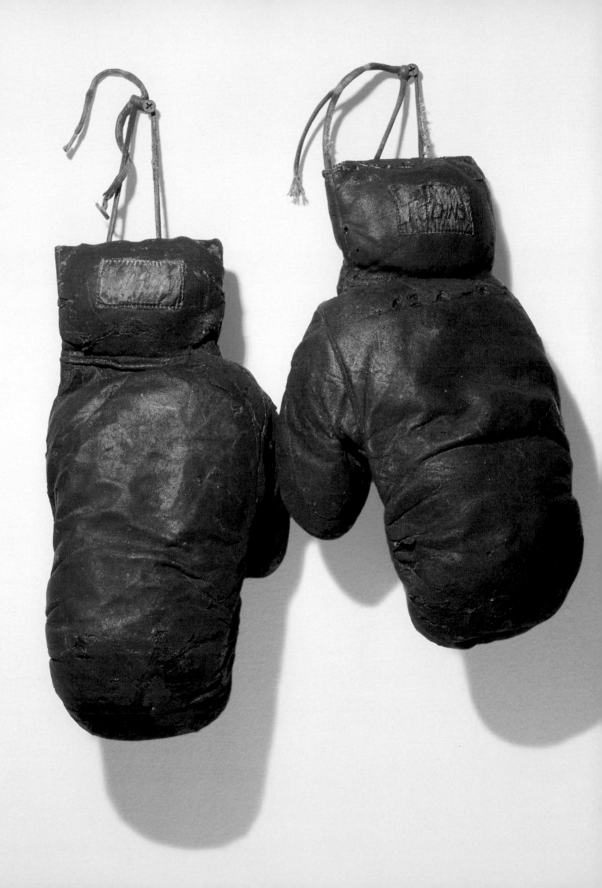

Captain Smith, when he got his load,
Might 'a' heared him holl'in,' "All aboa'd!"
Cryin,' "Fare thee, Titanic, fare thee well!"

Jack Johnson wanted to get on boa'd,
Captain Smith hollered, "I ain' haulin' no coal,"
Cryin,' "Fare thee, Titanic, fare thee well!"

It was midnight on the sea,
Band playin,' "Nearer My God to Thee,"
Cryin,' "Fare thee, Titanic, fare thee well!"

Titanic was sinking down,
Had them lifeboats aroun,'
Cryin,' "Fare thee, Titanic, fare thee well!"

Had them lifeboats aroun,'
Savin' the women, lettin' the men go down,
Cryin,' "Fare thee, Titanic, fare thee well!"

When the women got out on the land,
Cryin,' "Lawd, have mercy on my man,"
Cryin,' "Fare thee, Titanic, fare thee well!"

Jack Johnson heard the mighty shock,
Might 'a' seen the black rascal doin' th' Eagle Rock
Cryin,' "Fare thee, Titanic, fare thee well!"

Black men oughta shout for joy,
Never lost a girl or either a boy,
Cryin,' "Fare thee, Titanic, fare thee well!"

"De Titanic"
Lyrics by Huddie Ledbetter with John A. Lomax and Alan Lomax

A GHOST NURSE
STILL NEEDS TO CARE

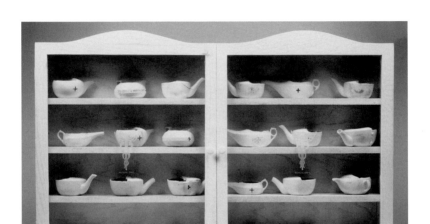

Vintage military hospital invalid feeders cast and carved
from bone dust from every bone in the body, homebrewed honey (infused with:
water, home-cultured antibiotics, iron peptonate, coco quinine, white oak bark, white
pine tar, white pine bark, white chestnut, blood root, sweet balsam,
meadowsweet, honeysuckle, blessed thistle, peppermint oil, rose oil,
butterfly weed, butterfly nectar, royal jelly, spirulina, senna leaf, bittersweet,
colostrum, iodine, castor oil, melted vinyl records
of Brenda Lee's "Break It To Me Gently" and Roy Orbison's "Only the Lonely"),
water extendable resin, rust, white oak, glass, typeset

2004
44 x 27 x 5 inches
Collection of Allison and Ed Shearmur,
Los Angeles, California

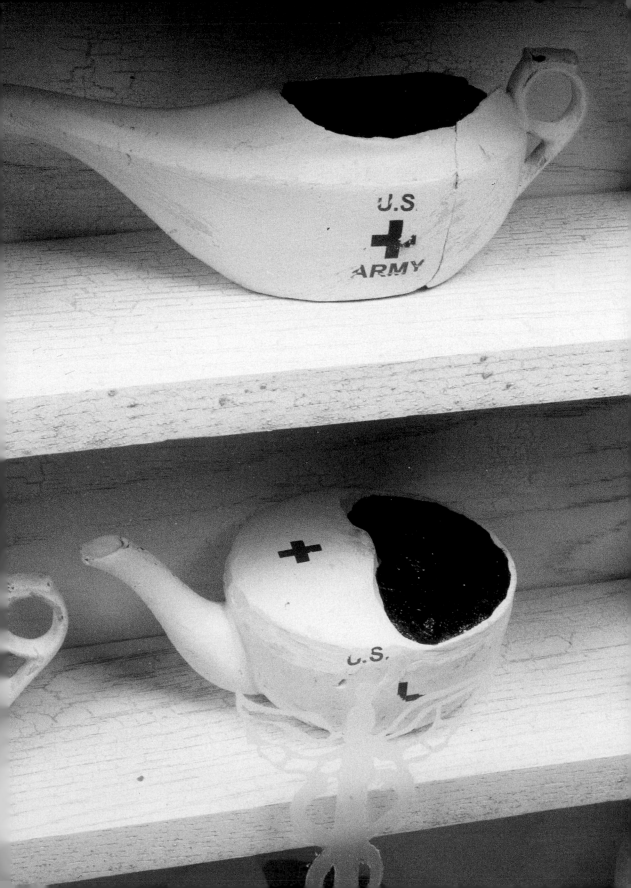

Break it to me gently
Let me down the easy way
Make me feel that you still love me
If it's just, if it's just for one more day

Break it to me gently
So my tears, my tears won't fall too fast
If you must go, then go slowly
Let me love you to the last

The love we shared for, oh, so long
Is such a big part of me
If you must take your love away
Take it gradually

Oh, oh, break it, break it to me gently
Give me time, oh, give me a little time
To ease the pain
Love me just a little longer
'Cause I'll never, never love again
'Cause I'll never love again

"Break it to Me Gently"
Lyrics by Diane Lampert and Joe Seneca

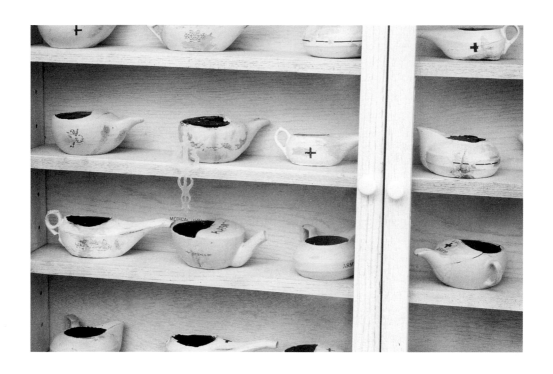

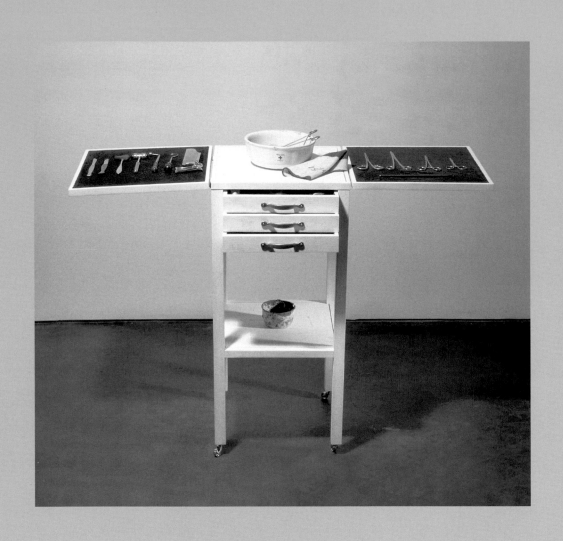

AN ATHEIST
AS DESCRIBED BY A SURGEON

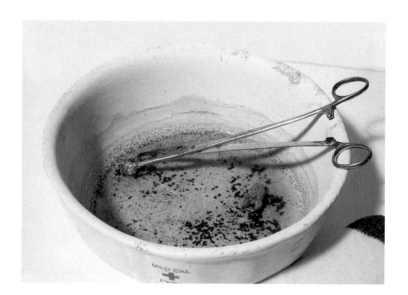

Cast of a Civil War-era "pain bullet"
(bullets used by soldiers to bite on during surgery)
made from re-melted bullet lead salvaged from
battlefields of every American war, cast bone calcium,
antique bullet probe with carved finger bone handle,
antique iron surgical extractor, antique bullet forceps,
amputation saw, excavated WWI medical bowl,
surgical silk, water treated with homemade tincture
(aged holy water, blood root, arnica, Dead Sea salt, hellebore,
butcher's broom, angelica root, myrrh resin,
blessed thistle, Jacob's staff, Solomon's Seal, belladonna),
ash, silver, rust, velvet

2004
38 x 40 x 18 inches
Collection of Ernst Siegel, Paris, France

THE CREATIVE POTENTIAL
OF DISEASE

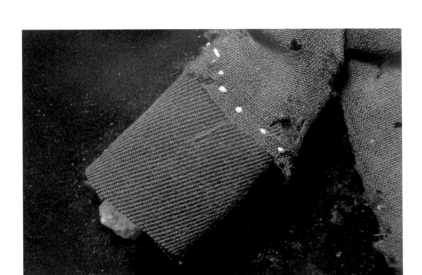

A self-portrait doll
made by a Civil War Union soldier amputee while recovering in the hospital,
mended and repaired with a modern-day surgeon's surgical needle and thread,
new pant leg material made from a modern-day soldier's uniform,
cast leg made from femur bone and prosthetic alginate
treated with Balm Of A Thousand Foreign Fields,
vegetable ivory, collagen, melted shrapnel and bullet lead,
cold cast steel and zinc, polyester resin, rust

2004
12 x 9³/₄ x 1 inches
Private Collection

NIHILIST WITH A DREAM

Case: *Cast ballistic gelatin, sulfur, diatomaceous earth,*
cold cast zinc, copper, brass, nickel and steel, leather,
alligator skin, rust, pigments, violin resin, velvet, water extendable resin
Violin and fife: *Cast and carved dehydrated bone calcium,*
de-carbonized bone dust from every bone in the body,
bone charcoal, bone oil, collagen, ground ivory, antler velvet,
dirt from various battlefields, melted shrapnel and bullet lead,
Civil War-era rosewood folding camp chair, music stand

2003-2004
Dimensions variable
Fonds régional d'art contemporain—Languedoc Roussillon,
Montpellier, France

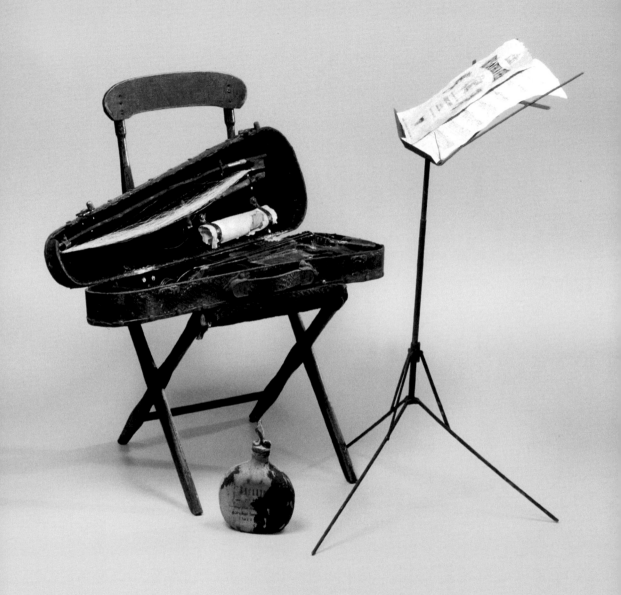

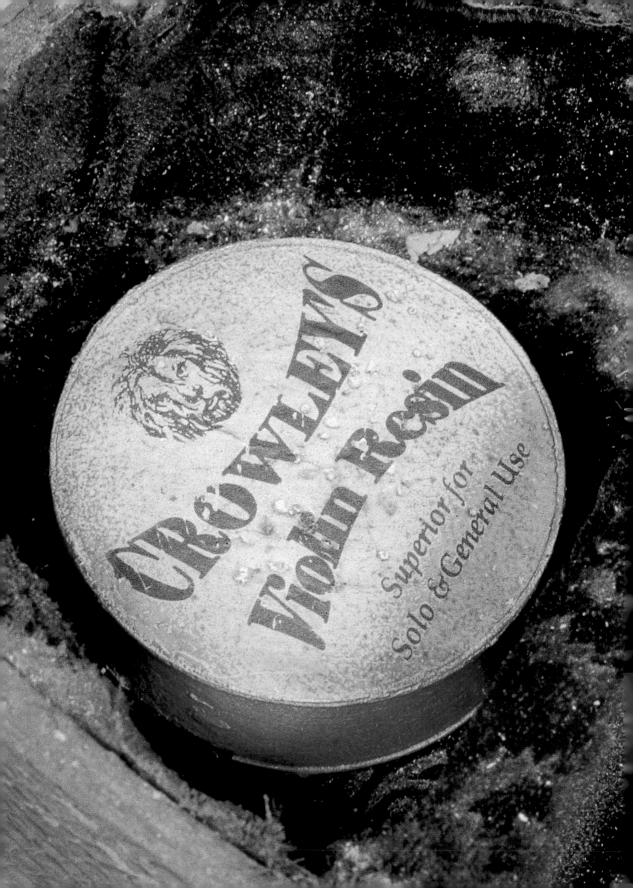

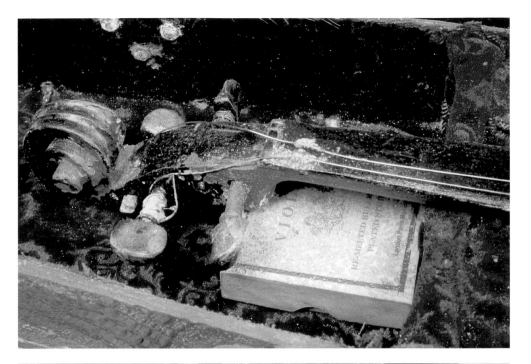

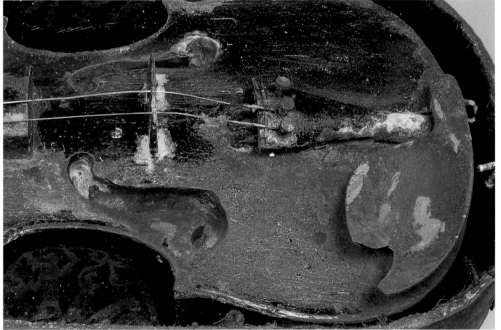

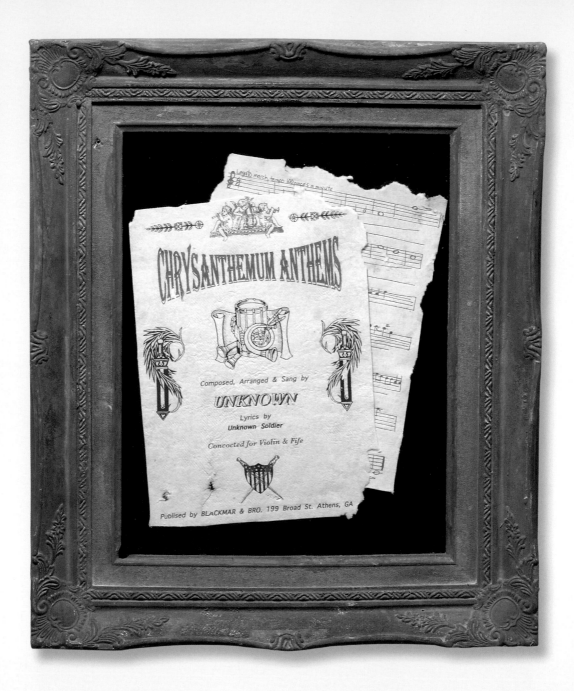

CHRYSANTHEMUM ANTHEMS

*Homemade paper (pulp made from a poem a WWI soldier wrote
while recovering in the hospital, dried and crushed chrysanthemum petals,
crushed blood root, bugleweed, sweet balsam, rose water,
rose oil, peppermint oil, sunflower oil, dandelion oil, aloe juice, cotton),
melted shrapnel and bullet lead, cold cast steel and brass,
polyester resin, rust, bone glue,
typeset, original score* for violin and fife composed for soldier's poem*

*Production assistance by Justin Boyd

2004
18 x 11 inches
Collection of Gregory Higgins, Dallas, Texas

NO ONE HAS
A MONOPOLY OVER SORROW

Men's wedding ring finger bones
coated in melted bullet lead from various American wars,
men's wedding bands excavated from American battlefields,
melted shrapnel, wax-dipped preserved bridal bouquets of roses
and white calla lilies from various eras, dried chrysanthemums,
male hair flowers braided by a Civil War widow,
fragments from a mourning dress, cold cast brass, bronze, zinc,
silver, rust, mahogany, glass

2005
11 x 10 x 9 inches
Collection of Julie and John Thornton, Austin, Texas

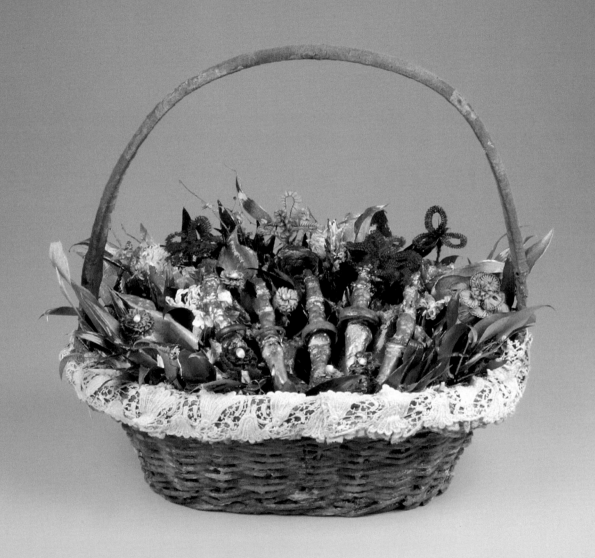

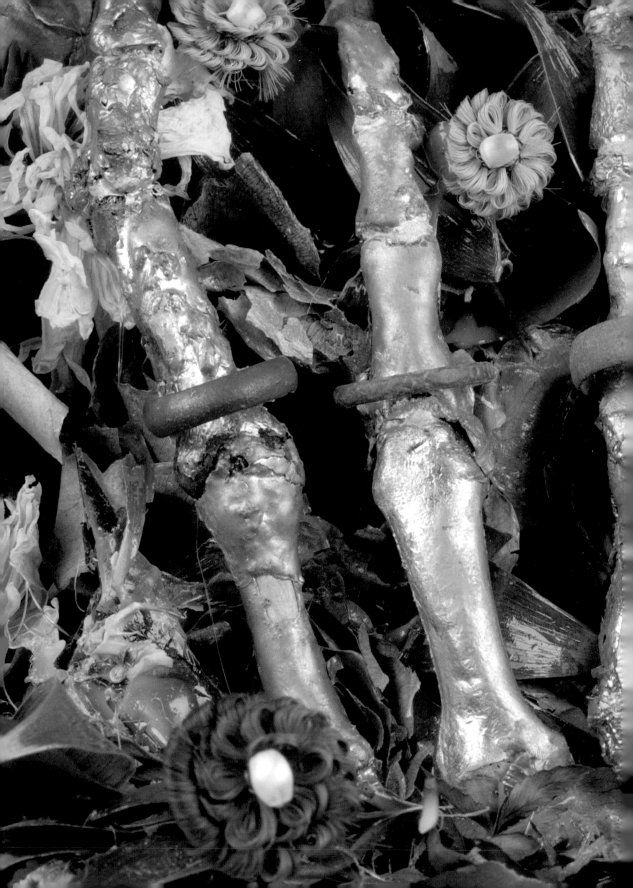

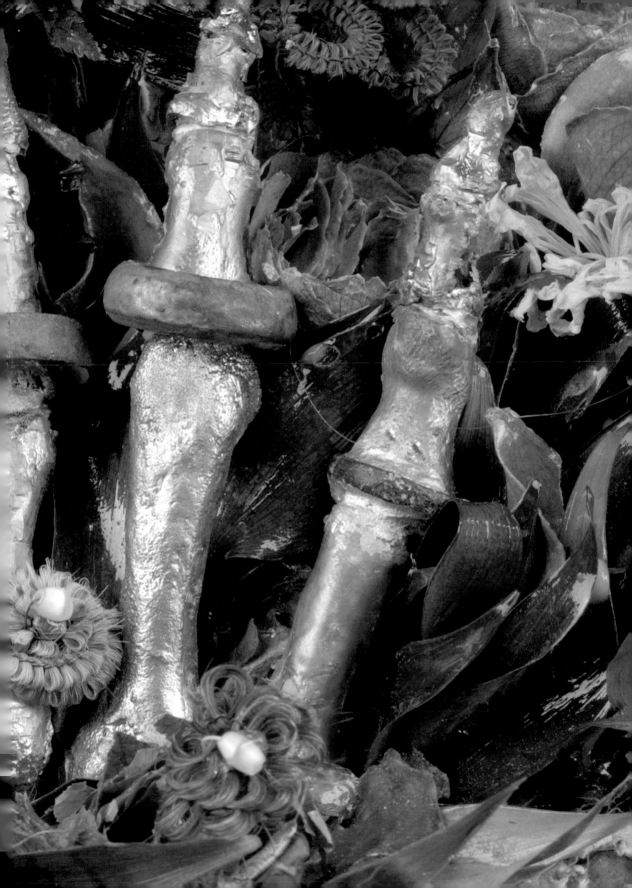

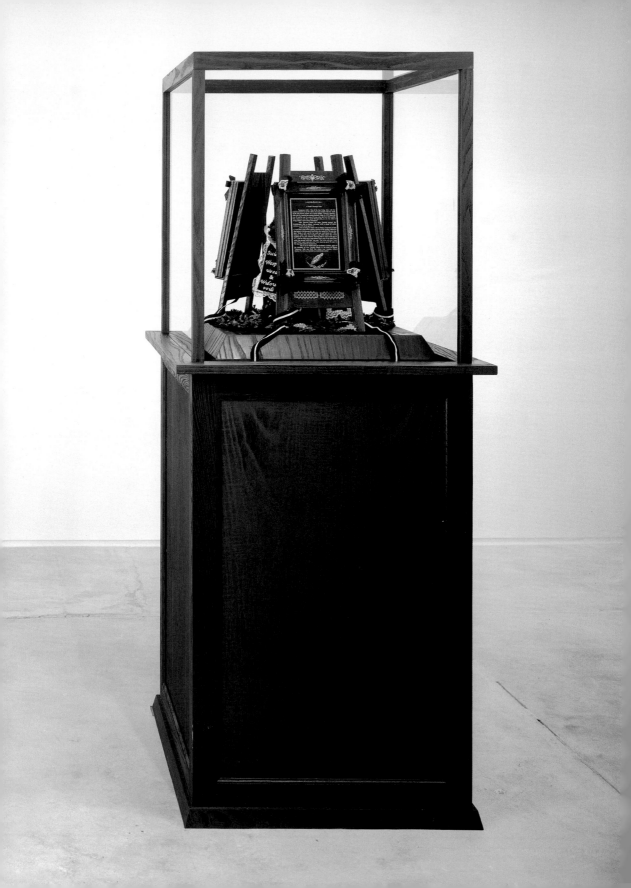

THE PAUSE BECAME PERMANENCE

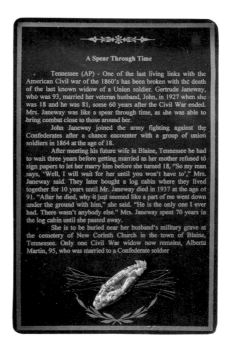

A Spear Through Time

Tennessee (AP) - One of the last living links with the American Civil war of the 1860's has been broken with the death of the last known widow of a Union soldier. Gertrude Janeway, who was 93, married her veteran husband, John, in 1927 when she was 18 and he was 81, some 60 years after the Civil War ended. Mrs. Janeway was like a spear through time, as she was able to bring combat close to those around her.

John Janeway joined the army fighting against the Confederates after a chance encounter with a group of union soldiers in 1864 at the age of 18.

After meeting his future wife in Blaine, Tennessee he had to wait three years before getting married as her mother refused to sign papers to let her marry him before she turned 18, "So my man says, 'Well, I will wait for her until you won't have to'," Mrs. Janeway said. They later bought a log cabin where they lived together for 10 years until Mr. Janeway died in 1937 at the age of 91. "After he died, why it just seemed like a part of me went down under the ground with him," she said. "He is the only one I ever had. There wasn't anybody else." Mrs. Janeway spent 70 years in the log cabin until she passed away.

She is to be buried near her husband's military grave at the cemetery of New Corinth Church in the town of Blaine, Tennessee. Only one Civil War widow now remains, Alberta Martin, 95, who was married to a Confederate soldier

Ink-dyed willow and ash, hair lockets
made of stretched and curled audiotape recordings
of the last known Confederate and Union Civil War soldiers' voices,
excavated and melted shrapnel from various wars,
hair flowers braided by war widows, homemade paper (pulp made from
soldiers' letters sent home by sea), lace and fabric from widows'
mourning dresses, colored paper, silk, ribbon, milk paint, glass, typeset

2005-2006
69 x 26 x 26 inches
San Antonio Museum of Art, Purchased with funds provided by
an anonymous donor in honor of Nancy Brown Negley

ALLOY OF LOVE

Soldiers' uniform fabric and thread from various wars,
military blanket wool from various wars, homemade paper
(pulp made from soldiers' letters sent home and wife/sweetheart letters
sent to soldiers from various wars, ink retrieved from letters, cotton),
excavated and melted bullet lead and shrapnel, braided human hair,
Civil War soldier's woven hair, excavated locket and chain, military buttons,
colored paper, mahogany

2005
36 x 36 x 4 inches
Charlotte and Bill Ford Collection

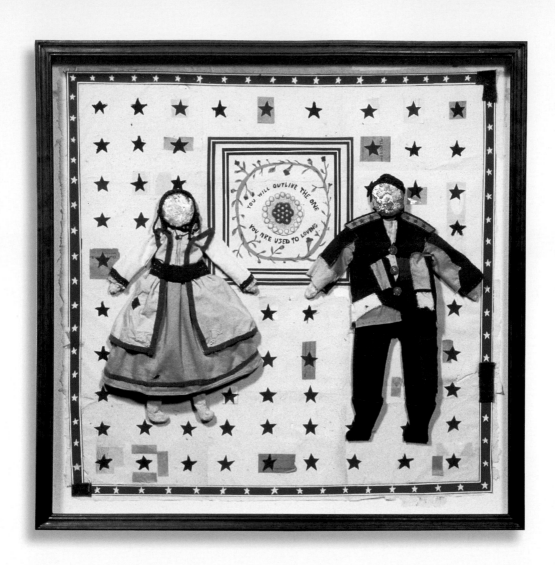

A COLOR GOD NEVER MADE

Cast and carved de-carbonized bone dust, bone calcium,
military-issued glass eyes for wounded soldiers coated with ground trinitite
(glass produced during the first atomic test explosion from
Trinity test site, c. 1945, when heat from blast
melted surrounding sand), fragments of a soldier's personal mirror
salvaged from a battlefield, soldiers' uniform fabic and thread from various wars,
melted bullet lead and shrapnel from various wars,
fragment of a soldier's letter home, woven human hair of a war widow,
bittersweet leaves, soldier-made clay marbles, battlefield dirt, cast bronze teeth,
dried rosebuds, porcupine quill, excavated dog tags, rust, velvet, walnut

2004-2005
51 x 48 x 21 inches
Collection of the artist, San Antonio, Texas

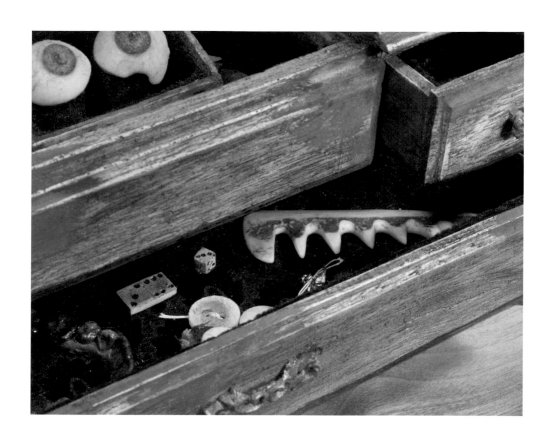

A CENTURY OF NOVEMBER

*Child's mourning dress made with homemade paper
(pulp made from sweetheart letters written by soldiers who did not
return from various wars, ink retrieved from letters,
sepia, bone dust from every bone in the body),
carved bone buttons, hair flowers braided by a Civil War widow,
mourning dress fabric and lace, silk, velvet,
ribbon, WWII surgical suture thread, mahogany, glass*

2005
38 x 38 inches
Collection of Nancy and Stanley Singer

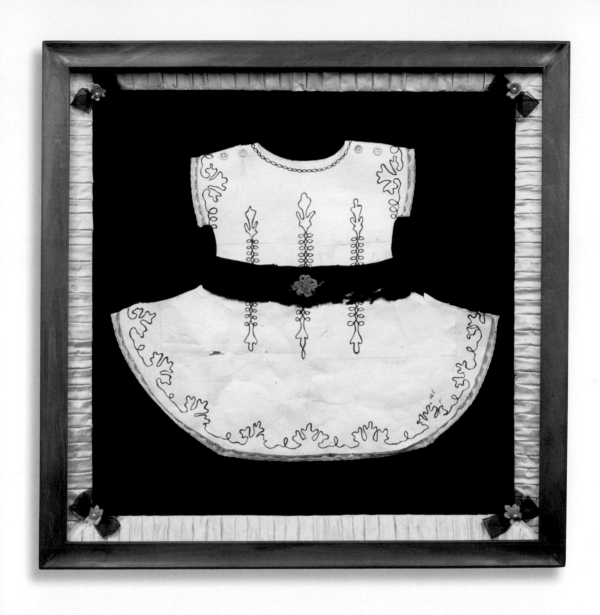

His wet white face and miserable eyes
Brought nurses to him more than groans and sighs:
 But hoarse and low and rapid rose and fell
His troubled voice: he did the business well.

The ward grew dark; but he was still complaining
 And calling out for "Dickie." "Curse the Wood!
"It's time to go; O Christ, and what's the good?—
 "We'll never take it, and it's always raining."

I wondered where he'd been; then heard him shout,
"They snipe like hell! O Dickie, don't go out"…
 I fell asleep … next morning he was dead;
And some Slight Wound lay smiling on his bed.

"Died of Wounds"
by Siegfried Sassoon
The Old Huntsman and Other Poems, 1918

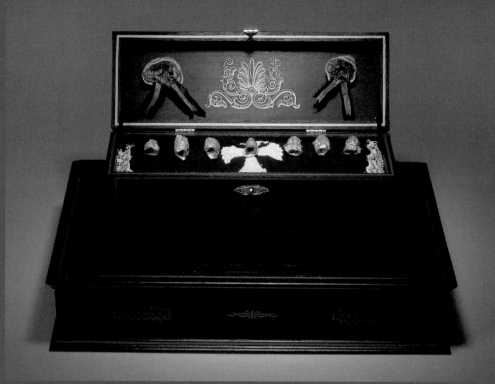

A SADNESS SILENCE CAN'T TOUCH

Casts of Civil War-era "pain bullets"
(bullets used by soldiers to bite on during surgery) made from
dissolved audiotape recordings of poets' voices, lace and fabric from mourning
dresses, ink dyed yellowheart and ash, nickel, silver, milk paint, typeset

Walt Whitman—"America"
Lord Alfred Tennyson—"The Charge of the Light Brigade"
Siegfried Sassoon—"Died of Wounds"
T.S. Eliot—"The Wasteland"
Robert Graves—"In Procession"
Dylan Thomas—"A Refusal to Mourn the Death, by Fire, of a Child in London"
David Jones—"In Parenthesis"

2005-2006
9½ x 14½ x 9¼ inches
Collection of Julie and John Thornton, Austin, Texas
Promised gift to the Blanton Museum of Art,
The University of Texas at Austin

IF WE FLY AWAY, THEY'LL FLY AWAY

Cast and carved bone dust from every bone in the body,
bone calcium, feathers made from a carved vinyl record of Florence Nightingale
addressing war veterans and nightingale bird love songs,
homemade paper (pulp made from soldiers' letters to sons and daughters
from various wars, ink retrieved from letters), fragments of military uniforms and
blankets from various wars, excavated child's spoon and fork from a battlefield
coated with melted bullet lead from the Revolutionary War,
residue from female tears of mourning overlaid with residue
from male tears of mourning, war widow's mourning dress fabric and lace,
hair flowers braided by a war widow, military photograph,
military surgical suture thread, ground iron and brass, rust, walnut, typeset

2005-2006
24 x 16 x 16 inches
Collection of Heidi L. Steiger, New York

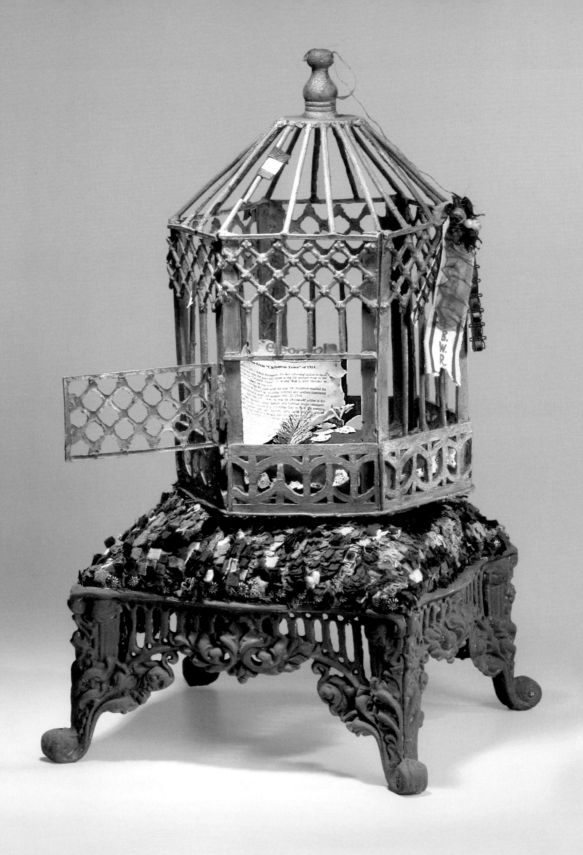

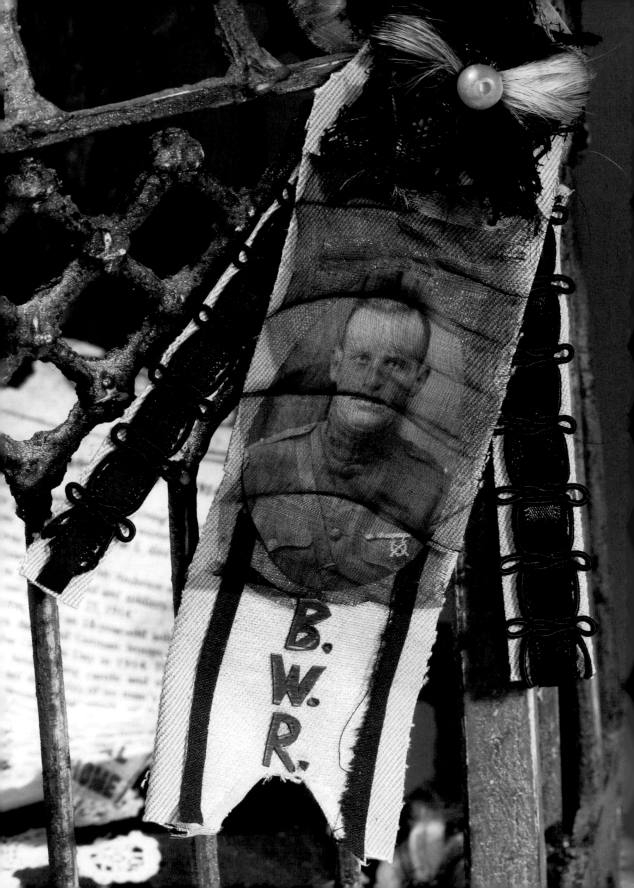

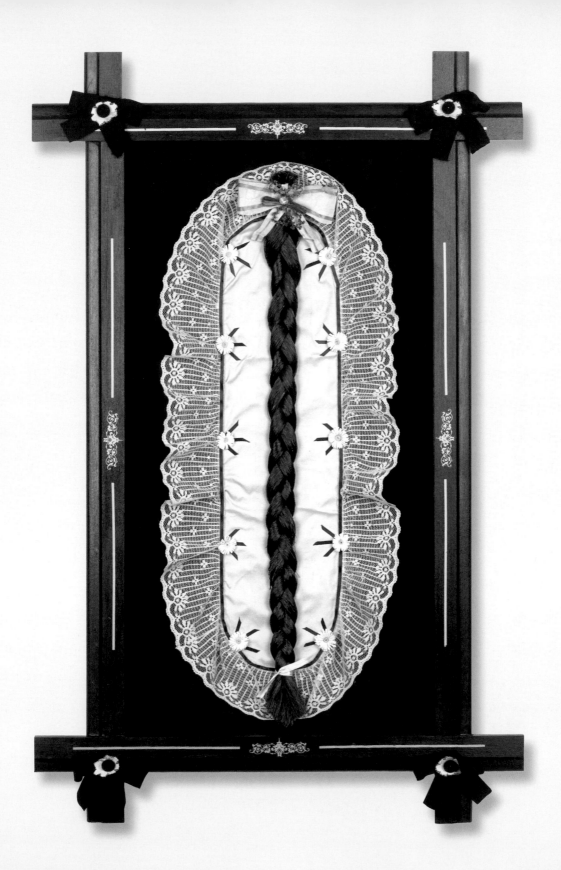

DAUGHTERS OF
WOUNDS AND RELICS

*Hair braid made of stretched and curled audiotape recordings
of the last known Union Civil War soldier's voice
and the last known Confederate Civil War widow's voice,
homemade paper (pulp made from sweetheart letters written by soldiers
who did not return from various wars, sepia,
bone dust from every bone in the body), lace and fabric from mourning dresses,
hair flower braided by a Civil War widow, colored paper, silk, milk paint,
ink-stained ash, glass, typeset*

2006
30 x 19 x 3¼ inches
Collection of Jeanne and Michael Klein
Promised gift to the Blanton Museum of Art,
The University of Texas at Austin

THE SOUTHERN DIARISTS SOCIETY

Homemade paper
(pulp made from brides' letters to soldiers from various wars,
ink retrieved from letters, cotton), colored paper,
fabric and thread from soldiers' uniforms from various wars,
hair flowers braided by war widows, mourning dress fabric, silk,
ribbon, lace, cartes de visite, antique buttons,
excavated shrapnel and melted bullet lead from various battlefields

2006
45 x 37 x 6 inches
Collection of Jean Chatelus, Paris, France

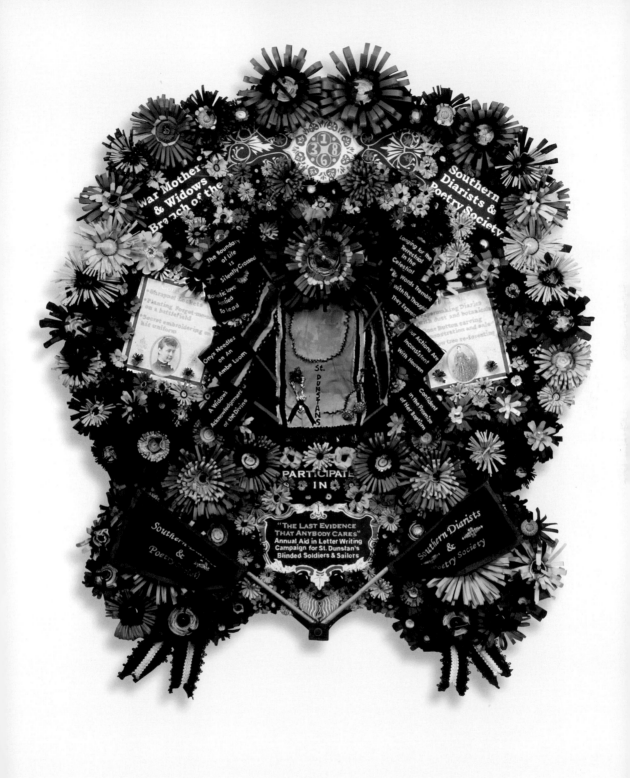

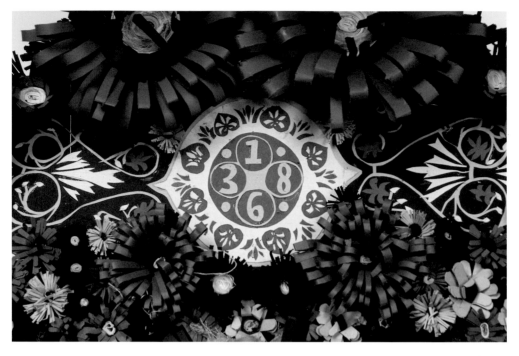

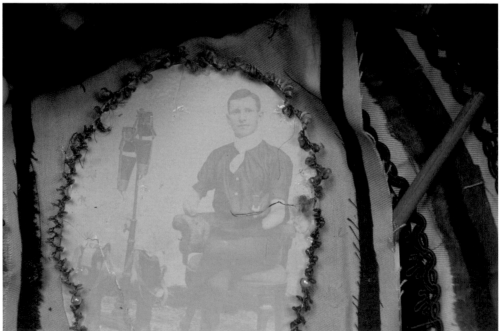

Course IV

* Shrapnel Lockets
* Planting Forget-me-not on a battlefield
* Secret embroidering on his uniform

The Boundary
of Life
is
Silently

Romntic Love
Applied
To Lead

Onyx Needles
on An
Ambe L

A Widow's
cknowledges
the

OBSEQUIES IN ALBANY

Homemade paper
(pulp made from soldiers' letters home from various wars,
ink retrieved from letters, cotton),
colored paper, thread and fabric from soldiers' uniforms from various wars,
cartes de visite, lace and fabric from a mourning dress,
hair flowers braided by a Civil War widow, lantana stalks, silk,
ribbon, ink, foamcore

2006
33 x 27 x 3½ inches
Collection of Julie and John Thornton, Austin, Texas

Dario Robleto

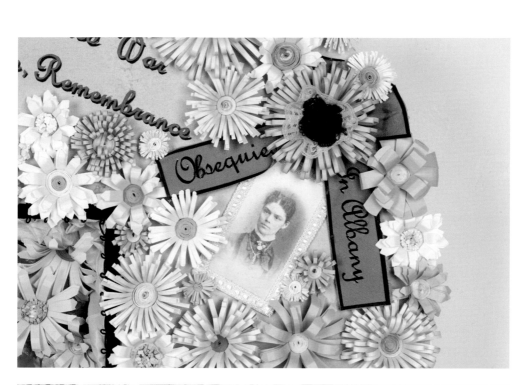

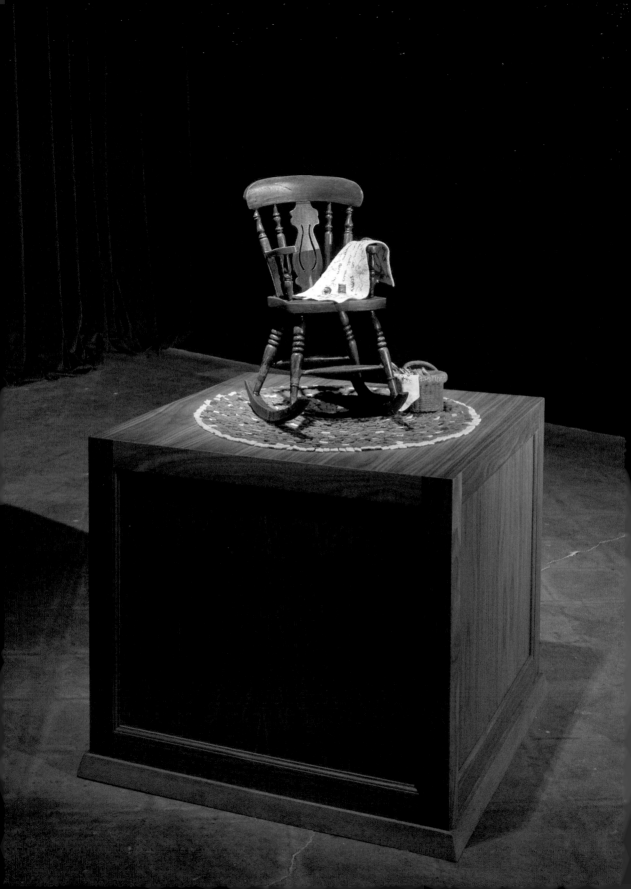

A SOUL WAITS
FOR A BODY THAT NEVER ARRIVES

Chair: *Cast and carved bone dust from every bone in the body,*
stained and sealed with homemade balm (almond oil, beeswax, honeysuckle,
resurrection plant, life everlasting, motherwort, mistletoe,
sundew, lady's mantle, eternal flower, life root, immortal root),
zinc, nickel, silver, water extendable resin, polyurethane
Sewing materials, tools, and rug: *Thread and fragments*
of American soldiers' uniforms from various wars,
wool from combat casualty blankets, silk, cotton, carved bone,
melted bullet lead and shrapnel from various wars, zinc,
nickel, silver, walnut

2004-2005
17½ x 21 x 21 inches
Collection of Lester Marks and Dr. Penelope Gonzalez,
Houston, Texas

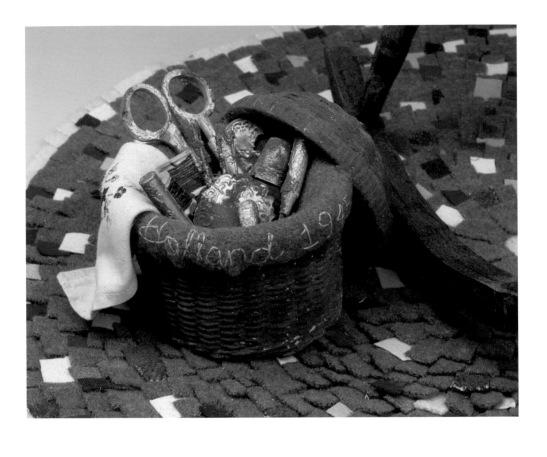

Dario Robleto

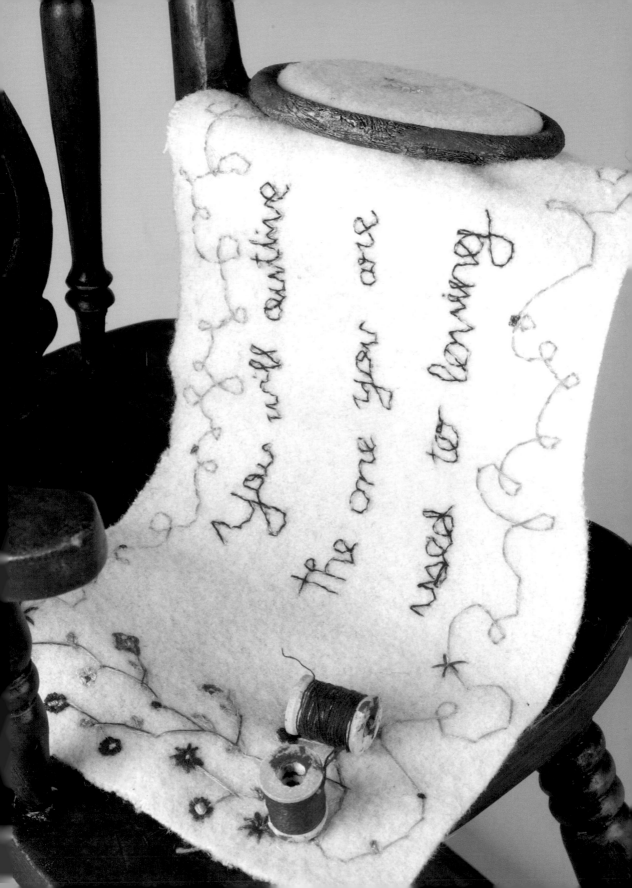

BLIND WILLIE BOONE

Cast and carved bovine cartilage, cast of homemade paper
(pulp made from cotton, ground stoneroot
and bone dust from every bone in the body),
Devil's shoestring root, tree sap,
dirt from various battlefields, melted bullet lead, zinc, brass,
water extendable resin, pigments, rust, typeset

2004
59 x 16½ x 1 inches
Collection Domaine Departmental de Chamarend, France

Dario Robleto

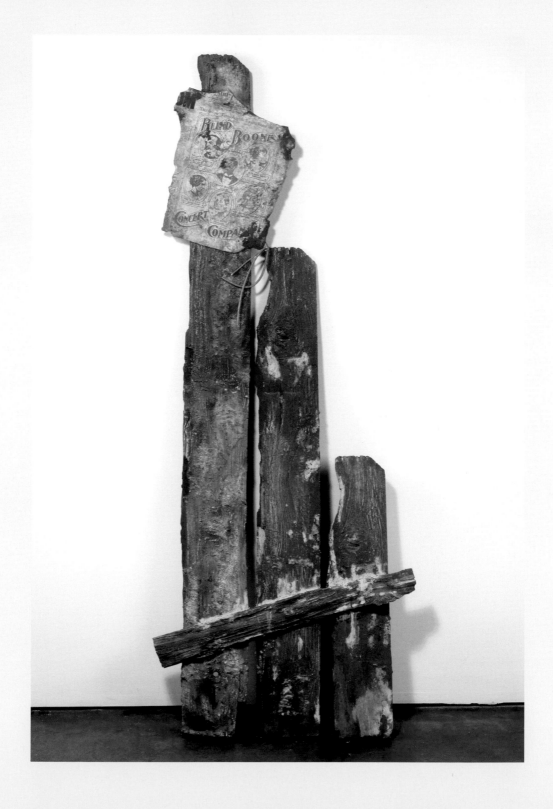

GREENVILLE SANITARY FAIR

Homemade paper
(pulp made from soldiers' letters home from various wars,
ink retrieved from letters, cotton),
colored paper, thread and fabric from soldiers' uniforms from various wars,
cartes de visite, silk, ribbon, wood clothespins, pen,
foamcore, poplar, ash

2005
38 x 32 x 3½ inches
Collection of the artist, San Antonio, Texas

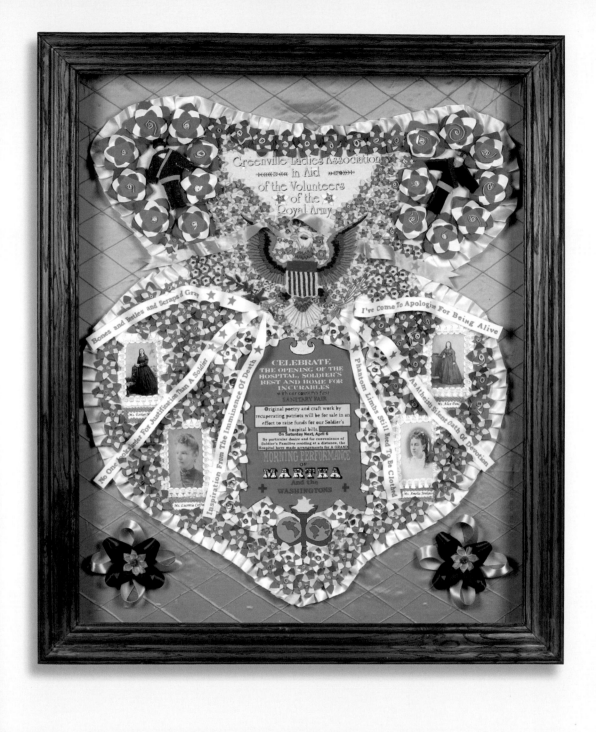

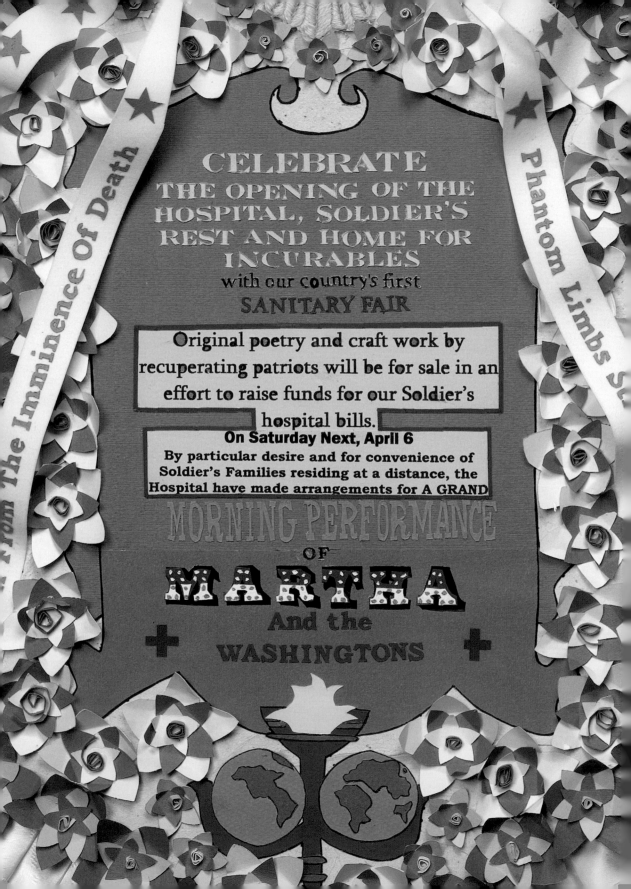

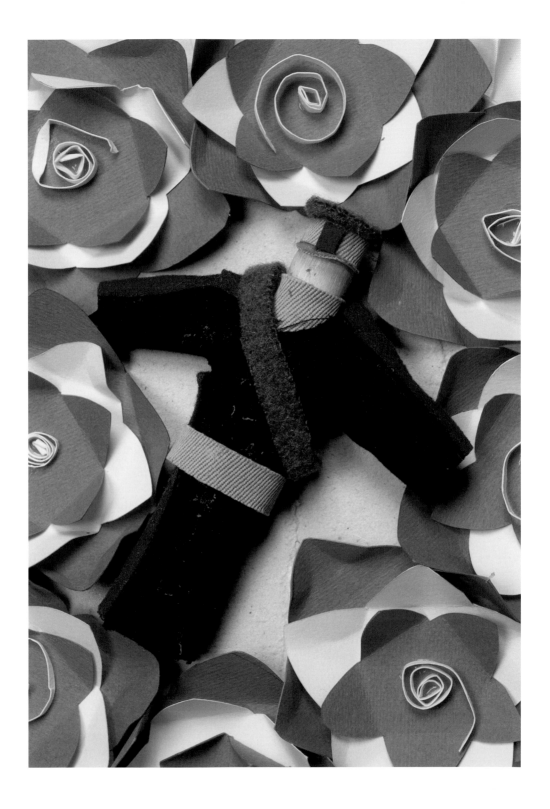

LIVING WITH DEATH
AS SOMETHING INTIMATE
AND NATURAL

*Oak tree twig carved from a dissolved audiotape recording of
the heartbeat of an unborn child and the last heartbeats of a loved one,
dried flowers picked on foreign battlefields sent home
by foot soldiers from various wars,
thread and fabric from military uniforms from various wars,
veteran's old mason jar, mourning handkerchief,
mourning dress fabric and thread,
pigments, water extendable resin, willow, glass*

B | W

THE ARTILLERY OF HEAVEN

*Casts of excavated fired bullets and
spent shell casings from various wars made with ground fulgurites
(glass produced by lightning strikes when heat
from blast melts surrounding sand),
battlefield sand and soil from various wars, rust*

2005-2006
62 x 16 x 16 inches (with pedestal)
Collection of the Museum of Contemporary Art San Diego,
Museum Purchase with proceeds from
Museum of Contemporary Art San Diego Art Auction, 2006

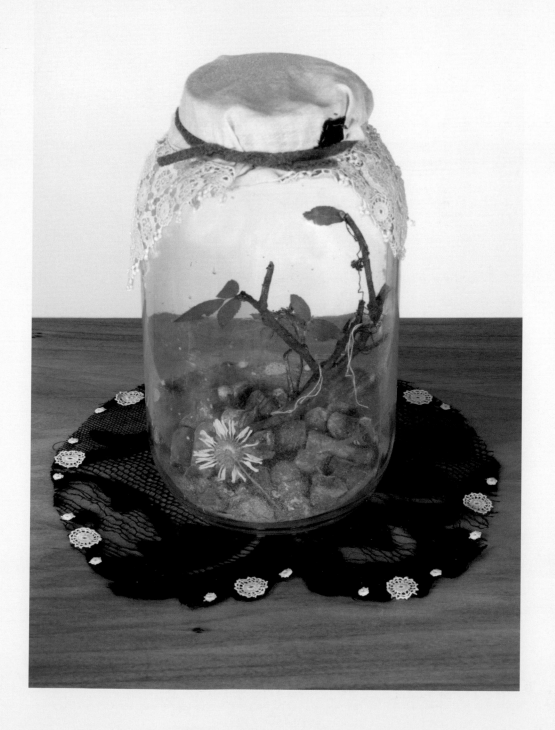

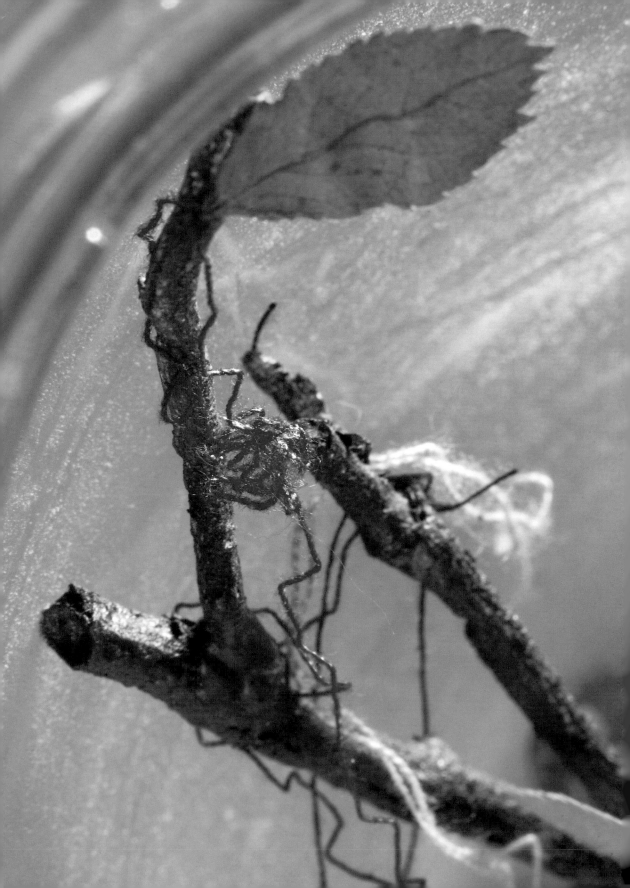

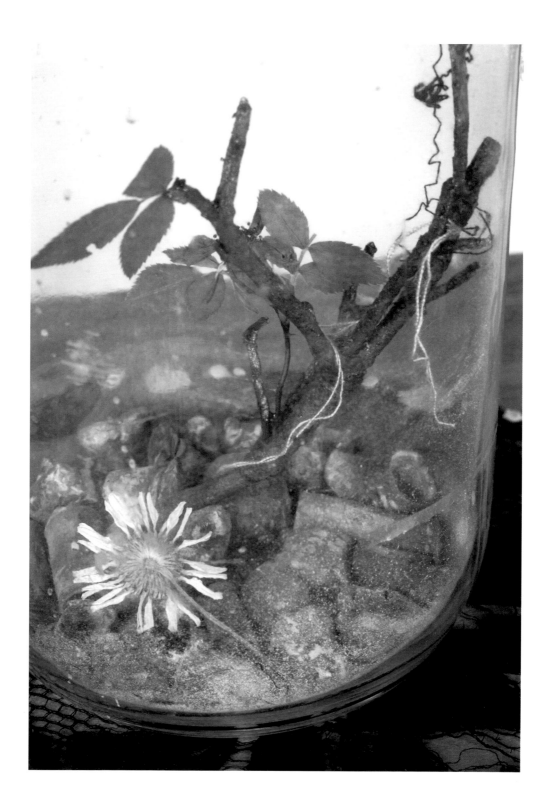

WHEN PINCUSHIONS ARE POLITICAL

Homemade paper
(pulp made from soldiers' letters home from various wars,
ink retrieved from letters, cotton),
colored paper, carved bone buttons,
needles, thread from soldiers' uniforms from various wars,
cartes de visite, ribbon, colored pencil,
pen, foamcore

2005
31 x 23 x 3 inches
Collection of Julie Kinzelman and Christopher Tribble,
Houston, Texas

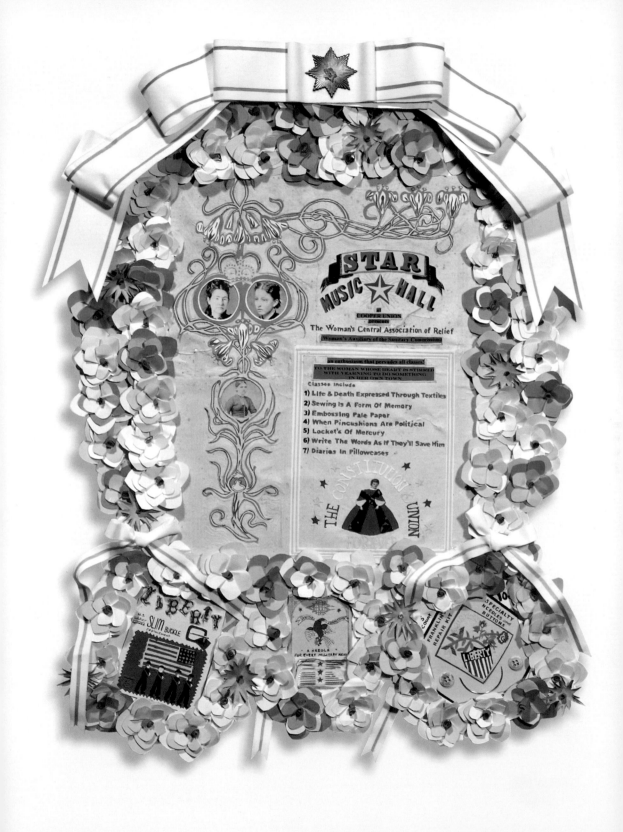

STAR
MUSIC ★ HALL
at COOPER UNION
presents
The Woman's Central Association of Relief
(Woman's Auxiliary of the Sanitary Commission)

an enthusiasm that pervades all classes
TO THE WOMAN WHOSE HEART IS STIRRED
WITH YEARNING TO DO SOMETHING
IN HER OWN TOWN

Classes Include

1) Life & Death Expressed Through Textiles
2) Sewing Is A Form Of Memory
3) Embossing Pale Paper
4) When Pincushions Are Political
5) Locket's Of Mercury
6) Write The Words As If They'll Save Him
7) Diaries In Pillowcases

THE CONSTITUTION & UNION

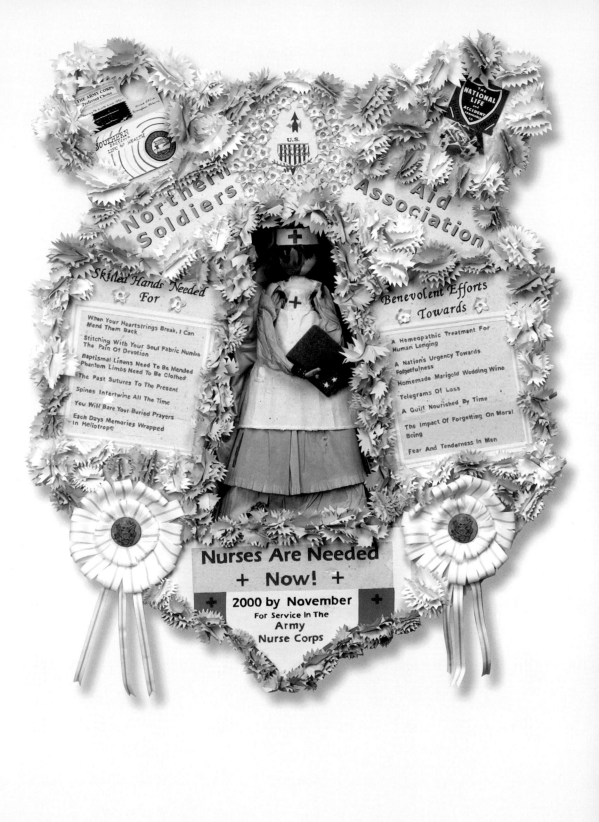

NURSES NEEDED NOW

*Homemade paper
(pulp made from soldiers' letters home from various wars,
ink retrieved from letters, cotton),
colored paper, thread and fabric from soldiers' uniforms from various wars,
WWI gauze bandage, braided hair, crepe, cast military medal,
needles, ribbon, colored pencil, pen, foamcore*

2006
33½ x 26 x 6 inches
Collection of Nancy and Stanley Singer

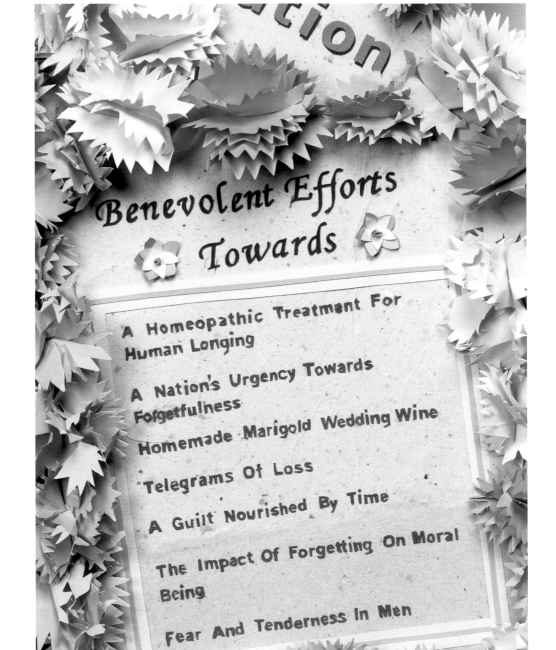

...tion

Benevolent Efforts
Towards

A Homeopathic Treatment For
Human Longing

A Nation's Urgency Towards
Forgetfulness

Homemade Marigold Wedding Wine

Telegrams Of Loss

A Guilt Nourished By Time

The Impact Of Forgetting On Moral
Being

Fear And Tenderness In Men

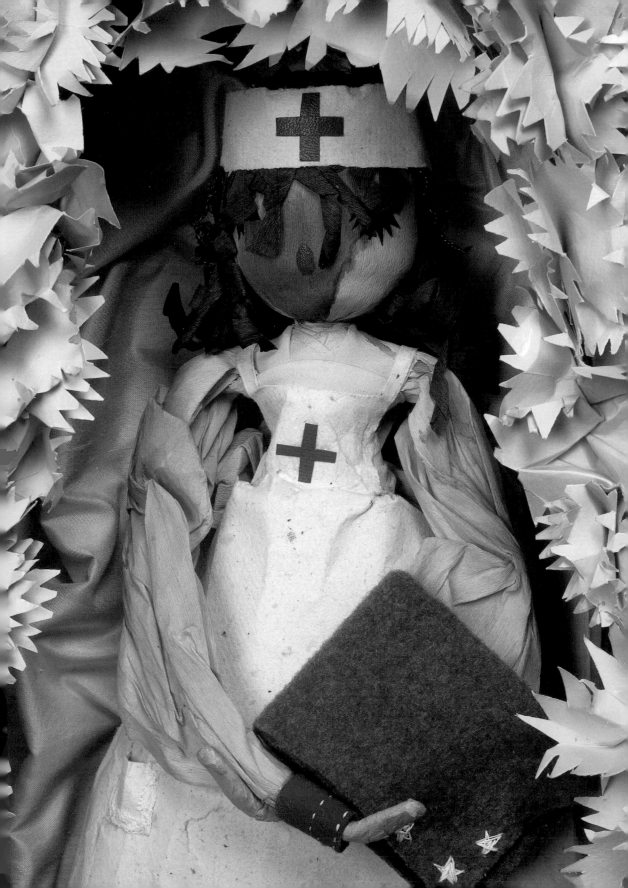

SHE CAN'T DREAM FOR US ALL

Bone dust from every bone in the body
cast and carved into the fossilized remnants of "Lucy"
Australopithecus Afarensis,
bone cores filled with melted vinyl and audiotape recordings
of Sylvia Plath reciting her poems "Daddy" and "Lady Lazarus,"
homemade paper (pulp made from mothers', wives' and daughters' letters
to soldiers in the field from various wars), ground iron,
calcium, water extendable resin, pigments, lace, silk, walnut, glass

2005-2006
42 x 48 x 24 inches
Collection of the artist, San Antonio, Texas

I have done it again.
One year in every ten
I manage it—

A sort of walking miracle, my skin
Bright as a Nazi lampshade,
My right foot

A paperweight,
My face a featureless, fine
Jew linen.

Peel off the napkin
O my enemy.
Do I terrify?—

The nose, the eye pits, the full set of teeth?
The sour breath
Will vanish in a day.

Soon, soon the flesh
The grave cave ate will be
At home on me

And I a smiling woman.
I am only thirty.
And like the cat I have nine times to die.

This is Number Three.
What a trash
To annihilate each decade.

What a million filaments.
The peanut-crunching crowd
Shoves in to see

Them unwrap me hand and foot—
The big strip tease.
Gentlemen, ladies,

These are my hands,
My knees.
I may be skin and bone,

Nevertheless, I am the same, identical woman.
The first time it happened I was ten.
It was an accident.

The second time I meant
To last it out and not come back at all.
I rocked shut

As a seashell.
They had to call and call
And pick the worms off me like sticky pearls.

Dying
Is an art, like everything else.
I do it exceptionally well.

I do it so it feels like hell.
I do it so it feels real.
I guess you could say I've a call.

It's easy enough to do it in a cell.
It's easy enough to do it and stay put.
It's the theatrical

Comeback in broad day
To the same place, the same face, the same brute
Amused shout:

"A miracle!"
That knocks me out.
There is a charge

For the eyeing of my scars, there is a charge,
For the hearing of my heart—
It really goes.

And there is a charge, a very large charge
For a word or a touch
Or a bit of blood

Or a piece of my hair or my clothes.
So, so, Herr Doktor.
So, Herr Enemy.

I am your opus,
I am your valuable,
The pure gold baby

That melts to a shriek.
I turn and burn.
Do not think I underestimate your great concern.

Ash, ash—
You poke and stir.
Flesh, bone, there is nothing there—

A cake of soap,
A wedding ring,
A gold filling.

Herr God, Herr Lucifer
Beware
Beware.

Out of the ash
I rise with my red hair
And I eat men like air.

"Lady Lazarus"
by Sylvia Plath
Ariel, 1963

THE BUTTON COLLECTOR

Cast and carved bone marrow buttons
(one button from each bone in the body),
fragments of pocket lining and thread from military
uniforms of various wars, carved bone
(cufflinks, spools, record holder, domino and die),
excavated spoon, buttons and bullets from various battlefields,
excavated "pain bullet," soldier-made Civil War marbles,
wool from a Civil War field blanket, WWI soldier's envelope fragment,
bronze teeth, American porcupine quills, bird egg,
prehistoric amber, 50,000-year-old meteorite fragment, bone ash,
bone glue, lint, dirt, wormy chestnut, ash

2004-2005
3 x 13 x 15 inches
Private Collection, New York

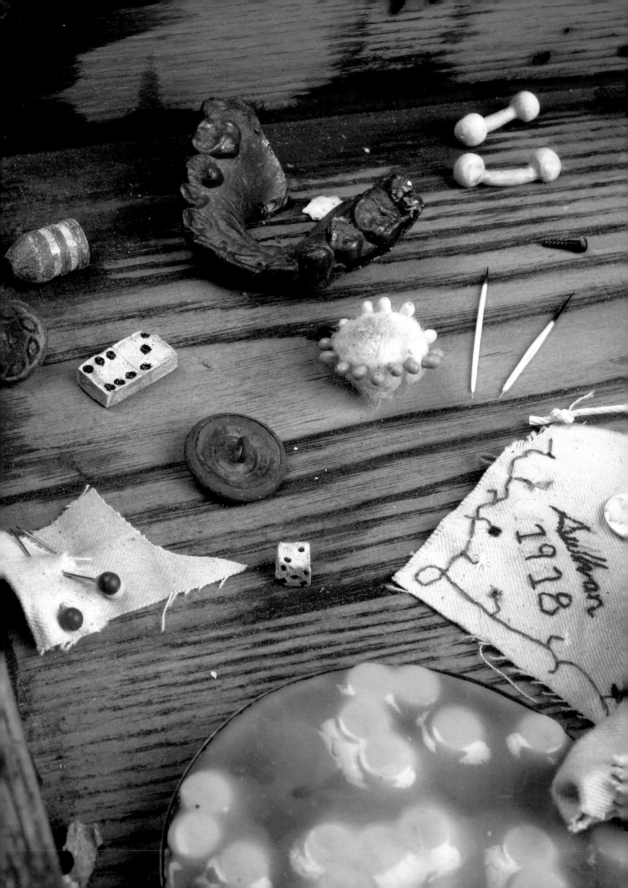

contents

ELIZABETH DUNBAR

THE RECONSTRUCTIONIST

I.

*I think how little we can hold in mind, how everything is constantly
lapsing into oblivion with every extinguished life, how the world is, as it were, draining
itself, in that the history of countless places and objects which themselves
have no power of memory is never heard, never described or passed on.*

—W.G. SEBALD[1]

1. W. G. Sebald, *Austerlitz*, trans. Anthea Bell (New York: Random House, 2001).

or more than a decade, Dario Robleto has been involved in an extended project to rescue the material wreckage of our collective past, mixing and transforming objects and elements into works that act as a magical elixir, one with the capacity to heal the wounds of history. In works inspired by a wide range of sources— from popular music and military history to the natural sciences and forgotten craft traditions—intimacy and engagement remain Robleto's touchstones. Like geologi-

cal fragments layered with history, his objects and actions belie a profound unearth-ing of emotional latency and intellectual implication. Robleto's every decision and gesture reflects a Romantic's quest to create works that can change the world, mak-ing it a better place. Against an era marked by cynicism, irony, and apathy, and a nar-cissistic art world bent on rapacious consumption and instant gratification, Robleto takes a radical stand by creating totems that inspire intense introspection. His self-directed course of artistic production is defined by integrity, generosity, and love.

Robleto utilizes a remarkable economy of means to fulfill his mission to "make art that is intertwined with life."[2] He loads as much meaning as possible into the smallest of spaces, pushing until it is "ready to explode," even infusing content into invisible sound waves, light waves, and the microscopic space of molecules.[3] Robleto's "microaesthetics" appear in his earliest works.[4] Collectively titled *Oh, Those Mirrors With Memory* (1996–97), these ameliorative actions were secretly performed by the artist and documented with short textual descriptions. As both poetic language and didactic object labels, these texts have since evolved into "liner notes" for increasingly complex works. The actions include increasing the over-all brightness of his neighborhood block, postponing the date of Armageddon in university library books, converting a manifesto of hate and destruction into love letters, and paying sentimental tribute to misunderstood or forgotten celebrities—all attempts to alter, shift, or reorder the world by enlisting art in a process of op-timistic transformation.[5] Robleto's anonymous gestures of generosity may escape notice or, if detected, provoke puzzlement—precisely the reactions he seeks in his integration of art and life.

While Robleto's acts of alteration reach beyond the limits of art and into the ev-eryday realm, it is his evocative titles in conjunction with carefully chosen materials that pack emotional charge and intellectual challenges. In one of the artist's earliest works, *We'll Dance Our Way Out Of The Womb* (1997) (illus. p. 6), the light bulbs boost-ing the illumination of neighborhood porch lamps symbolize the philosophical, spiritual, and scientific ideas and modes of inquiry that unite his work and provide keys to unlocking the layers of information embedded in them. But the work's site, the artist's childhood neighborhood (which Robleto purposefully lists as his second material), illuminates added meanings. Suddenly an entire city block becomes a col-

2. Conversation with author, September 15, 2007

3. Email with author, September 26, 2007

4. "Microaesthetics" in Gabriel Pérez-Barreiro, "Dario Robleto: Oh, those Mirrors with Memory," in Gabriel Pérez-Barreiro ed., *Zona Franca* (Porto Alegre: Fundação Bienal do Mercosul, 2007), 319.

5. While most of Robleto's early action pieces were completed in the late 1990s, his project to defer Armageddon, titled *Tonight I'm Gonna Party Like It's 2099*, is an ongoing project that started in 1996.

lective organism and transitory sculpture: a glowing disco dance floor representing the spiritual dimension of ecstatic dance, or a childhood playground nostalgically set against an imaginary soundtrack of booty-shaking beats. Robleto has infused the houses, street, and even the atmosphere itself—down to its atomic particles—with highly personal history in a benevolent gesture of positive social intervention.

The music suggested by the neighborhood "dance floor" becomes a tangible material in later pieces that evoke meaning by incorporating specific vinyl records. Like many teenagers, Robleto dreamed of rock stardom. While that was not to be, he did become the next best thing: an ultimate fan, one with an obsessive fascination with and encyclopedic knowledge of popular music, from gospel to hip hop, rock and roll to techno, and everything in between. His fandom and expertise mark such early works as *There's An Old Flame Burning In Your Eyes, Or, Why Honky Tonk Love Is The Saddest Kind of Love* (1998) (illus. p. 25) and *Sometimes Billie Is All That Holds Me Together* (1998–99) (illus. p. 26). These actions involve found objects improved by the artist—once made more meaningful, they are returned to their origins where, even if unnoticed, they can transmit their secret messages. For *There's An Old Flame Burning*, he coated the tips of wooden matches with melted country and western records, then planted them in bars where unsuspecting customers would strike them and inhale the essence of doomed love affairs—a subtle olfactory warning about honky tonk romance. Art and life merge here, even at the particulate level. Fusion also takes place in *Sometimes Billie Is All That Holds Me Together*, an elegant act of resurrection in which Robleto imparted new life to articles of thrift-store clothing—making them physically and spiritually whole—by replacing their missing buttons with ones lovingly crafted from his melted Billie Holiday records. Returned to their thrift stores, the works became catalysts for re-enchantment, an idea central to the artist's mission.

While undoubtedly related to modernism's idealist objectives, Robleto's alterations and actions counter the outspoken, heroically scaled aspirations of much twentieth-century art. Instead, as the artist has stated, his affectionate and moving gestures "needed no glory, no authorship to be legitimate," a philosophical approach to art making that has evolved to encompass what literary historian Mary Louise Kete terms "sentimental collaboration."[6] Rooted in mid-nineteenth-century Ameri-

6. Dario Robleto quoted in Joe Holley, "Conceptual Artist as Mad Scientist," *New York Times* (13 April, 2003), 33. Mary Louise Kete, *Sentimental Collaborations: Mourning and Middle-Class Identity in Nineteenth-Century America* (Durham and London: Duke University Press, 2000), xiv.

can sentimental novels, poetry, and craft objects, sentimental collaboration refers to a voluntary communal exchange and circulation of sympathy and support through various forms of creative production. Traditional examples of sentimental collaboration include poetic verse, quilts, needlework, and other personalized craft items that friends and family members created for one another as tributes or memorials, consolatory offerings, and gestures of spiritual connectedness. Fundamental to sentimental collaboration—and Robleto's work—is a belief in establishing and maintaining connections with others, especially in the face of loss, that can then transform grief and pain into something restorative and optimistic. Robleto uses this gift-economy system to address such questions as "Can art give someone the thing they are missing? Can art complete something that is unfinished? Can art right a wrong? Can art heal past wounds?"[7] For example, in *Untitled* (1998–99) (illus. p. 23), Robleto spun a spool of magical vinyl thread to mend Patsy Cline after she fell to pieces; in *I Wish I Could Give Kraftwerk All The Soul They Will Ever Need* (1998) (illus. p. 35), he created a trophy that acknowledged the German electronic music pioneers Kraftwerk; and in *Jimmie, Your Cheeks Will Never Lose Their Luster* (1999) (illus. p. 30), he formulated purple healing crystals from dissolved magnetic audio tape that could preserve Jimi Hendrix's reverb for eternity.

7. Conversation with author, September 23, 2007.

Robleto's philosophical stance criticizes postmodernism's pessimistic strains of deconstruction and cynicism. Unlike many of his generation, he refuses to succumb to a wave of consolatory amnesia that wipes out haunting memories of failures and atrocities. Instead, he has confronted the carnage head on, searching through past and present wreckage for the means and processes of healing. Robleto has concentrated on addressing humanity's need for love and redemption, especially in the wake of longing and loss. While the heartrending works he produced in reaction to the catastrophic events of September 11, 2001, have prompted the most discussion, the origins of his ideology are manifest in early works, particularly in melted vinyl memorials to tragic pop stars, from Patsy Cline, Elvis Presley, and Keith Moon to John Lennon, Karen Carpenter, and Kurt Cobain. Significantly, absence and abstract portrayals of individuals are defining characteristics running throughout all of Robleto's work, from singers and musicians to poets and artists and other pop cultural figures. In his more recent works, Robleto shifts to memo-

rializing anonymous individuals or groups, underscoring the universal nature of loss as well as the role of communal exchange in assuaging such pain.

While he values the role of doubt and sees questioning as a creative act, Robleto has put his faith in the power of art: "My work is ultimately about hope. It's about acknowledging the horror of the past and the present but suggesting that we're not powerless against it. We can be proactive about changing things, and that's where the hope comes in. The fact that you would even think that you could change something is a hopeful act."[8] Robleto's hopeful act is also a political one; his understated politics harbors a social agenda allied with that of Felix Gonzalez-Torres, an artist whom Robleto credits as having changed his view of art's possibilities. Though his career was cut painfully short by AIDS, Gonzalez-Torres demonstrated beyond doubt that love and romanticism could be critical and political tools.[9] It could be said that Robleto, by investigating and extending Gonzalez-Torres's ideas (and by physically incorporating parts of Gonzalez-Torres's works into his own), has entered into a sentimental collaboration with his creative and spiritual predecessor, in an act of regenerative mutual exchange.

8. Dario Robleto in Bea Camacho "The Magic That's Possible." http://www. presentspace.com/ presenttwo/presents/ robleto.htm.

9. Dario Robleto, "When You Cry, I Only Love You More," *Artlies* (Fall 2001): 3–7.

II.

Last night a DJ saved my life.

—INDEEP[10]

10. Michael Cleveland, *Last Night a DJ Saved My Life,* Indeep, 1982.

uried among the rubble of history's fallout lie fragments of hope—precious elements of transformation that are readily available to those who seek them. If Robleto is one such social archeologist, then music is among his most fruitful excavation sites. Our most accessible and defining cultural art form, popular music has the ability to express the entire range of human emotions and address every issue pertaining to our world, from the most lofty and expansive themes down to the minutiae and banality of everyday life. As such, this protean art form is the perfect vehicle for administering Robleto's sweeping vision. Comparing his methods to those of a DJ, Robleto digs through the dusty record bins of history in search of the perfect album, song, lyric, sound, or beat—one that can be sampled, re-mixed, or spliced

with others to create something much more than the sum of its parts, something that retains its latent historical and cultural energies. Sampled shards of the past are fodder for the future, a revisionist and reconstructionist attitude perfectly aligned with Robleto's creative sensibilities. As a methodology, sampling is a generative tool for reclaiming and transforming the past, for engaging with and creating new histories, and for participating in a future of our own design. A revolutionary hero for a generation often dismissed for its apathy and historical ignorance, the DJ offers a definitive rebuttal to such criticism, for according the artist, "There is no such thing as a good DJ who is historically ignorant."[11] Robleto extends samplings's restorative and additive powers into uncharted territory by contending that he is also making music—he is simply transferring the DJ's philosophical and technical attributes to sculptural materials.

Initially, vinyl records functioned as Robleto's primary sculptural material. Subjected to a variety of physical processes—melted, sliced, shredded, pulverized, or ground to dust—they were then combined with other materials and recast to produce representational objects bearing the symbolic weight of their sources. Although no longer recognizable as records, the memory of the music remained fixed in the vinyl. The resulting works become carriers of an archive of shared history and meaning, retrieving it from a more real, sincere spot. By imagining music from the past, we bring it back to life and charge it with renewed hope—a fundamental objective of the DJ and sentimental collaborator. Robleto is astutely aware of how popular music can profoundly imprint our lives, and masterfully deploys it to imbue his works with depth, breadth, and power. In *We Miss Sid!* (1998) (illus. p. 20), his first work in vinyl, Robleto distills his longing for the return of punk rock's political posture and anti-establishment antics, as defined by Sex Pistols' bassist Sid Vicious, into small but sharp tacks. The incendiary life of Sid Vicious, the legacy of punk rock, and the effects of 1970s anarchic counterculture on British society and politics are among the many issues that this potent work raises, prompting the engaged and inquisitive viewer to look beyond the object's humble physical aspect. This is, of course, exactly what Robleto hopes will happen: he often speaks of his respect for his audience's intelligence and his intent to reward their patient reading. This Brechtian idea has been increasingly losing its foothold in our con-

11. Dario Robleto, "I Love Everything Rock and Roll (except the music)," *NAAO's Leadership Development Initiative, The Co-Generate Project, Field Guide 1999–2000* (Washington: The National Association of Artists' Organizations), 2000.

temporary world of instantaneous information, which privileges immediate gratification while rejecting surprise and mystery.[12]

Every work that Robleto makes is woven with a plethora of meanings; the object's title and materials list help viewers tease out the multiple threads in its conceptual fabric. Described by the artist as "liner notes," the material list parallels a record album's printed lyrics and acknowledgments, operating as both poetic and elucidatory text. In the early action works, the liner notes are the artworks themselves; in all cases, the liner notes complete the artwork—object and language draw power from one another, like body and soul, a couplet which resonates throughout Robleto's oeuvre. Yet, the text is the real driving force behind the work, directing the object from its very conception. Robleto composes titles and material lists long before physically producing the object, an astonishing process given the bizarre, arcane, and seemingly impossible materials he conjures and eventually incorporates (among them dinosaur fossils, Civil War bullet lead, snake venom, bone dust from every bone in the human body, and glass produced by lightning, meteor crashes, and atomic explosions). This unorthodox process directly corresponds to Robleto's idea of sampling, for he believes a DJ's artistry lies in the vision to locate and integrate such obscure or unbelievable materials: "You have to imagine that something exists to have the ability to find it."[13] By inscribing meaning and value in texts most artists consider an afterthought, Robleto retrieves the object label from neglect and elevates it into an honorable literary form. He therefore calls himself a "materialist poet," whose texts read like found poetry. At the same time, a DJ's discrimination in sequencing songs and sounds underlies his methods: "The way those syllables work next to each other has to satisfy me as much as the material itself.... I'm choosing the next material based on language, totally on language."[14]

12. In his theoretical writings, poet and playwright Bertolt Brecht outlined his ideas for "refunctioning" the theatre as a means for educating society and hopefully generating political and social change through their later actions. Central to this idea was his belief that one should maintain a certain distance from the audience in order to allow them time to reflect and think, a process most effectively achieved through historicisation.

13. Dario Robleto in "The Magic That's Possible."

14. ibid.

15. Barnett Newman, "The First Man Was an Artist," *The Tiger's Eye* 1, no. 1 (1947).

III.

Man's first cry was a song.

—BARNETT NEWMAN[15]

Not until midway through college did Robleto decide to become an artist—he had been studying science, a lifelong passion and pursuit, and preparing for a career in biology. Following this remarkable turn, Robleto dedicated himself to learning the technical, conceptual, and theoretical aspects of visual art with an intensity and focus equal to his investigations of science, music, and history—the same topics that would form the crux of his artistic practice. Science operates similarly to music for Robleto, as a subject to explore, a set of experimental processes and procedures to emulate, and a model for discovering and assigning meaning. Its presence is ingrained in every work.

Astronomy, biology, chemistry, earth science, and physics weave in and out of Robleto's works just as seamlessly as musical allusions and historical references, stitching together narratives ripe with the tension between reason and faith. In early works he mixed fossils, crystals, and minerals, for example, with record vinyl and audio tape to make objects that simultaneously addressed cosmic events, geological evolution, musical lives and histories, and over-arching themes of race, gender, and belief. A paean to a particular moment of social optimism, *I'm Not So Sure The World Deserves You* (1999) honors the luminaries of Afrofuturism, a subgenre of funk that synthesized various musical styles and privileged science fiction as a means of exploring black experience. Robleto made three urnlike music boxes from melted Afrofuturist records, casting them from vintage space-age music boxes his grandmother owned, and filling them with crushed homemade crystals, amino acids, and carbon—the basic organic materials required to create life. The work mournfully characterizes the Afrofuturists' beliefs as too idealistic for our current world, but preserves their intentions as latent life forms capable of reanimation or resurrection by a more enlightened future generation.

Similarly, the monumental diptych *If We Ever Do Get Any Closer At Cloning Ourselves Please Tell My Scientist-Doctor To Use Motown Records As My Connecting Parts* b/w

The Polar Soul (1999–2000) (illus. p. 48–51) delves into the highly contested and ethically charged terrain of selective genetic mutation and cloning. The two-part installation (a well-stocked apothecary's cabinet backed with—"b/w," a reference to a record's A and B sides—a hermetically-sealed laboratory) plays with the scientific methods of extraction, replication, and manipulation as metaphors for the sterile, technical, and synthetic production of electronic dance music while also raising pointed questions about science's ability to impart "soul." Like a lab technician, Robleto approaches the subject with clinical impartiality, also revealing that dance music's genetic forebears, soul and R&B, were not entirely immune from studio engineering either. By mixing a drop of his own blood into his mother's Motown vinyl collection, he underscores the interdependent genetic and generational connections that link the two seemingly polar music genres and cultural aesthetics. The work also extends sentimental collaboration into biological discourse—the artist's blood, his mother's DNA (cultured from decades-old bacteria still clinging to the grooves of her girlhood records), and their shared and separate musical memories blend into a highly personalized self-portrait.

Science takes center stage, literally and figuratively, in the ten-part installation *Popular Hymns Will Sustain Us All (End It All)* (2000–2001) (illus. p. 66). Robleto's self-described "mixed tape of humankind" was inspired by Carl Sagan's "golden record," a compilation of earthly sounds and images carried into space in 1977 aboard the *Voyager* spacecraft as a message to any extraterrestrial life it might encounter.[16] The installation tells a more selective history than Sagan's, however, one that highlights some of humankind's less charitable moments. Our aggressive nature through the millennia—from the extinction of species to the colonization of peoples—is expressed in exuberantly colored geological formations and artifacts created from a sampling of melted record vinyl and other synthetic and organic materials. In identifying these grim human tendencies, Robleto acknowledges that acts we define as "innovation" or "progress" often intertwine with acts of destruction. Mindful of Walter Benjamin's comment, "There is no document of civilization which is not at the same time a document of barbarism," Robleto titles a related work *All Inventions Are Tragic Moments* (1999–2000).[17]

Innovation led to catastrophe in a particularly tragic and public way on January 28, 1986, when the Space Shuttle *Challenger* disintegrated seventy-three seconds after launch, killing all seven crew members on board. With schoolteacher Christina

16. Dario Robleto in Shamim Momin, *Dario Robleto: Say Goodbye To Substance* (New York: Whitney Museum of American Art, 2003), 5; Two *Voyager* aircraft were launched in 1977, each equipped with a 12 inch gold-plated record. As of August 2007, *Voyager* 1 was located in the constellation Ophiuchus, at an approximate distance of 9.7 billion miles away from the sun, and is currently headed for interstellar space.

17. Walter Benjamin, "On the Concept of History," 1940. Trans. by Harry Zohn, reprinted in Howard Eiland and Michael W. Jennings, eds., *Walter Benjamin: Selected Writings Volume 4, 1938–1940* (Cambridge: Belknap Press of Harvard University Press, 2003), 392.

18. According to a *New York Times* poll, 48 percent of children ages nine to thirteen watched the televised launch at school. John C. Wright, Dale Kunkel, Marites Pinon, Aletha C. Huston, "How Children Reacted to Televised Coverage of the Space Shuttle Disaster," *Journal of Communication* 39, no. 2 (Spring 1989): 27.

McAuliffe as part of the crew, the launch drew a large television audience, many of whom were children who watched from classrooms.[18] The *Challenger* crew was scheduled to retrieve several amateur science experiments sent to space on a probe in 1984, including one from an elementary school class, who sent packets of tomato seeds into orbit with a plan to grow and study them after their return. As a result, the seeds were forgotten and literally lost in space. They were finally retrieved in 1990. Years later, Robleto acquired some of them and completed the children's experiment. He planted them in seven custom-made porcelain cups, each incorporating fragments of the shuttle's heat shield and bearing a crewmember's name. Robleto then digitally photographed each plant as it bloomed from its protective spacecraft-planter, thereby preserving its existence for eternity. In *I Won't Let You Say Goodbye This Time* (2001–03) (illus. p. 75) Robleto fulfilled the dreams of the schoolchildren, completed part of the *Challenger*'s mission, and, in doing so, commemorated both groups. Sadly, as Robleto was finishing the project, the crew of the Space Shuttle *Columbia*, the craft which retrieved the seeds, also perished, a turn of events that rattled Robleto and tested his faith in art's power to make a difference. "My project did not stop anything, it didn't do what I had invested so much into, and it hit me hard that I hadn't changed anything," the artist recalled, although adding, "I realized that the idea was about trying, and there is something to be said for the gesture…You just can't stop trying."[19]

19. Dario Robleto in Momin, 13.

IV.

It is to be remembered that all art is magical in origin—music, sculpture, writing, painting—and by magical I mean intended to produce very definite results.

—WILLIAM S. BURROUGHS[20]

20. William S. Burroughs, "Brion Gysin," in Colin Naylor and Genesis P-Orridge, eds., *Contemporary Artists* (London and New York: St. James Press, Macmillans, 1977).

obleto's work is a poetry of persuasion as well as pathos. It brings to light the absurdities of war and other atrocities, distant and present, in an attempt to honor casualties of the past and to alter our genetic disposition towards future violence. Sentimental collaboration and its contemporary kin, sampling, provide a framework for Robleto's reconstruction process, as does the age-old practice of alchemy, a metaphor of utmost importance to him. Because of his ingenious transformation

of materials, many have described his methods as alchemical. However, alchemy is more than just a metaphor for transformation; he truly imagines himself carrying on a spiritual tradition dating to the Middle Ages and revived in modern times by artists such as Joseph Beuys and Anselm Kiefer, both of whom have used metals and other eccentric materials to symbolize healing and regeneration.

Rooted in the practices of ancient metallurgy and smelting, alchemy is a medieval philosophy and early form of chemistry whose aim was the transmutation of base metal into gold.[21] Practitioners believed that these attempts would render spirit in material form. Alchemical experimentation, which included a variety of secretive and elaborate operations involving fire, acids and other reagents, focused on seven metals, each representing different degrees of purity on a continuum toward the most spiritual metal, gold. Descendents of religious masters, alchemists sought not only to transmute matter into a higher form of spiritual purity, they also sought such transformation in themselves; they hoped their pious dedication and accumulated wisdom would lead to a purification and perfection of the soul.

In his practice, Robleto carries the torch of alchemy, maintaining its spiritual determination and goals. He uses some of its materials—gold, silver, and especially, lead—and techniques including amalgamation (the making of alloys), cineration and assation (the reduction of a substance to ash), coagulation, and corrosion. Robleto also cherishes the secrecy that alchemists maintained towards their investigations, equating mystery and myth with the beauty and wonder of art. Robleto asserts that his reticence regarding his own work is not to be confused with dishonesty; he says every material he uses and every process he undertakes is true. He takes great pains to authenticate the historically charged materials in his work and meticulously researches the events he recounts. He grounds his resurrection and transformation of every material, from Civil War sweetheart letters to trench art made by wounded soldiers, in both romance and a sincere commitment to his audience, claiming, "Any question I pose or leap of faith I ask of others, I have grappled with as well."[22] These questions have prompted him to push even further, to raise the level of incredulity in his works as a way to force the issue of faith. Robleto wants those who see his works to reflect on the act of faith and consider its costs—what does it take to really believe?

While Robleto's early works mimicked real objects, they sometimes exhibited

21. Gold, the most pure of the seven metals, was associated with the sun, while lead, the most base, was associated with the planet Saturn. Saturn, the god of contemplation in Greek mythology, is also associated with creativity and melancholy, two attributes of the artist. The Saturnine temperament has been revered as encouraging self-knowledge, and, in this context, Saturn came to symbolize contemplative life and the search for that which was most secret.

22. Dario Robleto in "Regine Basha Interviews Dario Robleto," *InterReview* 06 (2006):40.

a purposeful rawness or clunky hand-craftsmanship that distanced them from reality, a strategy the artist used to draw attention to their material origins. As his work grew more conceptually sophisticated, however, so too did his technical proficiency, enabling his works to pack an even greater intellectual and emotional wallop. These works, dating back to around 2002, follow the tradition of *trompe l'oeil*—they are finely-crafted, meticulous reproductions of real world objects that simultaneously fool the eye and blow the mind. With the confidence and finesse of an alchemical magician, Robleto has conjured objects that are impossible to fathom, an impressive accomplishment given that there are no rules or procedures to follow in their creation. Indeed, who has written instructions for transforming human bone dust into an audiocassette tape? Despite their effortless appearance, Robleto's transformations are rigorous and time-consuming sculptural endeavors, some of which reflect several years of experimentation and failed attempts prior to their realization. Just as Robleto insists that we, his viewers, have faith in him, so too must he have complete dedication to and faith in his materials; to succeed in his work, the alchemist/artist must trust his materials and earn their respect in his quest to reveal their latent spiritual power.

It could be said that *Men Are The New Women* (2002) (illus. p. 77) is Robleto's philosopher's stone, the holy grail of alchemy and his ultimate sentimental collaboration. An elegant and deceivingly simple piece, it raises questions about how history has been written, from whose point of view, and how these factors have influenced the evolution of society and culture. From the pulverized dust of a female rib, Robleto has created a realistic male rib, a revolutionary biological reversal of Genesis's Creation story. This potent object posits an alternate route through human history, raising questions about the differences a female-devised origin myth might have made, or the controversies such a bone might have provoked as an archeological discovery. On the other hand, Robleto concedes, such a rib might have made no difference at all; perhaps we would end up just as we are now, with human aggression still bringing havoc and ruin. Nevertheless, Robleto's gesture sends a clear and powerful message: that artistic creation offers the possibility of hope.

V.

This book is not concerned with Poetry.
The subject of it is War, and the pity of War.
The Poetry is in the pity.

—WILFRED OWEN [23]

obleto's works from the past seven years reflect the concerns of someone living in a country grappling with the realities—and sometimes unrealities—of war. From the aftermath of 9/11 to the current—seemingly untenable and unstoppable—war in Iraq, the United States has been steeped in a period of mourning and a climate of increasing fear, anxiety, and despair. At the crux of Robleto's enterprise from this time forward has been an attempt to recover and recharge history through the medium of sculpture. Responding to the catastrophic events of September 11, "a unique existential moment in our country's history," Robleto felt an obligation to re-engage with American history, to examine its violent past in an attempt to understand the present and amend the future. [24] His approach since then is much more invested in historical resonance and political and social consequence; Robleto defines it as "historical empathy," a synthesis of his philosophies on sampling, communal healing and sentimental collaboration, the physical survival of the past in objects, and the poetic potential of materials. [25] Engaged in what he calls a "sustained meditation," the artist suggests that his is a lifelong undertaking—a way of moving through the world directly opposed to leaning on the crutch of historical amnesia. [26]

In these recent works Robleto incorporates highly-charged material from some of the most tragic inventions of all time, the materials of war. Like Walter Benjamin with his angel of history, who surveys the accretion of human cruelty and tragedy over the millennia with her backward glance, Robleto has conjured a fictional time-traveling soldier who moves through the blood-soaked battlefields of America's various wars from colonial times to the present. [27] Robleto has constructed the soldier's ongoing narrative through sculptural materials, especially those that house memories of war and loss—skeletal remains and other biological matter, ammunition and battle paraphernalia, trinitite (glass created by the first atomic bomb explosion at

<div style="float:right">

23. Wilfred Owen, "Preface," 1918, in *Poems* (London: Chatto and Windus, 1920), ix.

24. Conversation with the author, April 17, 2007.

25. Email with the author, September 21, 2007.

26. Conversation with the author, April 17, 2007.

27. Robleto's narrative took the format of five consecutive exhibitions: *Roses In The Hospital/Men Are The New Women*, Inman Gallery, Houston; *Diary Of A Resurrectionist*, Galerie Praz-Delavallade, Paris; *Southern Bacteria* at ACME., Los Angeles; and *Fear And Tenderness in Men*, D'Amelio Terras, New York and *Chrysanthemum Anthems*, Weatherspoon Art Museum, Greensboro, N.C. This multi-part structure recalls an earlier exhibition trilogy based on three fictional bands: *Speaker Hole, The Polar Soul,* and *Factory Girl*. Robleto also applies his strategy of re-mixing to the installation of objects; by configuring a different lineup in each exhibition, a new narrative emerges based on context, and new conceptual threads become evident.

</div>

28. Trinitite is also known as Atomite or Alamogordo Glass. Trinity, the first nuclear weapon test, occurred on July 16, 1945 near Alamogordo, New Mexico. In the late 1940s and early 1950s, samples were gathered and sold to mineral collectors as a novelty. Robleto used the substance for the first time to make a glass drumstick for *Your Moonlight Is In Danger Of Shining For No One* (2000–01), a tribute to the Who's deceased drummer Keith Moon. Video footage of the atomic test's effect on humans and animals was dissolved to make a pendant titled *I Like To Know Things Will End*, a single "track" from the "album" *Rarities and Demos Box Set (Scratch Attack)* (1998–2000).

29. Robleto increasingly began to replace record vinyl and audio tape with other non-musical sounds at this time, however, this type of sound appeared earliest in *We'll Dance Ourselves Out Of The Womb* (2000–01), which also featured an audible soundtrack, rare in Robleto's work. Included in the soundtrack were sounds recorded by NASA's *Cassini* space probe of solar winds crashing into Jupiter's magnetic field, as well as a recording of a meteorite piercing the Earth's atmosphere.

the Trinity test site), and soldiers' personal mementos and related ephemera.[28] In Robleto's episodic tale, the anonymous soldier travels from war to war, zigzagging through time and space, incurring wounds to his body and soul, until he is literally ground to dust. Works made from bullet lead, shrapnel, and dust from every bone in the human body allude to the soldier's physical annihilation. Other works register the spirit world, incorporating spirit photographs and electronic voice-phenomena recordings that claim to fix the ghostly presence of departed souls in "scientific" materials like film and magnetic audiotape. The sounds of gunfire and phantom soldiers' voices mix with the popular music found in previous work, stretching the power of aural associations farther than ever.[29] At the same time, a subplot involving race and class—issues initially raised in early works tracing the origins and divergent paths of dance music and rock and roll—becomes a way to consider the history of aggression in America.

Robleto's work is part of a long and embittered tradition of art responding to war. The work invites comparison to the carnage-fueled psychological trauma of Dada montage, a fractured and absurdist art form that arose in response to the industrialized violence of World War I. Robleto reverses the Dadaist strategy of tearing down imagery to signify irrationality, even while using the atrocities of war as critical tools. Instead, he seeks to suture the violated body back together, to heal and rebuild a future. Looking back to the genetic explorations seen in earlier works, he returns to organic agents as a means of renewing life, transforming bones and teeth, plants, herbs, minerals, and other organic and synthetic supplements into restorative elixirs and sculptural objects. Elevating medicine-making to its once dignified position as an art form, Robleto finds in its mixing and experimentation an analogy to sampling. His homemade tinctures, balms, tonics, and elixirs are based on the logic of antique recipes for medicines and herbal remedies and concocted in response to his soldier's unique ailments. With their lengthy ingredient lists, the liner notes for *Balm Of 1000 Foreign Fields* (2004), *The Last Lost Shipment Of An Untested Life Potion* (2003–2004) (illus. p. 118), *Hippies And A Ouija Board (Everyone Needs To Cling To Something)* (2003–2004) (illus. p. 121), and others read like poetical treatises on the spirit, as well as magical incantations, itemizing peculiar plants like "Devil's claw" "rosary vine," "blood root," and "artillery plant."

Beyond incorporating organic, healing elements, Robleto's works since 2001 also recover and venerate such historically neglected genres as trench, domestic, and mourning arts. As objects made in response to armed conflict and its aftermath, trench art is typically fashioned from recycled war materials—such as artillery-shell cases, bullets, shrapnel, and so on—but also includes examples of painting, sculpture, and handcrafts.[30] Created by servicemen, prisoners, recuperating soldiers, and even civilians, trench art powerfully represents the struggle to escape and overcome the inhumanities of war through creative expression. These loaded artworks transmute war's murderous materials into therapeutic objects for the body and soul. Most of Robleto's recent work participates in the rubric of trench art, an interpretation the artist strongly advocates, sharing the genre's transformational aspirations and focus on the emotion-filled material history of war. At the same time, Robleto pushes ideas of reclamation even further by incorporating vintage trench art objects into his own meditations on war. *I Never Took The Hippocratic Oath* (2002), for instance, is a memorial floral arrangement featuring an altered First World War artillery shell vase, while the centerpiece of *The Creative Potential Of Disease* (2004) (illus. p. 143) is a Union Army amputee's homemade, therapeutic self-portrait doll. In the latter, Robleto regenerated the doll's missing limb by casting a new leg from femur bone dust, shrapnel, and bullet lead, healing the soldier in an act of reverse vodou. Through historical empathy and sentimental collaboration, he has traveled back in time to surgically and artistically heal a phantom limb, that manifestation of the body mourning its own loss, giving the soldier what he so desperately needed to be complete.[31]

Like traveling medicine men or bards, the artist and his soldier are each on a quest to heal the scars of the past through creative acts. But Robleto knows that the tinctures and salves, prosthetics and stitches he makes for his phantom soldier will not change the past—in fact, these works can be read as a meditation on wounds that can never fully heal, works that question redemption. Perhaps acknowledgement, empathy, and remembrance are enough to make a difference, perhaps not. As Robleto has said, "the only real power an artist has is to invest things with meaning."[32] Meaning is what propels us forward.

30. For a thorough study of this little known genre, see Nicholas J. Saunders, *Trench Art: Materialities and Memories of War* (Oxford: Berg Publishers, 2003).

31. The relationship between a prosthesis and a phantom limb resembles that between body and soul, an idea central to Robleto's work. For example, the phantom causes pain when it lacks a prosthesis to give it purpose, and the prosthesis can only function when animated, when it is literally given a soul by the phantom. See Gaby Wood, "Not a Happy Fraction of a Man," *Cabinet* no. 26, (Summer 2006).

32. Dario Robleto in Dan Goddard, "San Antonio artist's work draws acclaim," *San Antonio Express News* (16 March, 2003).

VI.

*Can the beautiful be sad? Is beauty inseparable from the ephemeral and hence
from mourning? Or else is the beautiful object the one that tirelessly
returns following destructions and wars in order to bear witness that there is survival
after death, that immortality is possible?*

—JULIA KRISTEVA[33]

33. Julia Kristeva,
*Black Sun: Depression
and Melancholia*,
trans. Leon S. Roudiez
(New York: Columbia
University Press,
1989).

With the war works Robleto also refers to the legions of
women who gave selflessly in field hospitals and military
medical facilities, including nurses, Red Cross workers,
and reconstruction aides (a term for physical and occupa-
tional therapists). But women provided much more than
just medical assistance during wartime, a fact frequently overlooked in historical
accounts.[34] Robleto rescues these lost histories from the dusty archives of the past,
giving them new currency as critical tools for understanding suffering and sur-
vival, as well as poignant warnings about history's recurring mistakes. The heart-
breaking and inspirational stories of women interwoven with those of Robleto's
soldier reflect the important social, political, and cultural roles that women play
in uncertain times. From the selfless nurse who provides comfort and support, to
bereaved family members mourning their loss, their stories fill another chapter in
Robleto's sculptural tale.

The spirit of Florence Nightingale, pioneer of modern nursing, materializes in
several works exposing the hidden impact that women had on war efforts. A shin-
ing example of female compassion, "The Lady of the Lamp" was also a pivotal figure
in the proto-feminist movement. Robleto refers to the Victorian heroine in *If We Fly
Away, They'll Fly Away* (2005–06) (illus. p. 167), an empty birdcage littered with stray
feathers made from vinyl recordings of a veterans address by Nightingale as well as
birdsongs of the nightingale, alluding to the soul's flight from the body. Nightingale's
spirit also hovers in the background of several large wall wreaths that revive the gen-
erous and communal spirit of sanitary fairs, patriotic fundraising events organized by
women's relief groups. Elaborate constructions of homemade paper, produced from
the pulp of antique letters exchanged between soldiers and loved ones, plus other

34. Women occupied
many important roles
during various
war efforts. In the
Civil War, for
example, women
were employed by the
government's
pharmaceutical lab
that made and
supplied medicine
and supplies to
the troops. On the
opposite end of
the spectrum were
the munitionettes
of WWI who worked
in ammunition
factories making artil-
lery shells and bullets
(Robleto's own grand-
mother made bullets
in San Antonio
while her husband
was serving in WWII).
In an ironic twist,
women were both
responsible for
the agents of death
and mutilation
that maimed and
killed their loved
ones, as well as for the
care and healing of
these same men.

war and mourning materials, Robleto's wreaths mix the forms of floral funerary displays with those of advertisements for sanitary fairs. Such fairs acted as the fundraising arm of "soldiers' aid societies" and "ladies' aid societies." In addition to sending essential items to soldiers, they also recruited nurses and raised funds by selling their creative wares. The pincushions, knitted scarves, embroidered handkerchiefs, tatted collars, and other handcraft items these women made became powerful political and creative tools. "Though not beside you in the hour of danger," one aid volunteer wrote her soldier correspondents, "our hands shall not be idle...The Soldier Relief Society has enlisted for the war."[35]

Aid volunteers performed numerous other charitable duties, including reading to and writing letters for the injured soldiers. Robleto's *The Southern Diarists Society* (2006) (illus. p. 175), a magnificent, melancholic totem to mourning, alludes to the letter writing campaigns undertaken for amputee soldiers who could no longer write. Like each of Robleto's wreaths, the work incorporates letters exchanged between soldiers and loved ones, private documents that, down to the molecular level of paper and ink, are infused with loss, love, and longing, along with the minute physical traces of their writers and recipients. In an act of reclamation, Robleto saves the letters from forgotten boxes, prolonging their lives by bestowing on them new relevance and meaning as sculptural materials. Robleto even extracts and reuses their ink, distilling every single letter, word, and phrase into a potent, regenerative brew. Letters and poems replace the lyrics of love and loss embodied in the mute vinyl records of years prior: a sentence in a letter is like a groove in a record.

Letters written by husbands and sweethearts who never returned from war register a particularly devastating loss. Had these soldiers returned home, would the sweetheart couples have married and had children? *A Century Of November* (2005) (illus. p. 163), an eerie replica of a child's white Victorian mourning dress sewn from such letters, represents this lost generation of children—an embodiment of absence, the empty dress signifies a child ghost who mourns its parents' nonexistence as well as its own.[36] Robleto has returned repeatedly to the creative nature of procreation, most explicitly in the autobiographical *Our Sin Was In Our Hips* (2001–2002) (illus. p. 103), a coital fusion of human pelvic bone and his parents' rock and roll records, music symbolizing their generation's sexual awakening and tied to the artist's own con-

35. Letter of Ellen Matilda Orbison Harris, February 10, 1862, quoted in Nina Silber, *Daughters of the Union: Northern Women Fight the Civil War* (Cambridge: Harvard University Press, 2005), 173. While selling their crafts was a major component of the fairs, there were also other exhibitions of items for display or sale, including trench art, battlefield memorabilia, historical collectibles, curiosities, and geological specimens. Indeed, a catalogue of items on display at the 1863 Great Western Sanitary Fair in Cincinnati reads like the liner notes from Robleto's works.

36. The rupture of family bonds has been a recurring element in Robleto's work, ever since *It Sounds Like They Still Love Each Other To Me* (1998), a pair of melted vinyl earplugs referring to the breakup between Courtney Love of Hole and Kurt Cobain of Nirvana.

ception. These works pay tribute to the biological and metaphysical family bonds that endure turmoil and destruction, and can even survive death. Robleto's interest in intergenerational aesthetics, particularly through matriarchal lineages, began with his use of objects belonging to his mother and grandmother, especially records they owned. His miniature replica of his mother's teenage bedroom, complete with tiny vinyl albums and an LP he recorded for her, then melted down, draws on memories to elicit both personal and universal emotion. Such works draw on women's craft traditions—samplers, quilts, hair wreaths, and others—which allude to the maternal values of family unity. Robleto's links with his creative foremothers have strengthened and solidified through his espousal of sentimental collaboration; he has resurrected women's undervalued methods of creative production by adopting and extending them, creating his own samplers, rag rugs, woven hair flowers, and other items that infuse art with biological material as an emblem of familial love.[37]

37. The tools and materials of women's domestic crafts—including spools of thread, sewing needles, thimbles, buttons, fabric, and blankets—have been a mainstay of Robleto's work for more than a decade.

A melancholic beauty emanates from these heartfelt domestic objects: touching memorials to loved ones and poignant reminders that everyone will pass from this world. These objects are intimately tied to the sentimental mourning customs of the nineteenth century, when death was a common, integrated element of everyday life. Reaching its zenith in the Victorian era, especially during the Civil War, the "Cult of Memory" permeated nearly every conceivable aspect of culture with a highly ritualized and elaborate romanticism of death. The pageantry of woe extended from mourning costumes, jewelry, and funeral trappings to memorial portraits, commemorative artworks, and postmortem photographs—communal forms of mourning encouraging creativity as a therapeutic outlet for grief. Such items not only valorized the dead, but also fulfilled a need to keep them close physically and emotionally, like modern versions of religious relics from centuries gone by, connecting the present to the past and the future. Through these objects, death, time, and distance disappeared.

In these rich traditions Robleto has found a philosophy that perfectly meshes with his own—that art has the power to heal and that creativity can counter destruction. By incorporating examples of mourning ephemera and art—including funerary ribbons and announcements, lockets and earrings, hair flowers and wreaths, memorial and spirit photos, and paper and preserved flowers—or by making his

own mourning pieces from symbolic materials, Robleto resurrects a long-lost tradition that directly opposes contemporary culture's sterile and clinical approach to death. Robleto rejects today's cultural sequestration of dying and death and our tendency to deny or marginalize grief and mourning. Instead, he strives to reinstate a continuity of love that transcends death. The depth and sincerity of Robleto's belief in the enduring and transformative power of love is echoed in a moving memorial to his grandmother, *Living With Death As Something Intimate and Natural* (2005–06) b/w *The Artillery of Heaven* (2006) (illus. p. 193), for which he dissolved an audiotape of her last heartbeats and fashioned the residue into an oak tree twig, a mourning symbol for regeneration and eternal life.[38]

VII.

"Hope" is the thing with feathers—
That perches in the soul—
And sings the tune without the words—
And never stops at all—

—EMILY DICKINSON[39]

As we reflect upon a decade of Robleto's magical travels through time and space—from the dance floor to the battlefield, from the laboratory to the drawing room—a pure and simple sentiment rises from the ashes of history: the creative potential of hope. It is hope that motivates one of Robleto's most moving works, *War Pigeon With A Message (Love Survives The Death Of Cells)* (2002) (illus. p. 99), a broken and bullet-pierced homing pigeon who carries a message of love and salvation, and refuses to surrender until his epistle is delivered, no matter the distance of his journey or the danger he encounters.[40] Even after the pigeon's death, Robleto imagines him still striving to fulfill his mission. In his determination and optimism, this pigeon is perhaps a symbol for Robleto himself, pushing onward in an extended meditation on love, loss, longing, and the healing power of hope.

38. Since 2005 Robleto has been engaged in a related project to record the heartbeats of one hundred pairs of lovers. The recordings will be used to make a salve to treat heartache. The son of a hospice administrator and a former volunteer himself, Robleto attributes his interest in folk medicine and alternative healing to his hospice experience and his grandmother's "old wives' tales"—beliefs that faith and love-inspired healing can accomplish what medical science cannot. Conversation with the author, April 25, 2007.

39. Emily Dickinson, in *The Complete Poems of Emily Dickinson*, ed. Thomas H. Johnson (Boston and Toronto: Little, Brown and Company, 1960), 116.

40. Robleto's pigeon is loosely based on Cher Ami, a homing pigeon owned by the U.S. Army Signal Corps who delivered messages in France during World War I. In his final mission, which saved nearly two hundred American soldiers, Cher Ami delivered a message despite being shot through the breast, blinded in one eye, and losing a leg. He died as a result of his battle wounds and was awarded the Croix de Guerre. His body now rests at the Smithsonian Institution.

MICHAEL DUNCAN

ROCK MY SOUL

he recent bankruptcy of Tower Records has proved that pop music as we've known it is over. By making the CD obsolete, the iPod has radically changed music's mode of distribution, making shopping for song-tracks a sample-friendly, at-home, often freeloading activity. The once mighty Top 40 audience has diluted into fragmented pockets of downloaders not interested in hearing or buying what record companies and radio stations tell them to.[1]

Furthermore, the new technology has let these audiences do what they like with the music, even with sacrosanct performances of the past. With a few laptop clicks, they can sing along with Callas, remix the beat of the Beatles, make Marley hip-hop. With these increased parameters, the definition of a recording has changed. As one of novelist William Gibson's characters states of the new digital era, mass media no longer exists within the world; it comprises it.[2]

Given the collapse of the music industry, mass market consensus is not what

1. CD purchases in 2007 are reportedly down 19% from 2006, according to Geoff Boucher and Chris Lee, "A new record price: $0," *Los Angeles Times* (2 October 2007): 13.

2. William Gibson, *Spook Country* (New York: Putnam, 2007), 103.

it used to be. It seems unlikely that new singers will ever command the mythic attention once accorded to Piaf, Garland, Lennon, Marvin, Janis, Aretha, Joni, Elvis, Bowie, or Morrissey. Both timely and timeless, the best twentieth-century pop records documented particular cultural moments that managed to endure and speak to subsequent generations. In the past decade, many of those tracks have been digitally altered and broadcast to sell Nissans and Nikes, Toyotas and Target.[3] The stars have been tarnished.

Still, there are believers and new ways to believe. Dario Robleto, both true fan and visionary postmodern re-mixer, makes art that re-engages music with a broader history—itself a beleaguered entity in the Bush era of political amnesia. In assemblages of objects partly cast from melted vinyl of classic tracks, he has found new contexts for the music's original passion, addressing larger issues of war, grief, love, gender, and racial identity. Robleto's foundation firmly lies in his radical approach to the grand corpus of American song.

Starting with simple paeans to his musical heroes, Robleto's project has slowly evolved over the past decade to probe broad questions about aggression, sexuality, race, and freedom. As in the career trajectories of the best pop idols, his early lyrical efforts have been followed by works of increasing complexity and topicality. The recent remarkable series of works loosely tracking the actions of a time-traveling American soldier has gained Robleto a widespread audience eager for content and passion in art. Beyond its relevance to the disastrous U.S. invasion of Iraq, this project is perhaps the most profound artistic assessment of the effects of war in the new century.

In the past decade, Robleto's works have become grandly ambitious, willfully positive, redemptive endeavors, addressing fundamental notions about human existence. He has cast a male rib out of a crushed female one, skewering and reversing the origins of gender according to Genesis (*Men Are the New Women* [2002] [illus. p. 77]). In a container made of dust from every bone in the human body, he has bottled an elixir concocted from nutrients that could conceivably spawn new life (*Skeleton Wine* [2002] [illus. p. 104]). His role as alchemist-shaman has emerged from his roots as artist-DJ. The metaphorical regeneration promised by his work has been nurtured by life-enhancing vinyl.

From the outset, Robleto's work has dealt with public performance as a means

3. Some of the many classic songs recently co-opted by television advertisements are the Beatles' "Revolution" used by Nike, Iggy Pop's "Lust for Life" by Royal Caribbean cruises, the Rolling Stones's "Start Me Up" by Microsoft, Queen's "Bohemian Rhapsody" by Mountain Dew, and the Beatles' "All You Need is Love" by Luvs Diapers.

for private expression. In an untitled work from 1997, he repackaged audiotapes on which he had recorded personal conversations and returned the tapes to their retail racks in the store. In *Heartbreaker (Why I Love Johnny Depp)* (1997), he whited-out a *Vanity Fair* article about the actor, hand-wrote his own tribute, and returned the altered magazine to the newsstand from which it was purchased. This kind of subversive intervention—practiced in the late 1960s by LA artist Robert Heinecken, who produced altered, politically charged versions of *Time* magazine—circumvents the usual means for art to communicate by creating chance encounters with unsuspecting consumers.

The generous spirit, open emotionalism, and interactive, performative nature of the art of Felix Gonzalez-Torres was an early influence on Robleto, resulting in *I Miss Everyone Who Has Ever Gone Away* (1998–1999), a work that consists of origami airplanes made from candy wrappers taken from Torres's giveaway piece, *Untitled (USA Today)* (1990). Robleto's 2001 essay in *ArtLies*, "When You Cry, I Only Love You More," is a heartfelt appreciation of the sentiment, toughness, and participatory spirit of Gonzalez-Torres's work.

Taking his public tributes further, Robleto made works to honor musical heroes such as Billie Holiday, Patsy Cline, and the Sex Pistols. For him, the objects he cast from melted vinyl of their songs retain the spirit of the music—the conviction, passion, and lyricism of the individual tracks live on in a new form and context. For example, commenting on the intense and tragic relationship of Kurt Cobain and Courtney Love, *It Sounds Like They Still Love Each Other To Me* (1998) (illus. p. 27) consists of two earplugs, the left made from melted vinyl of a Nirvana album, the right one from vinyl by Hole. The work's title signals Robleto's faith that the couple's shared creative genius cannot be blocked out—despite Cobain's death and his tempestuous relationship with Love.

Robleto has made works in which vinyl was melted and cast into a surprising variety of objects: as buttons for thrift store shirts (*Sometimes Billie Is All That Holds Me Together* [1998–1999] [illus. p. 26]), nuggets of fool's gold (*I Saw a Pop Idol Sneer at a Dying Kid* [1998] [illus. p. 31]), antennae of a found butterfly (*Disco on Europa* [2000–2001]), and ground into powder and attached to the heads of matches (*There's An Old Flame Burning In Your Eyes, Or, Why Honky Tonk Love Is the Saddest Kind of Love*

[1998] [illus. p. 25]). He taps into the connoisseurship and historicism of pop fan culture, a world based on finely tuned appreciations of the distinctiveness of performers and individual performances. Existing largely outside of the academy, criticism of pop music has a depth, a broad-based readership, a sense of historicism, and an appreciation for nuance that arguably surpass those of contemporary criticism of fiction, art, or film.

For music fans, classic studio and live performances are aural evidence of undeniable value. The original preservation in vinyl of the voices of Piaf, Callas, or Lennon represents a kind of miracle. For believers, *I Wish I Could Give Aretha All the R.E.S.P.E.C.T. She Will Ever Need* (1999) (illus. p. 33, 34), Robleto's thrift store trophy cast from melted Aretha Franklin records is like a jewel-studded gold vessel by Cellini that dazzles with the import and value of its medium. Robleto is a new kind of goldsmith in service to the cults of twentieth-century song.

From the start, Robleto embraced the unabashed emotionalism and enthusiasm of fan culture as well as its criticality. His lyrical impulse is balanced by a playful, gently ironic awareness of the exaggerated mythology, scandalous self-indulgences, and comic aggrandizements inherent in pop music lore. Robleto has extended a pun on "rock music" into an investigation of music as a force of nature, akin to geological phenomena. Works have punned on the nomenclature of musical genres such as "dinosaur rock" and "heavy metal." Many works have used specific song titles and the connotations of specific performers as ways of broadening metaphorical meanings.

The historicity of music culture has been Robleto's route into an examination of wide-ranging historical events. His early pop apotheosis, *Mourning and Redemption (At the Gates of the Dance Floor)* (1999) (illus. p. 37–39), displays cast artifacts symbolizing the various downfalls of an eclectic group including Kurt Cobain, Atahuallpa, Jean-Michel Basquiat, Karen Carpenter, Freddie Mercury, Oscar Wilde, and the *Challenger* astronauts. Two copies of each symbolic object rest on a v-shaped shelf that Robleto intends as a kind of fashion runway maquette; one set is cast from melted vinyl of singer Crystal Gayle's country blues "Don't It Make Your Brown Eyes Blue," the other set from diva Gloria Gaynor's gospel-for-the-disco anthem "I Will Survive." Presided over by a disco ball covered in homemade blue crystals, the two sets present a musical dialectic of white and black, straight and gay, rural and urban

in an upbeat, regenerative spin on the tragic parade of history.

Robleto thinks of himself as a kind of DJ, mixing references to music and history to create new meanings and contexts. He takes his cue from the sampling common to hip-hop and electronica, appreciating that the practice "actually cherishes history—there is no such thing as a good DJ who is historically ignorant."[4] Sampling's radical approach to form emphasizes lateral similarities, metaphors, rhymes, stark juxtapositions, and rhythm shifts. An offshoot of the collage aesthetic first explored by the early modernists, sampling is a quintessential postmodern practice, presenting a sprawl of sometimes radically disparate sound-bites that complement each other in provocative ways. Like sample-heavy hip-hop, Robleto's assemblages of objects—with their arrays of loaded historical, geological, and musical connotations—are new forms of conceptually based collage.

Robleto's works spark a kind of conceptual synesthesia, conjuring a mix of visual and aural associations. *This Mineral I Call A Beat* (1999) (illus. p. 71) is a model of a small Casio keyboard made from a casting agent that includes a stew of minerals found in the human body. On this geologically structured soundboard, individual keys are labeled as if one could isolate the sounds of, say, carbon, sulfur, or hemlock. Recalling the symphony of tastes conjured by the esthete hero of Huysmans's novel *Á Rebords*, the keyboard's mineral "rock music" exists outside ordinary sensory perceptions. Robleto proposes an instrument on which one could potentially strike a chord that would generate new life.

According to most music historians, the term "rock and roll" has its roots in the motion of nineteenth-century mercantile and slave ships, which inspired the swinging rhythms of sea chanteys and spirituals. Black gospel music took up the phrase as an apt description of religious fervor and the presence of the Holy Spirit ("Rock my soul in the bosom of Abraham"). Rhythm and blues music became a secular response to the "rocking" rhythms of gospel, and in 1947, "Good Rocking Tonight" conjoined both the spiritual and sexual connotations of the term.[5] After DJ Alan Freed began to promote "rock and roll" to a white teenage audience, the music industry fully embraced the genre.

The geological connotations of the term "rock" emerged as the music's traditions and history solidified in the 1960s, both through a wide variety of puns ("The

4. Artist statement from Shamim Momin, "(Re)Making the World: Dario Robleto's Say Goodbye to Substance," (New York: Whitney Museum of American Art, 2003), n.p.

5. The song, written by Roy Harris (1947) and more popularly recorded by Wynonie Harris (1948), was a kind of secularized parody of gospel, mentioning Deacon Jones and Elder Brown "jumpin and stompin at the jubilee." It was recorded by Elvis Presley in 1954 in a version that omitted references to the church leaders.

Rolling Stones," "Hard Rock," "Stoner Rock," "Industrial Rock") and on AM "golden oldies" stations where classic hits were treated as ever-lasting, primordial experiences ("Rock Steady," "Rock of Ages"). Coalescing with his faith in the music's enduring value, Robleto's various riffs on the geological connotations of "rock" are sly extrapolations and re-interpretations of its heritage. The simple pun has led him, too, to analyze the music like a scientist. Experimenting with the idea of regeneration through sound-mix and music-related assemblage, Robleto has taken the role of an alchemist whose table of elements is a connoisseur's Top 40. His complex two-part installation, *If We Do Ever Get Any Closer at Cloning Ourselves Please Tell My Scientist-Doctor To Use Motown Records As My Connecting Parts* b/w *The Polar Soul* (1999–2000) (illus. p. 48–51), presents a mad scientist's attempt to decompose and reconstitute the "soul" from Robleto's mother's collection of Motown records. The Detroit record company's assembly-line formula for manufacturing soul music is here dissected into vials of doo-wop vocals, microscope slides of samples of vinyl records, and crushed essences of particular songwriters.

The notion of music as a physical component of life is taken further in *Our Sin Was In Our Hips* (2001–2002) (illus. p. 103), a sculpture consisting of a pair of conjoined skeletal pelvises, the male partly cast from the record collection of Robleto's father, the female from his mother's vinyl. The work plays off the taboo nature of rock and roll for his parents' generation of the 1950s, suggesting that the music's presumed incitement to sexuality impelled Robleto's own creation. He displays the sculpture on the floor, lit with a concert spotlight as if engaged in performance.

In *The Diva Surgery* (2000–2001) (illus. p. 78), Robleto presents a laboratory table with equipment dedicated to distilling the essences of various female singers. Beakers and glass vials labeled "Ella," "Peggy," "Yoko," "Joni," and "Björk" are filled with shavings from vinyl tracks; the glass-enclosed table is loaded with extracts, nutrients, and vinyl and tape samples. Sealed under glass like a diorama in a science museum, the display presents this distillation as an impossible, lunatic task. Despite efforts to isolate their qualities, the female singers' genius exists beyond the glass cabinet and all the efforts of the artist/scientist to define it.

Robleto's gently comic self-questioning of his enterprise grounds the work and pushes his ideas and ambitions further. Some works seem self-motivational tools; *I*

Wanna Rock My Little Honda Across the Universe (2000–2001) is a mirror ball globe made from homemade crystals covered with a mixture of plaster, resin, vinyl from the Beatles' "Across the Universe," and fragments from a 50,000 year old meteorite.

Yet while pop music can provide a kind of world unto itself, Robleto understands the cultural shifts of the past twenty years. Several works mourn the passing of the great performers of the twentieth century and seek their revitalization. In the set of twelve screenprints, *I Miss Everyone Who Has Ever Gone Away (The Suite)* (2000) (illus. p. 53), Robleto altered the cover images of notable live albums by favorite deceased performers (including Miles Davis, Marlene Dietrich, Sun Ra, Ella Fitzgerald, and Charles Mingus), eliminating all text and radically simplifying their graphic design. In Robleto's content-heavy spin on minimalism, this reduction aims to forestall the disappearances of the long-gone performers, symbolized by the bare-bones graphics and simple color designs. The assemblage *Hippies and a Ouija Board (Everyone Needs To Cling to Something)* (2003–2004) (illus. p. 121) conjures the aging of classic pop and the death of 1960s ideals. This work consists of a suitcase cast from human bone dust which holds a Ouija board, various 1960s pop records cast from prehistoric whale bone dust, and a variety of medical bottles filled with homemade health tonics—all that an aging hippie might need to survive.

The graying of baby boomer culture and the end of the heroic age of pop music led Robleto to the war-related work of the past few years. Cast vinyl objects appear in many of the recent works, providing contemporary links with subject matter of the past. *Not All Dead Rather Be Living* (2001–2002) (illus. p. 113), for example, is a set of Civil War era "pain bullets" used by soldiers to bite on during surgery, cast from vinyl tracks of murdered or suicidal rock stars such as John Lennon, Tupac Shakur, Sam Cooke, and Marvin Gaye.

The war works radically shift historical timeframes, using vinyl as a kind of linch-pin to the present. The frames for the spirit photographs in the heartbreaking *Diary of a Resurrectionist (I'll Be Waiting For You)* b/w *A Mourner Learns to Relinquish the Lost* (2004) (illus. p. 108–109) are cast from Jackie Wilson's "Lonely Teardrops" and Irma Thomas's "Time Is On Our Side." The soldier's prosthetic leg and World War I cavalry boots in the stunning installation *A Defeated Soldier Wishes to Walk His Daughter Down the*

Wedding Aisle (2004) (illus. p. 129) are cast, respectively, from the Shirelles' "Soldier Boy" and Skeeter Davis's "The End of the World."

The mythic grandeur, technical accomplishment, comic self-importance, and operatic emotions of pop music have provided Robleto's art with a tone unlike that of almost any other contemporary artist. Sampling and pop music history have enabled him to give new life to some of the most overused tropes of postmodernism—the burden of the past, the image-glut of the digital age, the death of the author, the fragmentation of formal purity. Imbued with good humor and lyrical passion, his works address real issues that have long seemed outside the art world's narrow aegis. In this transition period for music, Robleto's art provides a way to look at pop music from a broader perspective. As he excerpts, transforms, and synthesizes the sounds, he honors the sanctity of the music and keeps the past alive. Without irony, Robleto shows us that rock and roll will never die. And he makes us believe it too.

ROBLETO'S KEY MATERIALS ARE PHYSICAL CARRIERS OF HEARTRENDING HUMAN BEAUTY, COAXED INTO INFUSIONS, REDUCTIONS, AND

CAPTIONS. THE MORE YOU ACCEPT THAT HIS PURPOSE IS SERIOUSLY TO TRY TO SAVE HUMANITY

MATTER-OF-FACT THINGS INTO THINGS GENUINELY MOVING, THINGS THAT CHANGE YOUR HEALTH?

THROUGH THE INVENTION OF MEANING, THE MORE HIS CHOICES OF WITCHCRAFT INGREDIENTS SEEM BRILLIANT, HOW DO YOU MAKE

JENNIFER MICHAEL HECHT

YOU WILL SEE

Be out of sync with your times for just one day,
and you will see how much eternity you contain within you.

−RILKE[1]

1. Rainer Maria Rilke, Diary 1902, in *The Wisdom of Rilke*, ed. and trans. Ulrich Baer (New York: Modern Library, 1905), 10.

Does life have meaning? Apparently not. You live, die, and are forgotten. Daily life is all there is, and daily life is what it seems to be: washing dishes, eating doughnuts, walking dogs.

Yet the wisdom of the ages insists that life is better than death and that poetry is better than silence. Does this wisdom hold up even though its purveyors believed in ghosts?

Sometimes yes: the art of the ages, which claimed only to be decoration for truths, turns out to be the load-bearing wall and holds up just fine without the defunct truths.

Sometimes no: without a solid foundation of ghosts, some areas of the wisdom of the ages cannot hold us up. On matters of life and death we have a major meaning

deficit. Luckily, human beings are technological geniuses. We can make everything else—metal flying machines and working human hearts—so it is reasonable for us to try to make meaning.

When making a thing never made before, a good way to start is by deciding how you will know when you have succeeded. To test if a thing has meaning, we might ask ourselves if we could sleep normally in the same room with it.

Could we sleep in a room with a stack of correspondence from Civil War soldiers? Probably. Now separate out a smaller pile: the letters between a man and a woman who planned to marry after he returned from the war. Now consider that a man researches every biographical detail he can find on the couple, records the letters, looks up every forgotten phrase in them, finds every location mentioned in the letters on a map, imagines the daughter they dreamed of someday dandling on their knees, and then takes the letters and patiently transforms them. He soaks the ink off the letters, fabricates a white cloth out of the paper, and then, with attention and solemnity, uses the cloth to make a small dress, a gift to the daughter who never was born because the soldier never came home from the war. The ink soaked off the letters becomes black ribbon for the dress.

Could we sleep in that bedroom with this dress? I would feel that the unborn girl was there with me in the dark. If I ever got used to such a dress in my bedroom I think it would change my life. When we get used to the dress, the missing girl becomes a presence.

Let's take another example. Consider whether we could sleep normally in a room with a dry pile of human bones. I have listened to those who have had to try it and the consensus is that we can't. Those of us who get used to the presence of human bones are marked by them for life. Yet, I would sleep well next to a birdcage made from every bone in the human body. Such a night might even heal a broken inner wing. Test after test proves it: Robleto is making meaning. How's he doing it?

The artist takes whatever is so sublime it makes your face squint and pucker like you ate a lemon. Billie Holiday for example. There is something special about more obscure beauties, like Skeeter Davis, but if you were tasked to actually make meaning, you wouldn't stint on stunning. You don't stint on Billie Holiday, a perfect ten; even her name beats all for its meaningful valence. A holiday, yes, but with bills.

As for Skeeter Davis, if you don't know her already, go track down a recording of "The End of the World." Here's where Robleto takes it:

A DEFEATED SOLDIER WISHES TO WALK
HIS DAUGHTER DOWN THE WEDDING AISLE, 2004

*Cast of a hand-carved wooden and iron leg that a wounded Civil War
soldier constructed for himself, made from the
Shirelles' "Soldier Boy" melted vinyl records and femur bone dust,
fitted inside a pair of World War I military
cavalry boots made from Skeeter Davis's "The End Of The World"
melted vinyl records, oil can filled with homemade tincture
(gun oil, rose oil, bacteria cultured from the grooves of Negro
prison songs and prison choir records, wormwood,
goldenrod, aloe juice, resurrection plant, apothecary's rose and
bugleweed), brass, rust, dirt from various battlefields,
ballistic gelatin, white rose petals, white rice*

In the installation, the soldier's boots are posed at the end of a trail scraped through ballistic gelatin on the gallery floor (illus. p. 129).

Femur bone dust, and a melted-down vinyl recording of "Soldier Boy" by the Shirelles, to make a cast of a peg leg that a Civil War soldier made for himself. In the Shirelles' song a girl tells her fella, "You were my first love / And you'll be my last love"; she promises to keep his place at home. She says he is the alpha and the omega. Her given reason for this total love (in absentia) is this: "In the whole world / You can love but one girl / Let me be that one girl / For I'll be true to you." You have to pick someone with whom to make a covenant; the argument for making it with me is that I will not break the covenant. In the face of uncertainty the message gets simple. This soldier returned home and made himself a leg to stand on for the sake of his daughter. Women matter in Robleto's world. (Another test for the validity of a paradigm of meaning.)

As for the boots, Skeeter Davis has a girlish, honey voice, eerily happy when singing about "the end." She pronounces the word "end" as "ayned" in a painfully endearing way. Here's some of the lyric:

Why does the sun go on shining?
Why does the sea rush to shore?
Don't they know it's the end of the world,

'Cause you don't love me any more?
Why do the birds go on singing?
Why do the stars glow above?
Don't they know it's the end of the world?
It ended when I lost your love.
I wake up in the morning and I wonder,
Why everything's the same as it was.
I can't understand. No, I can't understand,
How life goes on the way it does.

We are human and the universe is not. Skeeter knows it. Davis hit the top of the pop charts with "The End of the World" in 1963, toured with Elvis Presley and the Rolling Stones, and sang on the Grand Ole Opry radio show for more than forty years. Born Mary Frances Penick, she was nicknamed Skeeter by a grandfather who thought she buzzed around like a mosquito. What kind of girl doesn't shake grandpa's nicknames? Davis came from the suggestively named Dry Ridge, Kentucky. The family moved to another part of Kentucky, and at Dixie Heights High School Skeeter Penick met Betty Jack Davis. They were "instant friends." Both loved to sing and in 1950 they formed a duet: Skeeter took Betty Jack Davis's name and they were the Davis Sisters. Their single was doing well and they were touring, but in 1953 a car wreck critically injured Skeeter and killed Betty Jack. Skeeter Davis went on to write more than seventy songs over her long career near the top. She won awards but wasn't the hit she wanted to be. She was a kind of flower-child-devout-Christian. She had some bad luck and her songs often came in second place: her best songs coincided with those of Patsy Cline. She died in 2004.[2]

The Civil War soldier made himself a leg to walk into the world of his daughter. To hold such a leg, boots need to be something other than leather. Robleto melts down vinyl recordings of Skeeter Davis's elegiac song and makes them boots. *A Defeated Soldier Wishes...*, as so much of Robleto's work, distills dregs and remnants of a strenuous effort made by someone long gone. Here it is in a tincture brewed with "bacteria cultured from the grooves of Negro prison songs and prison choir records."

Robleto's key materials are physical carriers of heartrending human beauty,

2. For more on Skeeter Davis, see her own *Bus fare to Kentucky: The Autobiography of Skeeter Davis* (Secaucus, New Jersey: Carol Publishing, 1993).

coaxed into infusions, reductions, and captions. The more you accept that his purpose is seriously to try to save humanity through the invention of meaning, the more his choices of witchcraft ingredients seem brilliant. How do you make matter-of-fact things into things genuinely moving, things that change your health? The more desperately serious you are, the more clear the call to use things reputed strangely potent. Robleto tackles the impossible task of making sacred things. The elixirs and enchanted colloids make intimate actions. To bring on insomnia is to awaken, and the soporific helps us rest. So does the lullaby.

If an object makes a person feel like breathing, it suggests that a hole in meaning has been patched. We should have a national registry to keep track of art that can save. Robleto's objects would ring that bell all day and night. Consider this work:

YOUR LULLABY WILL FIND A HOME IN MY HEAD, 2005

Hair braids made from a stretched and curled audiotape
recording of Sylvia Plath reciting "November Graveyard,"
homemade paper (pulp made from soldiers' letters
to mothers and daughters from various wars, ink retrieved from
letters, sepia), excavated and melted bullet lead,
carved ribcage bone and ivory, mourning dress fabric and thread,
silk, mourning frame from another's loss, walnut, glass.

The poem of the caption is great. The object imagined from the caption is very great indeed. When Plath reads "November Graveyard" her mouth on the words is chewy, nougaty, a schoolmarm-clipped perfection but with just too much sponginess on every final consonant.[3] An extreme commitment to every last sound.

3. For Plath reading her poem, one site is: www.salon.com/audio/2000/10/05/plath/

November Graveyard

The scene stands stubborn: skinflint trees
Hoard last year's leaves, won't mourn, wear sackcloth, or turn
To elegiac dryads, and dour grass
Guards the hard-hearted emerald of its grassiness
However the grandiloquent mind may scorn
Such poverty. No dead men's cries

Flower forget-me-nots between the stones
Paving this grave ground. Here's honest rot
To unpick the elaborate heart, pare bone
Free of the fictive vein. When one stark skeleton
Bulks real, all saint's tongues fall quiet:
Flies watch no resurrections in the sun.

At the essential landscape stare, stare
Till your eyes foist a vision dazzling on the wind:
Whatever lost ghosts flare
Damned, howling in their shrouds across the moor
Rave on the leash of the starving mind
Which peoples the bare room, the blank, untenanted air.

What Plath says here is that even though we love whatever is moving, elegiac, grandiloquent-minded, saintly, resurrecting, dazzling, flaring, howling, and raving on a leash, the fact is that the world stands stubborn, skinflint, hoards, won't mourn, dour, guarded, hard-hearted, unpicked, free of fiction. If you peer into a tomb and see a skeleton, it knocks out of your head all the pretty ideas about saints. It is flies, not resurrection in the sun. Still, if you stare hard, you'll see a vision, but whatever lost ghosts you see simply rave on the leash of your hungry mind, which populates the empty air. The transcendent part is that she says the world is not even magical enough to have the spirit of the dead exude up through the paving stones of the graveyard as forget-me-not flowers. Let alone resurrection. Let alone remembered. Yet with what care has she remembered them. Isn't dark Sylvia a forget-me-not? Then Robleto spins that thin, to make a thread, to make braids as a forget-me-not to a girl, and makes her a bow of paper made from soldiers letters from various wars, and puts these plaits into a used mourning frame, lined with an old mourning dress. Braid is a verb; it gathers and blends.

I began this essay with a quotation from the great nineteenth-century poet and letter writer, Rainer Marie Rilke, and I did so with this next quotation in mind:

If we wish to be let in on the secrets of life, we must be mindful of two things:
first, there is the great melody to which things and scents, feelings and past

lives, dawns and dreams contribute in equal measure, and then there are the individual voices that complete and perfect this full chorus. And to establish the basis for a work of art, that is, for an image of life lived more deeply, lived more than life as it is lived today, and as the possibility that it remains throughout the ages, we have to adjust and set into their proper relation these two voices: the one belonging to a specific moment and the other to the group of people living in it.[4]

4. Rainer Maria Rilke, Diary 1898, in *The Wisdom of Rilke*, ed. and trans. Ulrich Baer (New York: Modern Library, 1905), 7.

That is what Robleto is mastering. The strategy is both obscure and plain as day.

When we need a copy of something found in nature, like meaning or anything else, we usually start by mirroring the natural form of the original. The first airplanes had bird-wings, and flapped furiously. The first artificial hearts were stretchy, contracting bags. Then someone realizes the essence of the thing is the aerodynamics and the pumping. Making meaning the way it used to look when it was natural and naive works a little, but we are going to have to see past the way meaning looked in nature and realize something new about its essence. Something Robleto is doing makes his installations and objects have a heartbeat and fly around the sky carrying passengers.

Really, meaning has never been in sufficient supply on matters of life and death, even when cultures almost uniformly believe a single legend: when someone very close dies, even true believers will cock an eye of bitter resolve if you start to talk about an afterlife. They know that they are never seeing that person again. Later, when they have become grateful for very small things, the message of a leaf falling off a tree, they see how, in fact, they were wrong: they will never stop seeing that person. But in cosmopolitan, rationalist times like our own, there are keen deficits in strong meaning. There is a history of artists and scholars facing doubt, nurturing it and learning it, and healing its rifts, and Robleto has joined their number.

Can you name your four grandparents' mothers? Don't feel bad; barely anyone can—yet that is your own family, only a generation away from people who mean the world to you. Worse than individual nihilism is the fact that human life on Earth so teems with wriggling souls, each announcing, "I am!" and many of them suffering unspeakably. As the Zen monks throat-sing, "Sentient beings are numberless, I vow to save them." For the genius of Robleto, we need Rilke again:

It is rare that something very great is condensed into a thing that can be held en-
tirely in one hand, in one's own, impotent hand. It is like finding a tiny bird dying
of thirst. You draw it from the edge of death, and the little heartbeats increase
slowly in your hand, as if they were a wave at the edge of a giant ocean and you
are the shore. And you suddenly realize, while holding this little recovering ani-
mal, that life is recovering from death. And you hold it up. Generations of birds,
all their forests, and all the skies into which they will rise. And is any of this easy?
No: you are very strong to carry the heaviest burden in such an hour.[5]

5. Rainer Maria Rilke, "Letter to Otto Modersohn, October 23, 1900," in *The Wisdom of Rilke*, ed. and trans. Ulrich Baer (trans. adjusted by the author) (New York: Modern Library, 1905), 9.

Robleto has said that he writes the pieces as poetry first, letting the justness of the words dictate the caption, the materials. The beauty of the words comes first, then he finds the items he has named. Think of the commitment to the just word that this entails: the sound of it has to be so right that the item becomes a necessity.

Here is a meaning test for items that are small and sweet and do not much affect sleep: if everyone in the world were gone but you, would you still carry this object in the precise cup of your hand, as you would carry a bird? Do you carry it in a way that is matter of fact? Or in a way that is a matter of life and death? Even with all humanity gone, the last person would carry Robleto's small sweet totems with honest reverence. In the case of *Men Are The New Women* (2002) (illus. p. 77), in Robleto's words, "A female ribcage bone was ground to dust then recast and carved as a male ribcage bone." Another small object is *The Creative Potential Of Disease* (2004) (illus. p. 143), in which, again in Robleto's words, "A self-portrait doll made by a Civil War Union soldier amputee while recovering in the hospital, mended..."—mended with precious substances and processes so that the small sweet object fairly buzzes with sense.

Birth, family, and death. A baby's white-and-black paper dress, the boots of a one-legged man scraping down his child's wedding aisle, the braids of a November graveyard. I'm sure you know different things than I do about all of this, about the art, or the dead, or undead. I'm here to say that I like this art a great deal. It takes objects back and forth from matter of fact to matter of life and death.

In Mary Shelley's famous book, her monster howls at Victor Frankenstein, his maker, "How dare you sport thus with life?" The answer is that we must dare; someone must dare go to the laboratory and sport thus with life. The other question is how, and the answer to that seems to be: very carefully.

ROBIN HELD

HEAVEN IS BEING A MEMORY TO OTHERS

From an imaginary, time-traveling soldier-narrator comes this diary entry, dated 2 December 1899: "From some long lost radio signal I hear you say, 'Please don't let me fade from your heart. I don't want to die a second time.' Suddenly the words to all the love songs start making sense. So for now, heaven is being a memory to others. And the sky, once choked with stars, will slowly darken."[1]

This passage forms a hinge between the 2006 exhibition *The Gospel of Lead: Dario Robleto and Jeremy Blake*, in which this text first appeared, and the 2008 exhibition, *Heaven Is Being a Memory to Others*. Presented with the traveling exhibition *Dario Robleto: Alloy of Love*, a survey of the artist's work, *Heaven* is a collaborative exhibition project conceived especially for the Frye Art Museum in Seattle, Washington. It is a project that showcases Robleto's own work while taking the unique history of the Frye and its collection as its starting point.

The tale of *Heaven Is Being a Memory to Others* begins, oddly enough, back in

1. *The Gospel of Lead* (Austin, Texas: Arthouse at the Jones Center, 2006), 29. All diary entries written by Dario Robleto.

1893, when Charles and Emma Frye took the leap from art viewing to art collecting. After their first purchase, they never turned back; over the next thirty years, the couple's collection grew exponentially. The Fryes left their private collection as a gift to the city of Seattle upon their deaths, and in 1952, the Frye Art Museum, the city's only free art museum, opened to showcase this art. For many years, from 1952 to 2007, the museum treated these works, the Frye Founding Collection, like a fly in amber, never exhibiting the Fryes' paintings with other works from the museum's collections or with loaned art. But since 2004, one of the new mandates at the Frye is to revitalize the Founding Collection, making it relevant for contemporary audiences and finding new ways of honoring and extending the legacy of Charles and Emma Frye. *Heaven* is an important part of this endeavor.

The story of the Fryes and their collection proves integral to *Heaven*. Charles Frye and Emma Lamp were both first-generation Americans of German descent. Born in Iowa, they settled in Seattle in 1888 and built their fortune in agriculture, livestock, meatpacking, and real estate. Both Fryes were civic-minded; in addition to serving on arts boards, Charles was a trustee of the Seattle Pulmonary Hospital, and both he and Emma hosted concerts in their home for the Seattle Music and Art Foundation.

The couple's most significant and lasting contribution to the region, however, was their private art collection. Over several decades, the Fryes amassed hundreds of paintings and in 1915 built an addition to their home, a picture gallery open to invited guests and special groups.

In building their art collection, Charles and Emma Frye were true partners. They acquired their first painting in Chicago, at the 1893 World's Columbian Exposition. In subsequent decades, the Fryes made several trips to Europe, buying from galleries and often directly from artists in their studios.

Reflecting the Fryes' interest in their German heritage, the collection focused on works by two generations of Munich artists from the nineteenth and early twentieth centuries, a period when Munich was a center of technical and stylistic innovation. The Fryes favored artists such as Franz von Lenbach

(1836–1904), a portraitist of the German elite and member of the Munich Academy, but also collected artists like Symbolist Franz von Stuck (1863–1928), one of the founders, in 1892, of the Munich Secession, a younger, internationalist group committed to the cross-cultural exchange of ideas, technical innovations, and the embrace of a wide variety of modern styles.

Beginning in 1930, the Depression forced Charles to return his full attention to his businesses. He stopped purchasing art after Emma died in 1934, and died himself in 1940.

In 1952, the Charles and Emma Frye Free Public Art Museum opened its doors, thanks in large part to Walser Greathouse, executor of the Frye Estate and the museum's first director. Greathouse complemented the Founding Collection of primarily German paintings by acquiring many fine nineteenth- and early-twentieth-century American works. With several galleries devoted to its permanent exhibition, the Founding Collection remains an integral part of the Frye Art Museum's identity.

2. *Gene(sis): Contemporary Art Explores Human Genomics*, at the Henry Art Gallery, University of Washington, spring 2002, explored the impact of genomics on artistic practice and our notion of the artist; biological art; and genetic and genomic research, which provides new tools, new materials, and new issues for critical consideration by artists. Key works were new transgenic life forms created by artists as art. *Gene(sis)* was the first museum exhibition to be registered with the National Institutes of Health as laboratory activity. The exhibition traveled to the University of California, Berkeley, Art Museum (fall 2003); the University of Minnesota, Frederick Weisman Museum of Art (spring 2004); and Northwestern University, Block Museum of Art (fall 2004). In the Seattle and Minneapolis presentations, artist Justin Boyd animated Robleto's artwork with a live performance.

IF WE DO EVER GET ANY CLOSER...

The story of *Heaven Is Being a Memory to Others* now jumps to 2001, when Dario Robleto exhibited in *Gene(sis): Contemporary Art Explores Human Genomics*, a show of recent work by artists engaged with the ideas, tools, and materials of human genomics at the University of Washington's Henry Art Gallery.[2] For the exhibition, Robleto created a "dance mix" version of his 1999–2000 sculpture *If We Do Ever Get Any Closer At Cloning Ourselves Please Tell My Scientist-Doctor To Use Motown Records As My Connecting Parts* b/w *The Polar Soul* (fig. 4) (illus. p. 48–51), a work destroyed in a flood. The new version of *If We Do Ever Get Any Closer*, completed in 2002, was a key component of *Gene(sis)*.

If We Do Ever Get Any Closer is a contemporary meditation on family love, memory, immortality, and soul, in all of that word's connotations. This imaginary cloning chamber has an A side, a large cabinet of curious ingredients, including toy

FAR LEFT: Henry Raschen (1854–1937), *Emma Lamp Frye*, 1913
Oil on fabric, 85½ x 48¼ inches, Charles and Emma Frye Collection,
Frye Art Museum, Seattle, Washington, 1952.132

LEFT: Henry Raschen (1854–1937), *Charles H. Frye*, 1913
Oil on fabric, 85½ x 48½ inches, Charles and Emma Frye Collection,
Frye Art Museum, Seattle, Washington, 1952.129

TOP: Franz von Lenbach (1836–1904), *Otto von Bismarck*, 1896
Oil on fabric, 37½ x 33½ inches, Charles and Emma Frye Collection,
Frye Art Museum, Seattle, Washington, 1952.090

medical equipment, biological specimens, melted Motown records, a "Soul Separator" in which a DJ's turntable serves as a centrifuge, and a drop of the artist's own blood. Backing this A side, a B side offers a heavenly stage, flanked with rows of homemade blue crystals of varying size and complexity, where a live DJ/scientist in a lab coat mixes at his turntables. Robleto imagines—with the help of Motown's best songstresses and a geneticist's big dreams—a procedure for distilling and extracting a soul's essence from vinyl records and transferring it to a realm beyond, perhaps creating new life in the process.

The records in *If We Do Ever Get Any Closer* belonged to Robleto's mother before he imaginatively recycled them. As a boy, he listened to them again and again with his mother. These highly charged objects, now melted and remixed, not only become catalysts for memory but also provide a DNA library of two generations, the vinyl grooves retaining skin cells and oils, hair, and other minute biological residues from both mother and son. Like a DJ or a geneticist, Robleto pursues a recombinant practice, taking samples from science and popular culture and splicing them together in new ways.

If We Do Ever Get Any Closer engages notions of soul and self, life and afterlife, music and science, biology and geology, memory and identity, and myths of origin and authorship.[3] The work provides several insights on his conceptual framework and artistic process.

First, Robleto's approach demonstrates an awareness of the fluid performativity of a viewer's relationship with a beloved artwork, a sensitivity he shares with certain curators and art historians. In his sculptures that materially engage the songs of pop legends, like Billie Holiday in *Sometimes Billie Is All That Holds Me Together* (1998) (illus. p. 26), or Patsy Cline in *Untitled* (1998–99) (illus. p. 23), Robleto pointedly omits the experience of hearing their recordings. The artist recognizes that as listeners (and as viewers), we all bring our own perspectives, customs, knowledge, vulnerabilities, and memories to our experience of an artwork. This subjectivity applies to the experience of a sculpture as well as a song, whether in a first encounter or a repeat performance. As Robleto insists, "My Patsy Cline will always be different from your Patsy Cline."[4]

Second, Robleto embraces the philosophy of sampling, which recognizes the cultural permeability of ideas and objects, and therefore is "as much an act of quo-

3. See Paola Morsiani, "Dario Robleto. The Difficult Art of Being a Fan," in *Dario Robleto: I Thought I Knew Negation until You Said Goodbye* (Houston: Contemporary Arts Museum Houston, 2001), 5–18.

4. In conversation with the artist, spring 2007.

5. Morsiani, "Dario Robleto," 12. Published quotes by the artist further demonstrate this understanding. For example: "Songs are liquid: never dead and never a finished entity," "A [pop song's] meaning is utterly permeable to the culture that plays and recycles it," and "As in DJ music compositions, ...the function of the listener and the composer become more deeply entwined with each other than ever before... until consumer and author become interchangeable." Morsiani, "Dario Robleto," 6.

6. E-mail correspondence with the artist, fall 2007.

7. Morsiani, "Dario Robleto," 12.

tation as of creation."[5] This implies a fluid mode of authorship as well as an ethical stance toward materials and history that permits Robleto to transform and reuse these charged materials, as long as he also respects their histories and preserves their power. His understanding of sampling displaces traditional notions of authorship, origin, and collaboration, dispersing them over both past and present.

The survey exhibition, *Alloy of Love*, demonstrates Robleto's theory and practice of sampling in his art of the last ten years, perhaps most visibly in his work engaging American histories of war, love, and loss. For example, for the 2005 sculpture *No One Has a Monopoly Over Sorrow* (illus. p. 151), the artist collected finger bones, adorning them with wedding rings, mourning dress fabric, melted shrapnel, and dried chrysanthemums. For this ongoing body of work, Robleto taught himself multiple funereal arts, including the weaving of dead loved ones' hair into flowers and wreaths, first learned by generations of anonymous nineteenth-century schoolgirls.

Third, Robleto thinks like a perceptive historian combined with the most seductive of storytellers. Take, for example, his notion of "historical empathy." This idea conveys the artist's anxiety about creeping historical amnesia, to which we all fall prey. The concept prescribes a commitment to a re-engagement with, even a re-enchantment of, the past as a tonic against such forgetting. It also bears a sense of personal responsibility for seeking out and sympathizing with another era's hopes and losses through its people's stories and materials. It essentially embraces both past and present rather than obsessively focusing on the new.[6]

Finally, Robleto's analogies between how DJs create music and how viewers experience an artwork develop his understanding of the nuances of exhibition formats. Curator Paola Morisani quotes Robleto's ideas about the dance floor as a special zone, an observation that extends to the museum gallery: "The disco floor is a place of heightened attention, even altered consciousness, intermittent light altering our perception of the objects, creating the heightened sensitivity aspired to by dance-club consciousness."[7] Robleto's work transforms the gallery into such a zone of extraordinary perception, as demonstrated by his ambitious, pivotal project, *The Gospel of Lead: Dario Robleto and Jeremy Blake.*

he soldier-narrator of *Heaven Is Being a Memory to Others* and *The Gospel of Lead* takes us underground in the diary entry dated 2 December: "Battlefields are remarkable works of alchemy. Down here spines intertwine all the time. The past sutures itself to the present. This other kingdom, down below with its gospel of lead. You will bare your buried prayers."[8]

Austin, Texas's Arthouse was the site of *The Gospel of Lead*, an experimental exhibition project including works by Robleto and Jeremy Blake, a digital installation artist who tragically died in 2007. Sue Graze, director of Arthouse, called the exhibition "a rare and generous occurrence";[9] indeed, by all accounts, intellectual and creative generosity and a great deal of trust among the key players characterized this unusually collaborative project. For exhibition curator Regine Basha, *The Gospel of Lead* provided an opportunity to consider "how an exhibition could learn from and possibly contribute to genres such as the re-mix, the opera, the fable, the epic, the memorial, the curiosity cabinet, the magic show, and...the phantasmagoria."[10] Most of all, the presentation explored the exhibition form as a site of redemption.

Basha initiated the conversation with artist Robleto; Robleto selected artist Jeremy Blake to participate. Blake, at Robleto's request, loaned arguably his most renowned artwork to Arthouse and stayed at a remove from the project, trusting his colleagues to act in their mutual interest.

Blake's *Winchester* trilogy (2002–2004) anchored *The Gospel of Lead* installation. The trilogy is based on what has become known as the Winchester Mystery House, and projects one segment of a digital, painterly portrait in each of three darkened galleries shrouded in velvet curtains.[11] Sarah Winchester, widow of the heir to the Winchester Rifle Company fortune, built this Victorian mansion in San Jose, California, in 1884 as a memorial to her husband and baby. A psychic persuaded her that completing the house would reverse her tragic luck by placating the souls of those killed by Winchester rifles. Directed by spirits, she designed basements and towers, ballrooms and bedrooms, forty-seven fireplaces, miles of dark hallways, doors opening onto walls, and stairs that rise to the ceiling. Sarah Winchester devoted the remainder of her life

8. *The Gospel of Lead*, 29.

9. Sue Graze, "Foreword," in ibid., 3.

10. Regine Bahsa, "Durational Aesthetics in Dario Robleto and Jeremy Blake," in ibid., 5.

11. The complete *Winchester* trilogy was presented for the first time as a projected triptych in 2005 at the San Francisco Museum of Modern Art. See www.winchestermysteryhouse.com for details about the mansion, its history, and its myths.

to the house's construction, completing 160 rooms by her death in 1922.

Blake's opulent animated trilogy features historical film footage and luscious hand-painted imagery. It uses the story of this performative architecture and Sarah Winchester's obsession to explore larger themes of creation and destruction, sanity and madness, the westward drive of manifest destiny, the confinement of guilt, and the quest for absolution.

The Winchester trilogy—composed of *Winchester* (2002), *1906* (2003), and *Century 21* (2004)—became not only a point of departure for the exhibition but also "a guiding principle" for Robleto's complex and nuanced contribution. His offering included a remix of artworks from his *Southern Bacteria* series (2003–2006), also a trilogy, and new sculptures created in response to the occasion and to Blake's art.[12] Finally, Robleto collaborated with Basha on the *Gospel of Lead* installation itself, which was intended to allow Robleto's art to enhance, envelope, and infiltrate Blake's art. The visually compelling and conceptually rich exhibition exceeded everyone's expectations, the whole work greater than the sum of its three collaborators' contributions.

Robleto's *Southern Bacteria* is a series of poetic reliquaries that go beyond simply commemorating loss to physically embodying sorrow, mourning, memory, and the legacies of violence. The protagonist of the artist's rich narrative, as elaborate as the story of Sarah Winchester and her Mystery House, is an unnamed Civil War soldier whose diary entries have appeared above. This lost and uneasy spirit is never corporeally present or fixed in time; he is "a narrator unrolled with the narrative."[13] He travels but has no destination, guided only by his hunger to make meaning of war's devastations and to find deliverance for those who have suffered and died—including perhaps himself—as well as the loved ones left behind.

Dense, multivalent narratives emerged in the mixing of the *Southern Bacteria* series and the Winchester trilogy. Robleto's imagined soldier seemed to take up residence in Sarah Winchester's redemptive project—in her physical home and even in her mind. Perhaps he represented a long-lost lover, or a new beloved helping her imagine a future rather than try to perfect the past, or perhaps just another of the countless murdered soldiers, Native Americans, and civilians whose burdens she must manage. Sometimes his voice mingles with the widow Winchester's; the diary

12. Robleto's strategies of sampling and remixing make precise dating of his artworks difficult. I use these dates for the *Southern Bacteria* series because they encompass all key sites of its public elaboration in Los Angeles; Paris; New York; Greensboro, North Carolina; and Ridgefield, Connecticut. Robleto's *Southern Bacteria* trilogy has since expanded to encompass *Chrysanthemum Anthems*; the artist considers the four-part project complete and refers to it in whole as *Chrysanthemum Anthems*.

13. This is Trinh T Minh-ha's apt description of a storyteller who does not impose a tale on a reader, an anti-colonizing strategy. See "All-Owning Spectatorship," in Trinh, *When the Moon Waxes Red: Representation, Gender, and Cultural Politics* (New York: Routledge, 1991), 81–105.

entries may be as much hers as his.

Robleto's *A Color God Never Made* (2004–2005) (illus. p. 159) was positioned in the center of the first gallery. A man's vanity case cast and carved from de-carbonized bone dust and bone calcium sits atop an oak altar. The velvet-lined drawers of the case contain personal effects, itemized poetically on the accompanying label. Contents include "fragment of a soldier's letter home, woven human hair of a war widow, ... soldier-made clay marbles, battlefield dirt, cast bronze teeth."[14]

This cabinet of curiosities supports the most deeply prized of objects, nestled in a velvet-lined box within a velvet-lined box: two glass eyeballs, one brown, the other blue, in human eyes a genetic mutation.[15] The label identifies the artificial eyes as "military-issued glass eyes for wounded soldiers, coated with trinitite (glass produced during the first atomic test explosion, when heat from the blast melted surrounding sand)."[16] These "blind eyes," which have witnessed so much, stare up at viewers, implicating them in wars of the past, those being waged now, and those still in the future. Above these eyes hangs a cracked mirror, presumably "a soldier's personal mirror, salvaged from a battlefield."[17] It reflects the sumptuous and hallucinatory images of Blake's Winchester projection, joining the two artworks.

In the third gallery, the story continues in a diary entry by Robleto's soldier, dated 6 November 1897. Here the veteran details his deteriorating body and spirit, musing on faith, doubt, and patriotism, and recounting memories of a lover left behind. He says his eyes have turned "a color God never made," a transformation—physical and metaphorical—caused by the horrors he has witnessed.

This complex layering of meaning and authorial roles exemplifies a strategy Robleto uses throughout *The Gospel of Lead*. Basha noted how this strategy "amalgamates [both artists'] narratives and materializes their possible tangents."[18] Overall, the exhibition offered an opportunity to reconsider both artists' work together, while emphasizing the reciprocal relationship that exists between viewers and artworks.

14. *The Gospel of Lead*, 15.

15. This color combination might also refer to country singer Crystal Gayle's hit "Don't It Make My Brown Eyes Blue" (1977) and her follow-up, "I've Cried (the Blue Right Out of My Eyes)" (1978).

16. *The Gospel of Lead*, 15.

17. Ibid.

18. Basha, "Durational Aesthetics," 7.

The story of *Heaven Is Being a Memory to Others* now hurtles back to 1860 and the birth of Emma Dorothea Lamp, a woman who intrigues Robleto and about whom we know very little.[19] Born to a wealthy German farming family in Scott County, Iowa, Emma attended Catholic boarding school, where she developed a lifelong passion for fine embroidery and other crafts. Emma married Charles in 1885, and joined him in Montana, where he had ventured to seek his fortune. While in Montana, Emma suffered a miscarriage; afterward the Fryes would remain childless. In 1888, business prospects lured the couple to Seattle, where they lived for the rest of their lives. Emma's name lives on, along with her husband's, in the Charles and Emma Frye Free Public Art Museum.

In addition to paintings, Emma collected fine linens, lace, first editions of books, and Persian rugs. A bright woman, she was an excellent mathematician and subscribed to French and German newspapers. She played a key role not only in acquiring artworks but also in arranging them in the Frye home; she also managed the collection, directing its care and cleaning and selecting the frames.

The story of *Heaven* continues through Robleto's fascination with what we don't know about Emma, which engaged his longstanding obsession with manifestations of longing, loss, and memory. He imagined Emma in her multiple possible roles: lover, bride, wife, thwarted mother, music lover, art collector, hostess, and civic benefactress.

Robleto searched archives, read letters, visited Emma's grave, and tracked down the player organ, currently dismantled, that played music from punched-paper rolls in the Fryes' home gallery. The *Heaven* exhibition will feature the instrument, fully restored—it had likely kept its silence since the 1930s, when it played for the Fryes' evening waltzes. Records show that the Fryes hung a favorite painting, *Study for the Death of Mozart* (illus. this page), by Mihály von Munkácsy (1844–1900), near the organ, a curatorial decision and meditation on the themes of art and music that *Heaven* will maintain.

Robleto spent much time with Charles and Emma Frye's collection, becoming acquainted with the many paintings Emma

19. Details of Emma Lamp Frye's biography come from several unpublished sources: author unknown, "Interview with Joshua Green, Sr.," undated, unpaginated; Louisa Rier, "Charles and Emma Frye," undated, unpaginated; correspondence between Betty Lenz, Frye & Company, and Nelle Seaman Vogt, niece of Charles and Emma Frye, June and July 1951. Also, author unknown, "Story of Charles and Emma Frye," *The National Cyclopaedia of American Biography* (New York: James T. White, 1954), unpaginated photocopy.

20. *The Gospel of Lead*, 11.

Mihály von Munkácsy (1844–1900), *Study for the Death of Mozart*, 1884
Oil on panel, 18 x 14¾ inches, Charles and Emma
Frye Collection, Frye Art Museum, Seattle, Washington, 1952.124

had cared for. In conversation he said he wanted to "know the collection through her eyes, through her history." The checklist for *Heaven Is Being a Memory to Others* includes many nineteenth-century paintings from the Frye Collection, including psychologically charged portraits of heroes and socialites by Franz von Lenbach; Romantic images of women by Gabriel Cornelius Ritter von Max (1840–1915); and sentimental depictions of children by Ludwig Zumbusch (1861–1927). Selected portrait studies and bronze busts of the couple by various artists suggest how the Fryes wanted to present themselves to the world.

Robleto started with the question "How is immortality imagined?" and used the Founding Collection Galleries' floor plan as a basis for the spatial and conceptual plan for *Heaven Is Being a Memory to Others*. In this sketch, each of the three galleries looks at the theme of immortality from a different vantage point: that of a lover, of a soldier, and of an artist or a collector. Each also considers perspectives from various life stages: among them child, cadet, bride, father, widow, and elderly parent. Young lovers might live in ignorance of death but later build a family to continue their love and legacy; a soldier lives according to codes of honor and might find meaning in war through a military lineage; a composer imagines his or her music echoing in performance eons after its creator's death; an art collector might see longevity in a museum bearing his or her name and preserving cherished works.

The sketch recognizes that these are not mutually exclusive domains; the larger concepts of love, war, and art cross all boundaries, conceptually linking narratives throughout the galleries and through Robleto's *Alloy of Love*, presented in adjacent galleries. Emma came up often in discussions of possible directions for *Heaven Is Being a Memory to Others*. Robleto wondered if her collecting impulses might have come from the loss of her child. Did she long to care for another? Might her desires to love a child manifest themselves in an art collection? Is the collection her "living legacy," like the child who was never born?

As *Heaven* takes us forward to 2008, Robleto's new sculptural works for the exhibition take his imagined Emma, the Frye Founding Collection, and the themes of love, war, and art as points of departure. He has talked at length about proposed works to be juxtaposed with paintings from the Founding Collection.

One sculpture, titled *The Boundary of Life Is Quietly Crossed*, stems from the artist's curiosity about super-centenarians, people who live beyond 110 years of age, approximately twenty of whom are alive today. The eldest of these, in a sense, carries the torch at the extreme edge of human longevity. When they die, obituaries for these super-centenarians always mention—along with the usual biographical details and lists of surviving loved ones—the next oldest living person to whom the torch has been passed.

Robleto has long been intrigued by Victorian memorial objects and the obituary form. He imagines *The Boundary of Life* as a catalogue of these super-centenarians, of loved ones now deceased, of a torch now passed. Keeping the love alive after the beloved's death becomes the work of the archivist, the obituary writer. A large case displays a row of memorial objects, framed death notices and hair lockets made from melted and stretched recordings of the super-centenarian's voices, each one archiving the eldest, the next eldest, and the eldest after that. Current sketches position the work near Gabriel Cornelius Ritter von Max's *Soap Bubbles* (1880) (illus. this page), in which a beautiful young woman gazes at her reflection in a mirror while a mischievous angel blows soap bubbles at her image. This painting, a *vanitas*, reminds us how rarely a youth's thoughts might stray toward mortality, when in fact the one certainty is that life is uncertain.

A fitting question comes again from the soldier-narrator, or the widow Winchester, or both, from a diary entry dated 6 November 1897: "My gray matter is always blue and the melancholic in me refuses to surrender. Tragic optimist. There is an instinct toward life only a phantom can know. Read again today how God has not made Death. Deep down I don't believe in hymns. Anyway, my soul is rarely with me anymore. What have I done with my baptism? With a faith clinging to me that won't face the facts. Can't believe in anything meant to be now. How many times can you be born again?"[20]

20. *The Gospel of Lead*, 11.

IAN BERRY

MEDICINE ON THE SPOON

A DIALOGUE WITH
DARIO ROBLETO

IAN BERRY: *Let's start by talking about a recent sculpture,* No One Has a Monopoly Over Sorrow *(illus. p. 151). Tell me about the materials that are in this piece. What is it, physically?*

DARIO ROBLETO: Not everything is what it seems in my work and this is a great example. You are looking at the ring fingers from male hand bones. The finger bones are coated with melted bullet lead and shrapnel that has been excavated from various American battlefields, and on each finger is an actual wedding band that has also been excavated from those sites. When I describe these battlefields as "various" I mean that in terms of both location and through time.

IB: *How do you mean "through time"?*

DR: The objects and artifacts that I use can come from any American conflict, like the Civil War or the Korean War, so it ranges in place and time. That's an important factor for me.

IB: *These objects are excavated by you?*

DR: No, not these specifically. For some works I have done the finding myself, but I did not excavate the rings or the bones for this piece. The basket itself is made from melted bullet lead and shrapnel as well; it has rusted, which is what gives it that strange patina. The last layer of material is the bouquet that the rings are sitting on: white calla lilies, roses, and dried chrysanthemums, all coated in wax. This comes from a practice still done today, but which peaked in the nineteenth century—preserving your bridal bouquet by dipping it in wax. Like the other materials, these flowers travel through place and time. A chrysanthemum from a bridal bouquet from the Civil War might be next to one from the Spanish American War era. The fabric that hangs over the edge of the basket is made from the lining of a mourning dress, which was also a nineteenth-century custom. There were very strict customs about how women in particular were expected to show their mourning publicly by the way they dressed. The hair flowers have also been plucked through time and place—these are all hair flowers that were braided by war widows and mended by me. So the sculpture brings together the materials of the battlefield and the materials of the home front. One can only exist because of the other. For example, the hair for the hair flowers would come from a lock of hair a soldier would leave behind before going off to battle. Only after receiving notification that the soldier had died would the widow braid the hair into these intricate flowers. I am interested in materials that exist solely because of these very dramatic moments in history.

IB: *You don't tell us which wars these are from—it's not about the specific details of each one of these wars. You give us a lot of specifics about the materials but not all the history behind them.*

DR: That comes down to the role of my "liner notes," which is how I refer to my captions, my titles and lists of materials. It's real poetry at this point. I'm constantly balancing how much information to provide to the viewer and asking myself, "How much is too much?"

I like the directness that comes from listing "bullet lead excavated from various battlefields," rather than giving a long inventory of each war. That supplementary information is crucial to me because I need to know all of that when I'm making the work, but it's not necessarily as important for the viewer. For me, the issue involves responsibility and respect. It is very important to me to honor the materials I

use, which means I need to know them inside and out. I do have this information and consider it while I am making my work, but when the material is fully incorporated into a new artwork it becomes supplementary.

The oral storytelling tradition comes into play around this idea. The ephemeral quality of this tradition fits nicely with many of my themes. I have always loved that an oral tradition requires a responsibility from the listener and that the fate of a story hinges on others participating. This fragile mode of communication suits my work.

IB: *Is it important to know that these are, or are not, portraits of specific people or specific wars?*

DR: Well, it's usually both. *No One Has a Monopoly Over Sorrow* is based on a story that has fallen through the cracks of history. The First World War brought with it an unprecedented level of destruction. For the first time in history, you could literally destroy a whole person on the battlefield, leaving nothing behind. This threw mourning customs into havoc, especially for people in some of the Catholic countries who had so much invested in mourning a body, or properly burying something. It led to a moment in which a whole generation of families did not know how to mourn properly and were torn apart by it. I'm drawn to these beautiful moments when people rise up to fill a hole that has been created by tragedy. Apparently, during World War I, a group of French women petitioned the government to do something about that fact that they had nothing of their loved ones to bury; they said, "Please send someone back out on that battlefield and bring us home something, anything, a fragment of their uniform, their rings, anything—we need to bury something." When the government did not move quickly enough a group of women decided to do it themselves. When I heard this story I imagined one infantry front moving across the battlefield, creating a wave of destruction, and the family members, the women, behind, slowly picking through that debris to bring something home. Soon they realized there was no way to know whose object belonged to whom. They might find a wedding band, but it would be in such a state of damage that there was no way to know—is this my husband's, my brother's, my father's?

IB: *The objects were anonymous in a way.*

DR: It produced an important shift in mourning customs when they realized

that mourning had to become communal: that one ring had to be everybody's ring, and that fragment of the uniform had to be everybody's fragment.

IB: *How did you learn about this story?*

DR: Research is a huge part of what I do. It's at least half of what I do on any given day.

IB: *What do you do? Do you go to the library, go on the Internet?*

DR: Everything you can think of, I've probably done it. I love going to old libraries, visiting collections, reading off the Internet. I feel that my research is a creative activity. It's hard for me to explain how it happens, but one dot connects to another and then I'm on a new trail to investigate. I go down this road. I find this story. I need to know these facts to make my objects, but it goes through a filtering process before it is presented to the public.

I would never claim that I am a historian in any academic sense of the word, but I have come to understand that any good historian marks what they do by breaking new ground even if it revolves around a story told a million times before. This is why sampling has always been so appealing to me. It suggests that there are a limitless number of stories in anything around you if you just know where and how to look. But it's not just about finding a story; it's about finding stories that shed light on bigger things about the human condition. I consider uncovering those things part of my job as an artist, just as much as making an object.

IB: *Research is such a big part of what you do, it's almost as if your studio is in the library or in a bookstore. Talking to somebody on the phone could be your studio practice, just as much as working with actual objects and materials.*

DR: The closest I get to the romantic idea of the artist in the studio splattering the canvas with paint is when I'm researching. There can be moments when I have twenty books laid out on the floor, spread out like a giant Pollock painting, and I somehow see the connections. It seems chaotic, but I see connections and run with them. When I get to the studio I pretty much know everything I'm going to do, it's a matter of just doing it. There is so much preparation that goes into each work that I can't really afford to go into the studio and mess up too much.

IB: *Your materials are precious and limited.*

DR: Yes. It's a strange way of making an object, but it's not coincidental—I think it's because of my interest in science and research.

IB: *Do you make sketches?*

DR: I make very few sketches; my equivalent is writing. My sketchbooks aren't filled with drawings; they are filled with variations on material lists and titles. What I'm doing when I sketch is like writing poetry or lyrics to a song. I am constantly writing titles, constantly writing little phrases, and then I edit and pick at them until it starts to make sense. For *No One Has a Monopoly Over Sorrow*, that piece originated as a title, then came the core story about the widows on the battlefield, and then a list of very unusual materials that was originally triple the size of what you see in the final version. I am constantly accumulating materials as well, and this is also a poetic endeavor. Recently I wrote this phrase down: "A million-year-old blossom." It made me think, "Does this exist in the world, and if so, where can I find it and how do I get it?" Because I wrote that phrase I had to find out if such a thing exists. As it turns out, there are literally several-million-year-old blossoms. There was a tree in prehistoric times whose blossoms would fall into its own sap, which in some cases would turn to amber. They are very rare, but you can find these blossoms stuck in amber to this day. Discoveries like this originate simply as my poetic investigation into a combination of words.

IB: *You said that your works often start with much longer materials lists and that you get down to the final list and then later the object through a process of editing. When you have your list but have yet to make something, does it then become a process of figuring out how to get all of those materials into the work?*

DR: Yes, but I would never force a material if it doesn't work. At the end of the day, if it doesn't work, it won't. But there are definitely times when I won't give up on a certain material because of the beauty of its description, of its language. For instance, the idea of male ring finger bones coated with melted bullet lead and shrapnel preceded any knowledge that I could get the bones or the lead, and preceded any technical knowledge of how to produce the object. I knew I loved that phrase and the bizarre image it put in my head, so I had to figure it out. Generally I feel pretty confident in letting the words direct the production of the object. But even once I've got the title, the story, and the material list, I still might not know what to make. That's

where the story becomes especially important. For *No One Has a Monopoly Over Sorrow*, I imagined what the women would have taken out onto the battlefields with them. They probably would have taken a basket; maybe they would have lined the basket with the bouquet that they had been preserving. Maybe they would have used their mourning clothing as lining. Once I let the story guide my imagination I have a rough idea of what to actually make.

IB: *Do you know where that particular title came from?*

DR: That was in my archive of titles. At this point I have thousands of titles that I'm constantly adding to.

IB: *So they are not appropriated? They are not lyrics from a song or lines of a poem or from other sources?*

DR: I'd say ninety-five percent of them are completely mine. Occasionally I'll use a full lyric from an existing song but there is always a web of reasoning as to why that lyric, why that singer, why that era. The fact that they have the ring of lyrics is just because my love of music is so ingrained. There is poetry in the way lyrics sound without their music.

IB: *Did you ever take writing classes when you were a student?*

DR: No. The things I've really loved, I've always been self-taught in. I never took a sculpture class in my time in art school.

IB: *Where did you go to school?*

DR: I went to school at the University of Texas in El Paso and in San Antonio.

IB. *Both for studio art?*

DR: Yes, my emphasis was painting. But when it comes to my greatest influences, my greatest loves—like writing or geology or archaeology or music—I've always been an amateur, never the expert. I never learned how to play an instrument, but that never stopped me from thinking I was a musician in some sense. It never occurred to me that I wasn't legitimate in my endeavors just because I didn't have the right training. I think that comes from my admiration for the American tinkerer, the tradition of the self-taught man, like Edison or Ford; those are great examples for me.

IB: *Inventors?*

DR: I love the idea that you can just go in your garage and figure things out.

IB: *There is great independence in that. You are making your own rules. But isn't that also a lonely place to be?*

DR: Over time I have come to understand the lonely aspect of it, especially with the last five or six years of work. Those pieces have taken me into some incredibly dark places topic-wise. Tinkering around with these really charged materials, knowing what they are and what I'm trying to do with them, it's just unavoidable that I reflect on what I am doing and the fact that I'm doing it all alone. The materials themselves exist because of some intense aloneness or feeling of loss. But in general I've always been more on the optimistic side, or rather a tragic optimist; for me it's about that freedom, that American spirit, doing it yourself, and it's always been such a private mental activity that I never interpreted it as lonely.

IB: *Are these darker topics symbolic of something about you?*

DR: I would be lying if I said that that wasn't true at some level. I don't mean it in any melodramatic way, it's just I've always been a loner. Everybody goes through that, I think. And the music I loved, and still love, is made by people like that.

IB: *But you've also never shied away from opportunities to show your work or talk about your work. So it's not about being alone and keeping this thing secret. It is about dialogue and relationships in some way.*

DR: Definitely, and I've gotten better about being more open over the years. There is an early body of work that was done in a mode where no one saw it. I'm going to show those works for the first time this year.

IB: *The actions?*

DR: I call them my early actions. They were things that most people would not have noticed. For example, I secretly changed all the light bulbs on the block I grew up on to ones with a higher wattage. It was such a subtle change, and yet it was an observable one. But the spirit of those actions was private, even though they were done in public. With later works a sense of responsibility forced me out of my shell. If I'm going to hold the wedding band of a dead soldier, I better suck it up and get out there and talk about this because the importance of the message outweighs my tendency to be alone.

IB: *Your message makes you a storyteller. Storytelling is an interesting concept because it brings up two different ideas that I think are important to your work. One is about building a narrative from meticulous research and very real things, like objects or archives. But also embodied in storytelling is the notion of spinning a yarn or taking a story to place that isn't true, even if the message or the moral behind it is. I know that people say to you all the time: "How could you have really done that? Is that really true? I can't believe you did that." How do you feel about that kind of doubt?*

DR: I find lying incredibly boring as an approach to art making. I feel that one of the worst injustices done to a whole generation of artists, including me, was that we were told that whatever could be done, had been done. Where do you go from there? There is this cynical, pessimistic, overly ironic form of postmodernism that we are still in the midst of. I realized early on that I was not going to accept this. It wasn't what I believed, so I started looking for other aspects of culture that rejected it, and hip-hop and sampling were shining examples of it to me.

IB: *Of truth?*

DR: Of a counter force to this "whatever can be done has been done" attitude. It's the ultimate radical spirit. A whole generation of artists said, if all we have are the scraps of the past, we're still going to make something out of it. The spirit behind that gesture was so empowering to me. Sampling is a crucial conceptual point in my thinking. The shock-value tactics of a lot of art making in the early 1990s represented things that I was very much against. It had gotten to the point where everyone expected you to be lying or ironic, or that you didn't really make it, or it just wasn't even a point of discussion anymore, and that frightened me. When an artist said, "I really did this, and I did it with my own hands," that somehow became the doubtful position. That to me seems a really important thing to reflect on. What does it say about our culture when to be sincere becomes the radical gesture? But when I'm in my studio and I'm working, I'm never thinking about any of those things. My practice is as real and sincere and based in reality and fact that it can possibly be.

IB: *So your reaction was to be positive, and to use that positivity in the studio.*

DR: Yes, but that's what's so funny—the first assumption in the present moment is that positivity is really the ironic, cynical stance. Why is that everyone's first

position? It wasn't always that way. The contemporary viewer today expects to see everything at every moment. The obvious example is reality TV. Everybody assumes it's their right to know how it was made, when it was made, to have proof that you made it, perhaps a videotape of you making it with all the behind the scenes action. What we lose when that attitude is brought to art are some valuable things: myth and mystery. The two things that have driven every meaningful art experience I have had. I'm not ready to surrender them just yet. But I want to make it clear I am talking about a form of myth and mystery that leads to re-enchantment, wonder, and awe with the world, not suspicion and aggressive cynicism and irony.

IB: *You want to encourage people to be active viewers, to help them sort out things that might end with questions rather than giving all the answers.*

DR: Exactly. Some of the great moments I've experienced in life have been filled with myth and mystery, and they've also required some homework. For example, I'd get a new Smiths album and the lyrics referenced Caligula. I didn't know who Caligula was. I would immediately go to my encyclopedia and figure it out, and I loved that the art object, the song, forced me to go figure it out. Morrissey didn't give me all the answers, and I'm glad he didn't. I'm glad I had to do some homework. With all that said, it's so important to me to assure that whatever I put out in public has been made by me and I've covered the ground as well as I am able to as far as fact-checking. Another important note on this point to me is the role of magical realism in my thinking over the years, too, as a reader. The thing that I've always been drawn to with magical realism was that it was a magic that was possible. It was still based in some fantastical world but it was written in such a direct way that it seemed normal. I actively look for that now.

IB: *Do you ever have doubts about your process? Do you wonder whether you should melt this bullet lead, or pulp this letter, or unweave this fabric?*

DR: I always choose materials that I know the National Archives is not waiting for. It is stuff that is lost, it is gathering dust in a basement, it is forgotten. I would never alter something that wasn't in that state. It's an important ethical point to me because of the nature of the material. I think that if you want to really get into what I'm doing you have to let go of a few assumptions, the main one being that alteration equals destruction. Assuming that changing the substance of one thing has de-

stroyed it is so much a fabric of our cultural moment that no one even reflects on it or understands that through time and culture this has not always been the case. I'm drawing on the idea that alteration equals creation and that the alteration has actually added on to the value. I don't mean it as monetary value, but as a spiritual dimension—alchemists thought turning lead into gold was spiritual progression. For me it can be asked this way: What's more interesting, a lost and dusty love letter of two lovers long gone and forever outside of public view and imagination, or the artistic reanimation of new life into that letter's molecules that makes it relevant to us today? An amazing number of people offer me materials, knowing fully what I'm going to do with them. To me that is an exciting development, although I also get the other end of that, which is doubt and even hostility.

It's also important to consider the uniqueness of the material. For example, a lot of the bullets I've used are from the Civil War. To this day, 150 years after the Civil War, there are still thousands and thousands of bullets excavated from battlefields every year. That can give you a mental picture of just how much lead is buried out there, and the Civil War was a little blip on the scale of the wars compared to World War I or II, for example. When you start to grasp how much metal was exchanged to destroy each other and consider the fact that I am using ten bullets, a lot of the questions fall away. I hope what my slight intervention has done is shed light on a topic.

IB: *Can you relate this back to the idea of sampling, and mixed tapes or remixes? Do you think there should be free access to this content?*

DR: I will defend the original spirit of taking the scraps around you and investing them with new meaning forever. I think it's a beautiful thing that shows up again and again across cultures and time. A contemporary word for it is sampling, but the gesture is ancient.

IB: *So even if that activity confounds current legal standards you say it's worth breaking the law?*

DR: I say the spirit that I am interested in transcends the specific copyright issue of the moment. History is littered with the basic spirit of it. Trench art, for example, what of that? That is sampling at it's core—someone takes the materials of war and upends them to make something beautiful out of it. The current copyright issue doesn't apply in the same way for me as an object maker. It's interesting that if I take

an old record and melt it down and turn it into an object I don't really face any copyright issues in the way a contemporary DJ would. The actual sound is copyrighted, not the material that is holding the recording. But in my work I am relying on people to know that sound-source, to play it in their head when they are looking at my work, so it enters a lot of strange gray areas that I find interesting.

IB: *You are using the real thing, the real power of the music. You are technically using the vinyl or the magnetic tape or whatever else, but what you are really using is the content. I suppose that is what copyright law is trying to protect, but it can't really.*

DR: It can't protect the spirit of it. It's a fascinating topic. There is a lot of sound in my exhibitions, but nobody physically hears it. I like to think that we are all walking jukeboxes, and that my artwork in many ways puts the coin into you that allows you to play the song internally. You can't claim a copyright on sparking someone's personal memory. I hope no one ever can do that.

IB: *How would you feel about a person sampling your work?*

DR: Friends have asked if they could take something I've made and melt it back down, turn it into something else, and I'd be fine with it. It hasn't happened yet. I'd be open to exploring it with someone. I've explored it on my own in some works.

IB: *Reusing pieces...*

DR: I'm constantly reshuffling. I'll even re-title works; I'm constantly tweaking them. I like remix culture. I did an early set of works where I made the same object three different times using different vinyl records as the source material. I realized I was trying to investigate how I could bring remix culture to the world of sculpture and if the two languages could talk to each other. What I found was that just by changing the selection of the record the object has to be read differently, even though you are looking at basically the same thing.

IB: *You grew up in Texas?*

DR: Yes, in San Antonio.

IB: *Your parents are both from San Antonio?*

DR: No, my father is from Nicaragua. But my grandmother and mother were the ones that raised me, and they decided to stay put in San Antonio once I was born.

IB: *And were they from Nicaragua also, or from Texas?*

DR: My grandmother was born in Alabama, and my mother was born in San Antonio. They moved around a lot. My grandmother was a huge influence on me, and an incredible source of inspiration. My mother and grandmother were complete nomads, always moving around. I once counted twenty-seven moves from my earliest memories through college years.

IB: *They never lived with the men in their lives?*

DR: No, and over the years I've reflected on the fact that I only have maternal figures in my life. I was really the first man in the household.

IB: *How did they meet their partners? How did your parents meet for example?*

DR: My grandfather was a very well known and respected Baptist minister. He emigrated from Nicaragua to El Paso, started a church there, and slowly brought the family over, over the years.

IB: *To El Paso?*

DR: To El Paso. My father joined the Army and was stationed in San Antonio during the Vietnam War. That's when he met my mother, who was a volunteer in the burn unit there, and they immediately connected through music. My father was a huge Beatles fan, which is one lasting thing I've gotten from him, a love of music and the Beatles. That was one thing I could talk to him about.

IB: *So you didn't live with him, but you knew him?*

DR: Yes, I never lived with him. I knew him and he is an interesting guy, he just wasn't meant to be a father. He joined the Army for the G.I. Bill, and he ended up getting his PhD. He was a biologist who helped identify a gene for fetal-alcohol syndrome. He kept in touch occasionally and I'd keep up with what he was doing. He encouraged my science interests.

IB: *Tell me about your mother and your grandmother.*

DR: My mother is a wonderful woman. My grandmother was incredibly eccentric, a tough-as-nails, Old South kind of woman; there are amazing stories about her. Anything that is good about me as an artist is because of her. Not that she ever encouraged me to be an artist, or really liked it, but she was, by her own eccentricity, the best

example I ever had of an independent spirit. She was an obsessive collector of things, and over the years I've realized that I was probably being influenced without knowing it. She would collect the strangest things and put them in boxes, like the tops of dishwashing soap bottles that she would store in milk cartons. I don't think she realized she was making an object. My mother's big influence on me was through her job as the director of a Hospice for almost eighteen years. Hospice has been a part of my life, by extension, for all those years, and I saw and learned amazing things.

IB: *So you got to know people who were dying?*

DR: I got to understand death as a respectful exit through life and to know about the processes people go through to deal with mourning. Her stories left deep impressions on me over the years. Now it makes perfect sense that I'm drawn to these extreme stories because my grandmother and mother were so extreme emotionally. Before she got the job at Hospice my mother had run a honky tonk in Texas, and that left impressions because on the weekends if she didn't have anyone to watch me, I'd sit in the honky tonk with her while she was working, just observing. I was six years old.

IB: *This is the 1970s?*

DR: Yeah, 1978 probably. I have memories of just watching people interact, and the particular melancholy of the honky tonk. I would constantly ask my mother for coins while she was behind the bar so I could play the jukebox. Being able to relate the music on the jukebox to what I was seeing happen in front of me really left an impression.

IB: *Seeing that some of those stories in the songs were true?*

DR: Exactly. A piece I did in remembrance of that time is *There's An Old Flame Burning In Your Heart, Or, Why Honky Tonk Love Is The Saddest Kind Of Love* (illus. p. 25). It's the little matchbox piece. It was an early investigation into ways I could DJ that weren't necessarily on the turntables. I had this idea of other ways in which people can ingest music. On the head of each match there is a very thin coat of melted vinyl, and each match has a different song from my memories on that jukebox. For example, the chorus to "Crazy" by Patsy Cline would be on the head of one match with Tammy Wynette on another or Conway Twitty. They are the songs I remember from

that jukebox. One of the unforeseen consequences of putting the vinyl on the head of each match was that when the match was struck it produced a puff of smoke as the flame burned through the vinyl. I did a series of works in which I took some of the matches back to sites where I expected them to be perfectly usable and functional.

IB: *Like the Billie Holiday shirt.*

DR: Right, there was the shirt and a few others, including the matches. I took the matches back to honky tonks in town and laid them on the bar counters. One time I stayed to observe. What happens is the typical encounter at a bar—the "hey baby can I light your cigarette" line—but unbeknownst to either person, hovering in that puff of smoke between them for a moment were the lyrics to a song that was probably predicting the outcome of that relationship. In a way they were breathing in what Patsy was singing about. Could you know it inside your body? They breathed it in when he lit her cigarette.

IB: *Did you ever tell them?*

DR: Oh no, these works were about seamlessly blending back into life.

IB: *Back to your upbringing, Texas has a substantial Latino population. Do you feel any connections to that ethnic group or think that it finds its way into your work?*

DR: I can't honestly say that. It's my father's side of the family that would have encouraged that. I grew up not really living it, so I thought it was not genuine to claim that. Plus DJ culture was like a prism of many cultures and identities.

IB: *Multiplicity and mixing.*

DR: From day one I was already thinking I could be anything I wanted.

IB: *Why choose one story when you could be a little bit of everything?*

DR: Exactly. When I began as an artist I started from multiple points of view.

IB: *Did you grow up religious?*

DR: No. My grandfather was strict Baptist, but I wasn't around him enough for that to rub off on me. My mother is religious—being in Hospice she had to deal with stresses everyday, and faith helped—but she never put her belief on my shoulders in any way. I was left to make my own decision about religion and belief. I really respect

my mother for letting me do that.

IB: *There are religious elements to your work.*

DR: Definitely, and I have grappled with religion over the years. I understand it today as searching for some deeper meaning. How you frame that meaning is not as important to me as searching for it. Art has fulfilled that role for me without putting any strict definition on it. There is another side of me that is rational and science-based and that doesn't allow me to go all the way into religious beliefs. But there is always a part of me that doesn't stop looking.

IB: *So faith is important, but maybe not relying on just one doctrine.*

DR: I'm searching for faith all the time. I don't think it's a coincidence that it shows up in my work in so many ways. In terms of a scientific approach to faith the person who has influenced me the most on this topic is Carl Sagan. Sagan always championed the idea that the world is wondrous enough on it's own, you don't need to make up anything else. The wonder of the universe itself could produce ethics and morals naturally, without someone else dictating them to you.

IB: *It's a beautiful idea.*

DR: I have always tried to be ethical, to have strong morals. But I worried about it, too—how can I say that I am truly ethical if I know it's not coming from God? Eventually I realized morals arrive naturally just by the wonders of the world. That was such a groundbreaking idea to me. If my work was all a lie that would contradict so many things I stand for and actively try to fight against. I was racked with guilt and distress for many years of my life, and in many ways I still am, but it was always about my fear that I couldn't become a moral or ethical person without religion. I had grown up with the idea that you can't have one without the other.

It was actually science that helped me realize that you can find morals and ethics away from religious doctrine. I think that's an important lens to view my work through. I still want the wonder and awe that faith brings, to inspire leaps of faith. It has pushed me to look for the same emotional outpouring that you traditionally consider part of extreme acts of faith, but I want those feelings to be based in this world. I want there to be reality to it, and that's where the science comes in. Every piece I've ever made, no matter how fantastical it seems, the material and story is

always based in fact. These things really exist and this story really happened.

IB: *This idea of a wonder—something that's truthful but also wondrous—is that part of why you were drawn early on to crystals? Do you ever think of that material as having an almost unreal reality?*

DR: Yes, the mineral and fossil worlds were part of some of my earliest awe-inspiring moments. It was about understanding what a fossil really is, a little snapshot of time that you get to hold in your hand. Kids have those feelings all the time, but a lot of people lose touch with that wonder. Mine has actually gotten more intense over the years. I don't have to make up anything, the world is amazing on it's own. To me that is something so much more exciting, that wonder is attainable.

IB: *It seems to me that wonder could be an important part of music fandom.*

DR: From my earliest days I've always been a great music fan. The faith and devotion that we were talking about before—I think that goes into being a great fan. Having every issue of every vinyl of every single, sticking by your band—that was so important to me. To this day I still actively keep up to date with groups I loved when I was fourteen. I made a commitment to them, and I'm going to stick with it. For some reason it never really occurred to me that I should be the musician, although I did dabble in the DJ stuff. I thought that was my opening to be a musician, but soon I realized I could explore these topics in a better way through art and specifically through materials. That's why I ultimately chose sculpture. The things that make you a good DJ—song selection, splicing, seamlessly mixing two works together or scratching—all those skills I just brought over into my art practice. When I mix two records together now, it is quite literal.

IB: *For those early works you also made prints, drawings, and collages based on album cover design. What do you tease out of a record by using the visual aspects of album design?*

DR: That was a commitment I made early on, too. I wanted every sculpture I made to have its accompanying record cover. Everything a musician would do to release his product into the world—experimenting in the studio, recording the final track, choosing the vinyl it's going on, putting it in its record cover, editing the liner notes—I wanted to do those same things. It meant I was "putting out" a sculpture, which for me related to the joy of getting to read the lyrics when you got home with

your new album, getting to sing along right away, which is one of my favorite art experiences. I thought, why couldn't you get home with your new sculpture and get to sing along right away?

IB: *You have recently completed a long series of works based on a wandering American soldier. How did that series first start to form?*

DR: With the wandering soldier I took my usual planning a step further and storyboarded the whole narrative. It was as if I was going to make a film, except I made sculpture instead. September 11 deeply impacted me, and that day I remember deciding to make a change in my strategy and thinking as an artist. I had to reevaluate everything, including the materials I used. That's when you see the shift in materials, starting to use the bone, for example. I remember very clearly telling myself to either go all the way or don't go at all. If I want to talk about the destruction of the human body in warfare there is no way to avoid the fact that people turn to dust on the battlefield. I went forward knowing that I would handle these objects in a sensitive way, because I didn't want the work to ever be reduced to shock. At the same time I'm not one to avoid what they are, and the destruction that's needed to make them.

IB: *Besides 9/11 was there a specific literary source or story that was one of the early influences on creating this work?*

DR: There is not an existing literary work that I can cite as the main influence. I came to my topics from bits and pieces of small, obscure histories, not necessarily literary stories. For the piece *A Defeated Soldier Wishes To Walk His Daughter Down the Wedding Aisle* (illus. p. 129), I found the real story of a Civil War soldier who carved his own leg out of a piece of wood and made himself an iron foot so that he could do that very thing—walk his daughter down the wedding aisle. During the Civil War for the government to supply soldiers with prosthetic limbs was not even an option, so there was a whole generation of soldiers who had to take that into their own hands. That blew me away. What if you had to carve your own body part? But again it's a story of love, and some extreme event in his life, which pushed him hard enough to grapple with that idea.

IB: *When you go into an exhibition space and are making a constellation of your works, what kind of environment do you like to have in the gallery?*

DR: The relationship of one work to another is always on my mind. That comes

from my love of music and the lost art of sequencing on a record. I look at exhibitions as albums; it always helps me to think, which one is the single, which ones are B-sides, which one is the remix? The color of the walls, the lighting—all that is very important. I like it to have theatricality in my exhibitions and this is heavily rooted in stage design, particularly music concerts.

IB: *What do you mean by theatricality?*

DR: You know, there's always that shift in mood in a rock show, when they are playing all the fast stuff and then they switch gears to the ballad. I've always loved that moment when the mood shifts so dramatically by lights or curtains or some change in the stage scenery. I like those peaks, the ups and downs in a concert.

IB: *Does that desire account for your handmade frames and casework, which are sometimes as elaborate as the objects they contain?*

DR: The case to me is not just for display. Often I choose certain woods for symbolic or medicinal reasons, so the cases are fully part of the sculpture. It is the stage the artwork is standing on while it performs its song. I love architecture at the pedestal level. For me architecture goes a long way in giving meaning to an object. I love the types of presentation you see in natural science museums or even in a record shop display, with its lines and lines of vinyl.

IB: *What are some of the most memorable rock shows you've seen?*

DR: My mother went to see Badfinger a week before I was due, and she always said I was kicking like crazy. I like that story that I responded so eagerly to the music. She took me to see this group called Sha Na Na when I was little, do you know them?

IB: *Sure, Bowser and the boys...*

DR: Right, they had a TV show too. She took me to see them because I was addicted to that show when I was five or six. I love that era. To this day I am mesmerized by my mother's experience of rock and roll. It has fueled so many pieces, trying to understand just how radical it all was at that moment for her.

IB: *When did you see Morrissey the first time?*

DR: I've seen Morrissey many times. The first time was in 1992. That year he came to San Antonio for the first and last time, I haven't missed an American tour he's done since then. That first show was an amazing experience because he played

for forty minutes and then left. It almost caused a riot because everybody was so angry. The security was out of control and being really rough with the fans that were trying to get on stage and I guess Morrissey couldn't stand it anymore so he just left. The obstacles he places in front of his fans are part of the ritual and I love it. He will cancel concerts twenty minutes before he goes on stage. He'll play at venues that are hard to get to or that seem illogical to most of his fans. At this point I love it because it's just part of a decision I made when I was young—if I'm going to be a fan then I'm going to be a fan through thick and thin. I imagine that he understands that philosophy, too. His whole career has been some test of faith.

IB: *Who are some visual artists that have been influential to you?*

DR: Felix Gonzalez-Torres was very influential and continues to be, in the spirit of his activities and gestures. The idea of what he expected from his work has always been with me. I'm constantly asking myself, what do I expect, what do I really expect this thing to do in the world? I want to make things that do matter, that do inspire some change. He embodied all that, especially the idea of a democratic spirit. Democracy is a word that has lost its potency in some ways, but it's still such a radical idea. It was such an anomaly when it emerged on the world stage. We're still in the midst of the experiment.

IB: *Gonzalez-Torres was also optimistic that his audiences would work along with him and his objects.*

DR: I love that. His work is perfect for someone like me who wants to do some homework and find things out and fill in the blanks. He always assumed his audience was smart. I'm not going to make the assumption that my audience isn't smart.

IB: *Things that you regularly use in your work that many other artists shy away from are sentimentality and romance.*

DR: I hope I am leading the charge in reclaiming the radical part of romance because that is really in the forefront of my thinking. I get criticized all the time for being overly sentimental. Romance has become a dirty word. I believe this is part of the historical amnesia of my generation—we've forgotten the roots of Romanticism as a movement, we've forgotten the radical spirit of its time. I want to reclaim those things. Plus, I've never bought the argument that you have to sacrifice the heart for

the mind. Some of the most "intellectual," uncomfortable, taboo things, like death, decay, or disintegration, are the underside of hyper-sentimentality. I'm glad it makes some people uncomfortable. If the overly sentimental and romantic is understood as an exaggeration of emotion, of the blunt force of pure passion, then really, what is more "punk rock" than that? The forms of Romanticism may change with each generation, but the spirit is the same.

In many ways our county was built on sentimentality. The way Americans dealt with loss produced some of the most amazing, beautiful art forms—poetry, or trench art, or hair wreaths, or mourning art. It happened in the bedroom of every family in the country. The country was filled with amateur artists, people who didn't think they were artists—they were just genuinely writing poems about a child that died from smallpox. There is a spirit underlining those gestures that is worth remembering and even rekindling.

IB: *You've said before that you hope your art functions as a medicine. What are you trying to heal in us?*

DR: This relates to my ideas about alchemy. Once I understood what alchemists did, I wanted to find a way to translate it into my practice. They went into their laboratory everyday not expecting to make a metaphor; they expected to really make transformations. What if I go into my studio tomorrow and instead of thinking in metaphor I worry about really transforming something? What is that going to take from me to make that happen? What changes do I need to make as an artist and as a person? It's an ongoing process and I'm not fully there yet; it involves so many dimensions of my life. But making that commitment was an important thing. Later I was able to blend that thinking with my interest in folk medicine traditions. The thing I love about folk medicine is that it's intimately tied to magic and belief—or to the placebo effect, which is the way contemporary science would explain it. You know how your grandmother gives you a spoon full of some concoction that has no real scientific base to it, but it has some real effect? I love the idea that art can somehow be that medicine on the spoon.

CONTRIBUTORS

IAN BERRY is Associate Director and The Susan Rabinowitz Malloy Curator of The Frances Young Tang Teaching Museum and Art Gallery at Skidmore College. A specialist in contemporary art, Berry has organized exhibitions for the Tang that combine eccentric collections of antique maps, scientific equipment, Edward Curtis photographs, Rube Goldberg cartoons, and Shaker furniture with new works of international contemporary art. Also at the Tang he organizes the Opener series of focused solo projects that has included artists such as Martin Kersels, Jim Hodges, Alyson Shotz, Joseph Grigely, Amy Sillman, Shahzia Sikander, Nina Katchadourian, Kathy Butterly, and Nayland Blake. Recent publications include *Kara Wallker: Narratives of a Negress* (MIT Press, 2003; Rizzoli, 2007), *Richard Pettibone: A Retrospective* (Tang and Laguna, 2005), and *America Starts Here: Kate Ericson and Mel Ziegler* (MIT Press, 2006). Berry is former chair of the Visual Arts Panel of The New York State Council on the Arts and serves on the artistic advisory committees for *Etant Donnes–The French American Fund for Contemporary Art* and *Art21: Art in the Twenty-First Century* among others.

ELIZABETH DUNBAR is Curator at Arthouse at the Jones Center in Austin, Texas. With a focus on emerging artists working in all media, she directs the temporary exhibition program and oversees an upcoming international artist residency program. Recent projects at Arthouse include site-specific commissions by Florian Slotawa and Fritz Haeg, as well as coordinating the commissions for the 2007 Arthouse Texas Prize. Previously Dunbar served as curator at the Kemper Museum of Contemporary Art in Kansas City and assistant curator at the Whitney Museum of American Art in New York. She has organized more than forty exhibitions in her career and has written frequently about contemporary art. Other significant projects include the group exhibitions *Phantasmania* and *Decelerate*, both of which explored the visual manifestation of prevalent topics within the broader culture, and solo exhibitions with Gajin Fujita, Phoebe Washburn, Teresa Hubbard/Alexander Birchler, Lisa Sanditz, Nikki S. Lee, and Amy Cutler, among several others. Her first exhibition of Dario Robleto's work, titled *Eunuch Euthanasia*, appeared at the Ulrich Museum of Art in Wichita, Kansas in 2004.

MICHAEL DUNCAN is an independent curator and Corresponding Editor for *Art in America*. His writings have often focused on maverick artists of the twentieth century, West Coast Modernism, twentieth century figuration, and contemporary California art. Among many exhibitions, his curatorial projects include *Pavel Tchelitchew: The Landscape of the Body*, Katonah Museum of Art, Katonah, New York, 1998; *The Big G Stands for Goodness: The Legacy of Sister Corita's Kent's 60's Pop*, Luckman Fine Arts Gallery, California State University, Los Angeles, 2000; *LA Post Cool*, San Jose Museum of Art, 2002; *Parrot Talk: A Retrospective of Works by Kim MacConnel*, Santa Monica Museum of Art, 2003; *High Drama: Eugene Berman and the Legacy of the Melancholic Sublime*, McNay Art Museum, San Antonio, 2005; *Richard Pettibone: A Retrospective*, Laguna Art Museum and Tang Teaching Museum, Saratoga Springs, NY, 2005; *Semina Culture: Wallace Berman and His Circle*, Santa Monica Museum of Art, 2005–06; *Cameron*, Nicole Klagsbrun Gallery, 2006; *Good Doll Bad Doll*, Armory Center for the Arts, Pasadena, 2008.

JENNIFER MICHAEL HECHT is the author of award-winning books of philosophy, history, and poetry. Her book *Doubt: A History* (HarperCollins, 2003) demonstrates a long history of religious doubt from the origins of written history to the present day. Hecht's *The End of the Soul: Scientific Modernity, Atheism and Anthropology* (Columbia University, 2003), won the Phi Beta Kappa Society's 2004 prestigious Ralph Waldo Emerson Award "for scholarly studies that contribute significantly to interpretations of the intellectual and cultural condition of humanity." Hecht's first poetry book, *The Next Ancient World* won the Poetry Society of America's 2002 Norma Farber First Book Award and her most recent poetry book, *Funny*, won the University of Wisconsin's 2005 Felix Pollak Poetry Prize. Hecht's book reviews appear in *The New York Times* and *The Washington Post*. Her newest book, *The Happiness Myth* was published by HarperCollins in 2007. Hecht earned her Ph.D. in the History of Science and European Cultural History from Columbia University in 1995 and now teaches at The New School University.

ROBIN HELD is Chief Curator and Director of Exhibitions and Collections at the Frye Art Museum, Seattle, where her dual mandate is to revitalize the Museum's collection of nineteenth-century German art and to increase its commitment to contemporary art. She has organized more than 100 exhibitions, many of which have facilitated the creation of new art. Recent projects include *Dario Robleto: Heaven is Being a Memory to Others* (2008); *Hug: Recent Art by Patricia Piccinini* (2007), *Tracy and the Plastics 101* (2006), *Swallow Harder: Selections from the Collection of Ben and Aileen Krohn* (2006), and *The Retrofuturistic Universe of NSK* (2005). Prior to joining the Frye in 2004, Held was associate curator at the Henry Art Gallery, University of Washington. Among her accomplishments there were the traveling exhibitions *Hershmanlandia: The Art and Films of Lynn Hershman Leeson, 1965–2005* (2005), and *Gene(sis): Contemporary Art Explores Human Genomics* (2002). Held has published widely on post-communist art in Eastern Europe, performance art and its relation to documentation, video art, and biological art in an age of bioterrorism. She was a 2003 Getty Grant Program Curatorial Research Fellow for *Hershmanlandia*.

Artist **DARIO ROBLETO** received his BFA from the University of Texas at San Antonio and was the recipient of a 2007 Joan Mitchell Foundation Award. He was also awarded a residency at ArtPace in San Antonio, TX in 2001 and has been a visiting lecturer at colleges and universities across the country including Cal Arts, Valencia, CA; Rhode Island School of Design, Providence, RI; and California College of Arts and Crafts, San Francisco, CA as well as teaching at Bard College, Annandale-on-Hudson, New York. His work was included in the 2004 Whitney Biennial and The 6th Bienal do Mercosul, Porto Alegre, Brazil, 2007. His 2004 exhibition *Roses In the Hospital* at Inman Gallery in Houston, TX was awarded Best Show in a commercial gallery nationally by the International Association of Art Critics. Robleto's work is included in many public museum collections including the Austin Museum of Art, Austin; Museum of Fine Arts, Houston; Museum of Contemporary Art, San Diego; Whitney Museum of American Art, New York; Los Angeles County Museum of Art, Los Angeles; and the Blanton Museum of Art, University of Texas at Austin.

EXHIBITION HISTORY AND SELECTED BIBLIOGRAPHY

DARIO ROBLETO

Born in San Antonio, Texas, in 1972
Lives and works in San Antonio, Texas

EDUCATION

1997

B.F.A., The University of Texas at San Antonio, San Antonio, Texas

1996

Yale University Summer School of Music and Art, Norfolk, Connecticut

The University of Texas at El Paso, El Paso, Texas

1993

The University of Texas at San Antonio, San Antonio, Texas

SOLO EXHIBITIONS

2008

Alloy of Love, Frye Art Museum, Seattle, Washington, May 17–September 1; Travels to: The Frances Young Tang Teaching Museum and Art Gallery, Skidmore College, Saratoga Springs, New York, September 27, 2008–January 25, 2009

Heaven Is Being a Memory to Others, Frye Art Museum, Seattle, Washington, April 26–August 10

Early Actions 1996–1998, Inman Gallery, Houston, Texas, April 11–May 24

2006

Chrysanthemum Anthems, Weatherspoon Art Museum, University of North Carolina, Greensboro, North Carolina, September 24–December 17; Traveled to: the Aldrich Contemporary Art Museum, Ridgefield, Connecticut, March 11, 2007–June 24, 2007; Hunter Museum of American Art, Chattanooga, Tennessee, August 25, 2007–November 4, 2007

Fear and Tenderness in Men, D'Amelio Terras, New York, September 8–October 28

2005

Southern Bacteria, ACME., Los Angeles, California, September 10–October 16

Eunuch Euthanasia, Ulrich Museum of Art, Wichita State University, Wichita, Kansas, January 22–February 29

2004

Diary of a Resurrectionist, Galerie Praz-Delavallade, Paris, September 11–November 6; Traveled to: FRAC Languedoc-Roussillon, Montpellier, France, December 8, 2004–January 29

2003

Cerca Series: Dario Robleto: A Surgeon, A Scalpel and A Soul, Museum of Contemporary Art San Diego, San Diego, California, July 11–August 24

Say Goodbye to Substance, Whitney Museum of American Art at Altria, New York, April 17–July 3

Roses in the Hospital/Men Are The New Women, Inman Gallery, Houston, Texas, February 14–March 22

2002

Deep Down I Don't Believe In Hymns, ACME., Los Angeles, California, January 12–February 9

2001

I Thought I Knew Negation Until You Said Goodbye, Contemporary Arts Museum, Houston, Texas, April 27–June 24

Requiem Writer b/w My Magnetic Flaw, Inman Gallery, Houston, Texas, April 27–May 26

Every Record Everywhere is Playing Our Song Right Now, Galerie Praz-Delavallade, Paris, March 10–April 21

2000

The Polar Soul, ArtPace, San Antonio, Texas, September 7–October 15

Factory Girl, ACME., Los Angeles, California, April 28–May 27

Speaker Hole, Finesilver Gallery, San Antonio, Texas, March 17–April 29

1999

New Frontiers 3: Dario Robleto: I ♥ Everything Rock n' Roll (Except the Music), Mint Museum of Art, Charlotte, North Carolina, December 4, 1999–February 20, 2000

Your Cheeks Have Lost Their Luster, Inman Gallery, Houston, Texas, July 2–August 14

1998

Goldie ♥s Björk, DiverseWorks, Houston, Texas, March 20–April 11

1997

The World Just Won't Listen: Collected B Sides, Cactus Bra Gallery, San Antonio, Texas, May 2–May 23; Traveled to: Small Projects Room, University of Houston, Houston, Texas, September 16–October 14

SELECTED GROUP EXHIBITIONS

2008

The Old, Weird America, Contemporary Arts Museum, Houston, Texas, May 10–July 20

3 Rooms: Cornelia Parker, Massimo Bartolini, Dario Robleto, D'Amelio Terras, New York, January 5–February 9

2007

Soundwaves: The Art of Sampling, Museum of Contemporary Art San Diego, La Jolla, California, September 23–December 30

6th Bienal do Mercosul, Porto Alegre, Brazil, September 1–November 18

America/Americas, Blanton Museum of Art, The University of Texas at Austin, Austin, Texas, October 1–December 30

2006

In Series: Recent Accessions in Prints & Drawings at the Museum of Fine Arts, Museum of Fine Arts, Houston, Texas, May 31–August 31

Ahistoric Occasion: Artists Making History, MASS MoCA, North Adams, Massachusetts, May 26, 2006–April 22, 2007

Accords Excentriques, Château de Chamarande, Chamarande, France, May 14–October 29

New Now Next: The Contemporary Blanton, Blanton Museum of Art, The University of Texas at Austin, Austin, Texas, April 29–August 13

The Gospel of Lead: Dario Robleto and Jeremy Blake, Arthouse, Austin, Texas, January 21–March 12

2005

L'humanité mise à nu et l'art en FRAC, même, Casino Luxembourg–Forum d'art contemporain, Luxembourg, October 1–December 16

A Thousand Words, Inman Gallery, Houston, Texas, July 9–August 27

From Aural Sculpture to Sound by Ink, Art: Concept, Paris, France, June 5–July 24

Estranged Objects, Yellow Bird Gallery (in association with the Center for Curatorial Studies, Bard College), Newburgh, New York, April 9–May 8

Color/Pattern/Grid: Selections from the Austin Museum of Art and Austin Collections, Austin Museum of Art, Austin, Texas, March 5–May 15

2004

San Juan Triennial, San Juan, Puerto Rico, November 22, 2004–February 28, 2005

Perspectives @ 25: A Quarter Century of New Art in Houston, Contemporary Arts Museum, Houston, Texas, October 16, 2004–January 9, 2005

Treble, SculptureCenter, New York, May 16–August 1

2004 Whitney Biennial Exhibition, Whitney Museum of American Art, New York, March 11–June 13

2003

Harlem Postcards, The Studio Museum in Harlem, New York, October 15, 2003–January 1, 2004

Dust Memories, The Swiss Institute, New York, June 3–August 2

International Abstraction: Making Painting Real, Seattle Art Museum, Seattle, Washington, May 2, 2003–February 29, 2004

2002

Watery, Domestic, The Renaissance Society, University of Chicago, Chicago, Illinois, November 17–December 22

A Moment's Notice, Inman Gallery, Houston, Texas, October 19–November 16

The Longest Winter, Florida Atlantic University, Boca Raton, Florida, September 19–October 26

Recent Accessions: Prints, Museum of Fine Arts, Houston, Texas, June 10–September 8

Gene(sis): Contemporary Art Explores Human Genomics, Henry Art Gallery, University of Washington, Seattle, Washington, April 6–August 25; Traveled to: Berkeley Museum of Art and Pacific Film Archive, University of California, Berkeley, California, August 27, 2003–December 7, 2003; Frederick R. Weisman Art Museum, University of Minnesota, Minneapolis, Minnesota, January 31, 2004–May 2, 2004; Block Museum of Art, Northwestern

University, Evanston, Illinois, September 10, 2004–November 28, 2004

Rock My World: Recent Art and the Memory of Rock 'n' Roll, Wattis Institute for Contemporary Arts, California College of the Arts, San Francisco, California, March 23–May 11

2001

Heads or Tails, Galerie Praz-Delavallade, Paris, December 8, 2001–January 19, 2002

Shelf Life, Gasworks, London, November 23, 2001–January 13, 2002; Traveled to: Spike Island, Bristol, England, January 25–March 10

One Planet Under a Groove: Hip Hop and Contemporary Art, The Bronx Museum of the Arts, Bronx, New York, October 26, 2001–March 3, 2002; Traveled to: Walker Art Center, Minneapolis, Minnesota, July 13, 2002–October 13, 2002; Spelman College Museum of Fine Art, Atlanta, Georgia, March 21, 2003–May 17, 2003; Museum Villa Stuck, Munich, Germany, October 18, 2003–January 11, 2004

A Work in Progress: Selections from the New Museum Collection, New Museum of Contemporary Art, New York, October 5–November 25

Recent Editions, ACME., Los Angeles, California, June 2–June 30

The Silk Purse Procedure, Arnolfini and Spike Island, Bristol, England, May 26–July 8

Hip-Hop Nation, Yerba Buena Center for the Arts, San Francisco, California, May 19–August 12

Uncommon Threads: Contemporary Artists and Clothing, Herbert F. Johnson Museum, Cornell University, Ithaca, New York, March 31–June 17

The Importance of Being Earnest, Occidental College, Los Angeles, California, January 26–March 16

Fresh: The Altoids Curiously Strong Collection 1998–2000, New Museum of Contemporary Art, New York, January 12–January 28

2000

Thrifting, Lombard-Freid Fine Arts, New York, December 2, 2000–January 6, 2001

1999

A Girl Like You, Galerie Praz-Delavallade, Paris, November 17–December 22

Paradise 8, Exit Art, New York, January 16–April 3

1998

Trade, Salon 300, Brooklyn, New York, November 19–December 20

Ticking, Webb Gallery, Waxahachie, Texas, August 22–September 20

Inside the Loop, Blue Star Art Space, San Antonio, Texas, July 3–August 2

Millennium Fever, DiverseWorks, Houston, Texas, February 13–March 6

BIBLIOGRAPHY

CATALOGUES AND BROCHURES

Basha, Regine, and Michael Duncan. *The Gospel Of Lead*. Exhibition catalogue. Austin, Texas: Arthouse at the Jones Center, 2006.

Baum, Kelly, and Annette Carlozzi. *Blanton Museum of Art: American Art since 1900*. Exhibition catalogue. Austin, Texas: Blanton Museum of Art, 2006. Essay by Regine Basha.

Berry, Ian, ed. *Dario Robleto: Alloy of Love*. Exhibition catalogue. Seattle, Washington: University of Washington Press, 2008. Essays by Elizabeth Dunbar, Michael Duncan, Jennifer Michael Hecht, and Robin Held.

Cuba, Nan, and Riley Robinson. *Art at Our Doorstep: San Antonio Writers and Artists*. San Antonio, Texas: Trinity University Press, 2008.

Doherty, Claire, and Catsou Roberts. *The Silk Purse Procedure*. Exhibition catalogue. Bristol, England: Arnolfini and Spike Island, 2001.

Dunbar, Elizabeth. *Eunuch Euthanasia*. Exhibition catalogue. Wichita, Kansas: Ulrich Museum of Art, 2004.

Eden, Xandra. *Chrysanthemum Anthems*. Exhibition catalogue. Greensboro, North Carolina: Weatherspoon Art Gallery, 2006.

Fowle, Kate, and Deborah Smith. *Shelf Life*. Exhibition catalogue. London and Bristol, England: Gasworks Gallery and Spike Island, 2001. Essay by Neil Leach.

Hanor, Stephanie. *CERCA Series: Dario Robleto: A Surgeon, A Scalpel, and A Soul*. Exhibition brochure. San Diego, California: Museum of Contemporary Art San Diego, 2003.

Held, Robin E. *Gene(sis): Contemporary Art Explores Human Genomics*. CD-ROM exhibition catalogue. Seattle: Henry Art Gallery, 2002.

Herbert, Lynn M., et al. *Perspectives @ 25: A Quarter Century of New Art in Houston*. Exhibition catalogue. Houston, Texas: Contemporary Arts Museum, 2005.

Higgins, Shaun, and Colleen Striegel. *Press Gallery: The Newspaper in Modern and Postmodern Art*. Spokane, Washington: New Media Ventures, Inc., 2005.

Hull, Steven. *Ab Ovo*. Santa Monica, California: Nothingmoments Publishing, 2005.

Iles, Chrissie, Shamim M. Momin, and Debra Singer. *2004 Biennial Exhibition*. Exhibition catalogue. New York: Whitney Museum of Art, 2004.

Latreille, Emmanuel. *Diary of a Resurrectionist*. Exhibition brochure. Montpelier, France: FRAC Languedoc-Roussillon, 2004.

Momin, Shamim M. *Say Goodbye to Substance*. Exhibition catalogue. New York: Whitney Museum of American Art at Altria, 2004.

Montgomery, Harper. *San Juan Triennial*. Exhibition catalogue. San Juan, Puerto Rico: Poly/Graphic San Juan Triennial, 2004.

Morsiani, Paola. *I Thought I Knew Negation Until You Said Goodbye*. Exhibition catalogue. Houston, Texas: The Contemporary Arts Museum, 2001.

Pace, Linda, and Jan Jarboe Russell, eds. *Dreaming Red: Creating ArtPace*. San Antonio, Texas: ArtPace Foundation, 2003.

Perez-Barreiro, Gabriel. "Oh, Those Mirrors With Memory." *Zona Franca: 6th Bienal do Mercosul*. Exhibition catalogue. Porto Alegre, Brazil: Fundação Bienal do Mercosul, 2007.

Roses in the Hospital / Men are the New Women. Exhibition brochure. Houston, Texas: Inman Gallery, 2004. Essay by Gean Moreno.

Rugoff, Ralph, Matthew Higgs, and Ann Powers. *Rock My World: Recent Art and the Memory of Rock 'n' Roll*. Exhibition catalogue. San Francisco, California: CCA Wattis Institute for Contemporary Arts, 2002.

Sirmans, Franklin, and Lydia Yee. *One Planet Under a Groove: Hip Hop and Contemporary Art*. Exhibition catalogue. Bronx, New York: Bronx Museum of Art, Walker Art Center, and Spelman College Museum of Fine Art, 2001.

Smith, Todd. *I ♥ Everything Rock n' Roll (Except the Music)*. Exhibition catalogue. Charlotte, North Carolina: Mint Museum of Art, 1999.

Speaker Hole / factory girl / The Polar Soul. Exhibition catalogue. Houston and San Antonio, Texas: Inman Gallery and Finesilver Gallery, 2001. Essays by Roberto Bedoya, Bernard Brunon, Glenn Ligon, and Franklin Sirmans.

Stellweg, Carla. *Inside the Loop*. Exhibition catalogue. San Antonio, Texas: Blue Star Art Space, 1998.

Thompson, Nato. *Ahistoric Occasion: Artists Making History*. Exhibition catalogue. North Adams, Massachusetts: Massachusetts Museum of Contemporary Art, 2006.

SELECTED ARTICLES AND REVIEWS

Abumrad, Jad. "Space." Radio Lab. WNYC New York Public Radio (25 June 2004).

Anspon, Catherine. "Fresh, Smart, and Visionary." *ARTnews* 100, no. 7 (Summer 2001): 96–102.

Atwell, Wendy. "Lonely Teardrops." *Glasstire: Texas Visual Art Online* (March 2006): http://live.glasstire.com/index.php?option=com_content&task=view&id=217>sect=Articles>cat=Review.

Baker, Kenneth. "At the Whitney Biennial, the art is afterthought and much of it is heavy with conceptual freight." *San Francisco Chronicle* (29 March 2004): E1.

—. "Yerba Buena packs art, artifacts into 'Hip-Hop Nation.'" *San Francisco Chronicle* (29 May 2001): E3.

Basha, Regine. "Regine Basha Interviews Dario Robleto." *InterReview* 06 (2006): 40.

Baum, Kelly. "Sincerely." *Artlies*, no. 49 (Winter 2006): 36–41.

Bayliss, Sarah. "Drawn to the Dark Side." *ARTnews* 102, no. 7 (Summer 2003): 126.

Camacho, Bea. "The Magic That's Possible." *Present!* 2 (Fall 2004).

Canning, Sue. "Dispatch: Whitney Biennial." *Sculpture* 23, no. 6 (July–August 2004): 78-79.

Caramanica, Jon. "Hip-Hop Don't Stop." *Village Voice*, no. 0202 (9 January 2002): 57.

Chambers, Christopher. "A Curiously Strong Collection." *Flash Art*, no. 217 (March–April 2001): 44.

Chute, James. "MCASD 'Soundwaves' a sampler plate of 'found' art, sampling." *San Diego Union-Tribune* (16 September 2007): E1.

—. "We borrowed this headline from Currents." *San Diego Union-Tribune* (16 September 2007): E8.

Conner, Justin. "Dario Robleto: A Contemporary Mix-Master of Our Time." *InterReview* 36, no. 9 (September 2006): 106.

Cooley, Lisa. "Dario Robleto." *Artkrush*, no. 45 (15 November 2006): http://artkrush.com/62863.

Cotter, Holland. "Changes Aside, SoHo Is Still Very Much SoHo." *New York Times* (12 February 1999): E35+.

—. "Thrifting." *New York Times* (5 January 2001): E41.

—. "Uptown, Too, Has Heat and Light Aplenty." *New York Times* (30 May 2003): E31.

Cox, Christoph. "Treble." *Artforum* 43, no. 1 (September 2004): 262.

Craig, Gerry. "Dario Robleto: The Phantasm of Matter." *Sculpture* 26, no. 2 (March 2007): 40–41.

"Dario Robleto." *The New Yorker* 82, no. 32 (9 October 2006): 16.

Demby, Eric. "What Planet Are You From?" *Village Voice* 46, no. 47 (27 November 2001): 66.

Devine, John. "In the Trenches." *Houston Press* (13 March 2003): 46.

Douberley, Amanda. "True Believers: The Gospel of Lead." *Glasstire: Texas Visual Art Online* (March 2006): http://live.glasstire.com/index.php?option=com_content&task=view&id=216>sect=Articles>cat=Review.

Duncan, Michael. "Dario Robleto at Blue Star Art Space." *Art in America* 87, no. 4 (April 1999): 151.

—. "Remixing the Past." *Art in America* 95, no. 10 (November 2007): 202–205.

Dunn, Melissa. "Whitney Biennial 2004: A Good-looking Corpse." *Flash Art* 37, no. 236 (May–June 2004): 63+.

Frank, Peter. "Dario Robleto, Rob Voerman." *L.A. Weekly* (15 October 2004): 150.

Freeman, David. "Dario Robleto." *Artlies*, no. 15 (Summer 1997): 66–67.

French, Christopher. "How do Texans stack up at the Whitney?" *Houston Chronicle* (2 May 2004): 11.

Gaines, Malik. "Dario Robleto: Southern Bacteria." *Artlies*, no. 44 (Fall 2004): 101.

Gajkowski-Hill, Sarah. "Inman Gallery: Gilad Efrat, Carl Suddath, and Dario Robleto." *Arts Houston* (August 2006): 28.

Garcia, Miki. "Interview with Dario Robleto." *LatinArt.com: Latin American Art Directory* (1 May 2003): http://www.latinart.com/transcript.cfm?id=50.

Glueck, Grace. "Under a Big Top, a Carnival of Lost Souls and Masquerades." *New York Times* (4 August 2006): E32.

Goddard, Dan R. "'00, what a year!" *San Antonio Express-News* (31 December 2000): 7H.

—. "He's Probing Rock History." *San Antonio Express-News* (13 May 2001): 1H.

—. "In The Eye Of The Beholder." *San Antonio Express-News* (12 July 1998): 7J.

—. "Inventive exhibits combine history, science, religion." *San Antonio Express-News* (10 October 2004): 8J.

—. "Local Artist, partner open Austin exhibit." *San Antonio Express-News* (18 January 2006): 4G.

—. "Rags, bones, guilt, grief." *San Antonio Express-News* (12 February 2006): 1J.

—. "Robleto piece pays tribute to the Challenger's crew." *San Antonio Express-News* (16 March 2003).

—. "San Antonio artist joins Biennial show." *San Antonio Express-News* (18 January 2004): 1J.

—. "San Antonio artist shines at New York show, Robleto hailed as a 'New Bohemian' at Whitney Biennial 2004." *San Antonio Express-News* (11 March 2004): 8B.

—. "San Antonio artist's work draws acclaim in N.Y." *San Antonio Express News* (16 March 2003): 1J.

—. "'Soul' man mixes music, science." *San Antonio Express-News* (13 October 2000): 4F.

Golden, Thelma. "Best of 2003." *Artforum* 42, no. 4 (December 2003): 126–127.

Griffin, Tim. "Out of the Past." *Artforum* 42, no. 5 (January 2004): 57–59.

Gupta, Anjali. "The Gospel of Lead: Dario Robleto and Jeremy Blake." *Art Papers* 30, no. 3 (May–June 2006): 22–24.

Gonzatto, Camila. "Complete Interview." *Fundação Iberê Camargo* (November 2007): http://www.iberecamargo.org.br/english/content/revista/entrevista_integra.asp?id=205.

Heartney, Eleanor. "The Well-Tempered Biennial." *Art in America* 92, no. 6 (June–July 2004): 70–77.

Holley, Joe. "Conceptual Artist As Mad Scientist." *New York Times* (13 April 2003): AR33.

Horton, C. Sean. "Dario Robleto: Say Goodbye to Substance." *Artlies*, no. 43 (Summer 2004): 90.

Janik, Art. "Dust to Dust." *New York Press* 16, no. 29 (16 July 2003).

Johnson, Patricia C. "A sense of loss permeates work of young artists." *Houston Chronicle* (29 July 1999): 1D.

—. "Complex, symbolic images stem from 'Roses.'" *Houston Chronicle* (22 February 2003): 9D.

—. "Exhibiting excellence." *Houston Chronicle* (23 December 2003): 5D.

—. "Spinning Thoughts." *Houston Chronicle* (25 May 2001): 5D.

—. "Wow, how'd they do that?" *Houston Chronicle* (15 July 2006): 3.

"Juicy Fruits." *Tokion*, no. 18 (July-August 2000).

Kendricks, Neil. "Upon Further Review; Robleto's clever message emerge with close look at 'A Surgeon.'" *San Diego Union-Tribune* (7 August 2003): 43.

Kerr, Merrily. "Dario Robleto." *Time Out New York*, no. 574 (28 September 2006): 72.

Kennedy, Randy. "Giving the Artists a Voice in Preserving Their Work" *New York Times* (29 June 2006): E1

Leray, Anne. "Archéologie fictive d'une histoire américaine marquee par la guerre." La Marseillaise: L'Herault du jour (11 January 2005): 6.

Lowther, John. "John Lowther on Dario Robleto." *InterReview* 06 (2006): 48.

Martin, Philip. "Back to the Lab, Into the Groove." *Ten by Ten* 2, no. 3 (2004): 36-39.

Mitchell, John E. "'Ahistoric Occasion' walks a thin line in time." *North Adams Transcript* (8 June 2006).

—. "Alchemy and Art." *North Adams Transcript* (27 July 2006).

Morisani, Paola. "Interview with Dario Robleto." *Tema Celeste*, no. 97 (May–June 2003): 60–63.

Muchnic, Suzanne. "Dario Robleto: ACME." *ARTnews* 101, no. 7 (Summer 2002): 179–180.

Myers, Holly. "For the Record: A Warped History Dedicated to Vinyl." *Los Angeles Times* (1 February 2002): F28.

Nesbett, Peter. "Graphic Exuberance." *Art on Paper* 8, no. 3 (January–February 2004): 32–35.

Newhall, Edith. "Mixmaster." *New York* 36, no. 18 (2 June 2003): 92.

—. "Top 10 Trends: American Gothic." *ARTnews* 105, no. 2 (February 2006): 112–113.

Ott, Lise. "Dario Robleto rappelle que l'Histoire n'est pas vaine." *Montpellier Sortir* (22 December 2004).

Owen, Paula. "Conversation with a Resurrectionist: Dario Robleto." *Artlies*, no. 44 (Fall 2004): 44–45.

Patterson, Tom. "Spins of a Visual Deejay." *Winston-Salem Journal* (5 December 1999).

—. "What's Left; Bullet, Bandages Transformed." *Winston-Salem Journal* (8 October 2006): F3.

Pincus, Robert L. "At the Whitney Biennial, more highs than lows—and most of the country is MIA." *San Diego Union-Tribune* (18 April 2004): F1.

Pollack, Barbara. "Art Rocks." *ARTnews* 101, no. 11 (December 2002): 98–101.

Ramade, Bénédicte. "Chamarande hausse le ton." *Oeil*, no. 582 (July 2006): 38.

Reese, Garry. "Dario Robleto: Roses in the Hospital/Men Are the New Women." *Artlies*, no. 43 (Summer 2004): 8.

Reeves, Emma, Mark Sanders, and Neville Wakefield. "The American Dollar Bill." *Another Magazine*, no. 4 (Spring-Summer 2003): 15.

Richard, Frances. "Dario Robleto." *Artforum* 45, no. 3 (November 2006): 296.

Robleto, Dario. "I ♥ Everything Rock and Roll (Except the Music)." *National Association of Artists Organizations Journal Field Guide 1999– 2000* (2000): 24–25.

—. "When You Cry, I Only Love You More." *Artlies*, no. 32 (Fall 2001): 3–7.

Rosenberg, Karen. "Biennial Favorites." *New York* 37, no. 7 (1 March 2004): 4.

—. "Dust Memories." *Frieze*, no. 78 (October 2003): 126-127.

—. "See Hear." *New York* 37, no. 17 (17 May 2004): 87.

—. "Vinyl Mania." *Village Voice* 48, no. 21 (21 May 2003): 62.

Ross, Lauren. "Material History: The Handmade Paper Work of Dario Robleto." *Hand Papermaking Magazine* 20, no. 1 (Summer 2005): 3–5.

Schinto, Jeanne. "Our Sin Was In Our Hips." *San Diego Reader* (31 July 2003): 77.

Schwabsky, Barry. "Dario Robleto." *Artforum* 40, no. 1 (September 2001): 202.

Shull, Chris. "Art of Protest." *Wichita Eagle* (18 January 2004): 1E.

Silva, Elda. "San Antonio Artist's Tin Curiously Musical." *San Antonio Express-News* (8 April 2001): 8H

Simpson, Bennett. "From noise to Beuys." *Artforum* 42, no. 6 (February 2004): 59–60.

Sirmans, Franklin. "Letter from San Antonio." *Artnet.com Magazine* (8 September 1998): http://www.artnet.com/magazine_pre2000/reviews/sirmans/sirmans9-8-98.asp

Smith, Roberta. "At Shows Painted with Sound, Be Prepared to See with Your Ears." *New York Times* (21 May 2004): E29.

—. "Dario Robleto: Fear and Tenderness in Men, Sara VanDerBeek: Mirror in the Sky." *New York Times* (29 September 2006): E33.

—. "Out of the Vociferous Planet and in the Orbit of Funk and Hip-Hop." *New York Times* (18 January 2002): E46.

Sternad, Jennifer Flores. "Jennifer Flores Sternad on Dario Robleto." *InterReview* 06 (2006): 43.

Sullivan, James. "How rock 'n' roll's rumbles have shaken the earth." *San Francisco Chronicle* (1 April 2002): D1.

—. "'Hip-Hop Nation' show has a rap on black culture." *San Francisco Chronicle* (17 May 2001): D1+.

Veras, Eduardo. "A arte de contra a arte." *Jornal Zero Hora* (2007): 8.

Vogel, Carol. "Gift to New Museum." *New York Times* (29 September 2000): B26.

Walker, Hamza. "Song Factory Substrates." *TRANS* (2000): 188–193.

Wilson, Michael. "2004 Biennial Exhibition: Whitney Museum of American Art." *Art Monthly*, no. 277 (June 2004): 25–26.

Wilson-Goldie, Kaelen. "A Branding New Game." *Art and Auction* 23, no. 7 (July-August 2001): 84–90.

Worman, Alex. "Dario Robleto: ACME." *Flash Art*, no. 239 (November-December 2004): 117–118.

Yablonsky, Linda. "Dust Memories." *Time Out New York*, no. 403 (19 June 2003): 60.

WAIT AWHILE
UNTIL I CAN FIND MY SMILE

Pumpkin seeds, dirt, water, sunlight, surprise

*I have secretly planted and am secretly
maintaining pumpkin seeds I planted in various people's yards.
People who I thought needed
to see a pumpkin patch growing in the yard.*

1996
Dimensions variable

Over the past decade, Dario Robleto has emerged as an artist of uncommon originality and depth, creating a body of work that is notable for the ideas and spirit motivating it, and for the exceptional craft necessary to its realization. The Frances Young Tang Teaching Museum and Art Gallery at Skidmore College and the Frye Art Museum are delighted to join forces to present the largest and most important gathering of his work to date in the exhibition *Alloy of Love* and the companion monograph of the same title.

Robleto's art presents a mixture of open sentiment, nostalgia, and sly humor that is surprising and rare in contemporary art. Through intimate objects painstakingly constructed from unusual and at times astounding raw materials, he speaks quietly about love, faith, music, American history, and everyday subjects of the recent and not-so-recent past. Listed carefully in each caption, his materials ground the meaning of each piece, evoking a web of allusions and references. The result is a body of work that is at once accessible and mysterious, alternately exotic and mundane in its enthusiasms, ruminations, and obsessions. For audiences, particularly American viewers, Robleto offers an opportunity to rethink who we are, where we came from, how we choose to record our presence in the world, and our passing from it.

Our thanks to guest curator Elizabeth Dunbar for initiating this project and to Ian Berry, The Susan Rabinowitz Malloy '45 Curator of the Tang Museum, and Robin Held, Chief Curator and Director of Exhibitions and Collections of the Frye Art Museum for organizing *Alloy of Love*, and to catalogue essayists Michael Duncan and Jennifer Michael Hecht who joined in this series of fascinating new essays on Robleto's work. Their close collaboration and dedication to this project have made it all possible. We thank also the many lenders to the exhibition for parting with their treasured artworks, our colleagues at the University of Washington Press for their enthusiastic collaboration on this catalogue, and Robleto's gallerists, Kerry Inman, Chris D'Amelio, and Lucien Terras, for their consistent assistance and support. We especially salute and thank the entire staffs of the Tang Museum and the Frye Art Museum for making this project a success.

Our deepest thanks are extended to the artist himself, Dario Robleto, for his cooperation during every stage of this project and his wholehearted support of this exhibition and publication. We are pleased to be part of his growing body of important work.

<div align="center">

John Weber, *Dayton Director*
The Frances Young Tang Teaching Museum and Art Gallery,
Skidmore College, Saratoga Springs, New York

Midge Bowman, *Executive Director*
Frye Art Museum, Seattle, Washington

</div>

ACKNOWLEDGMENTS

As an alloy is often stronger than its individual elements, this exhibition and catalogue are without a doubt strengthened by the many individuals who contributed to its success. *Dario Robleto: Alloy of Love* is the first exhibition to bring together works from this initial phase of Robleto's career. We are very pleased to work with guest curator Elizabeth Dunbar, Curator at Arthouse at the Jones Center, Austin, Texas, to realize her vision for the exhibition at the Frye Art Museum and the Frances Young Tang Teaching Museum and Art Gallery. The project began with conversations between Dunbar and Robleto and grew into a traveling exhibition exploring Robleto's work through a constellation of his objects that span the past decade. We are most thankful to Elizabeth for her perseverance over many years of promoting this important project and her guidance and steadfast belief in making it happen. We know that she joins with us in making the following acknowledgments.

We would like to offer our thanks to Tang Director John Weber and Frye Director Midge Bowman for their support of our collaboration and encouragement to expand the boundaries of our initial plans into the impressive and far-reaching project we have realized. From the Frye Board of Trustees, special thanks to David D. Buck, Peter Donnelly, Jan Hendrickson, Kate Janeway, and Frank P. Stagen. Thanks to the National Advisory Council of the Tang Museum and to the Administration and Board of Trustees of Skidmore College and the Friends of the Tang for their support.

Very special thanks to The Mattsson-McHale Foundation for their important gift which allowed us to fulfill our hope for a catalogue that would truly celebrate the whole of Robleto's work to date.

Thanks to the entire Frye staff, especially Shane Montgomery, Exhibition Designer; Mark Eddington, Exhibition Preparator; Donna Kovalenko, Curator of Collections; Laura Landau, Curatorial Manager; Annabelle Larner, Exhibitions Registrar; Nancy Stoaks, Curatorial Intern; Mary Jane Knecht, Manager of Publications; Jill Rullkoetter, Deputy Director and Director of Education and Visitor Experience; and Rebecca Garrity Putnam, Director of Communications.

All the staff of the Tang Museum ably contributed to the success of the project—thanks to Kristen Carbone, Ginger Ertz, Torrance Fish, Lori Geraghty, Susi Kerr, Gayle King, Chris Kobuskie, Patrick O'Rourke, Barbara Schrade, and Kelly Ward for their ever-present support. Thanks to the Tang's fantastic installation crew, including Dave Brown, Sam Coe, Rob Goodall, Erica Harney, Steve Kroeger, Sean O'Connell, and Jay Tiernan, and to student interns Justin Hirsch, Meredith Mowder, Risa Recio, and Erika Sabel for their diligent work on this project. Elizabeth Dunbar would also like to thank Mia Girard and Michael Tucker for their early assistance with research.

Elizabeth Karp, Tang Museum Registrar, served as managing registrar of the exhibition and we are most grateful for her work corralling the many artworks from all across the country. A tour of these very fragile objects requires care and finesse and she managed the complicated demands of our list with great skill. Ginny Kollak, curatorial assistant at the Tang, deserves special recognition for her attention to the many details of the project all along the way. She managed research, checklists, editing and preparing other catalogue documents with a keen eye for consistency and a great sensitivity for the work's content.

The inventive design of this book was crafted by Barbara Glauber and Erika Nishizato of Heavy Meta with an appreciation for the subtle details that are hallmarks of Robleto's practice. We had very

able partners in printing and binding with Conti Tipocolor, Florence, Italy. The work of many photographers is included in these pages, but special thanks go to Ansen Seale, Robert Wedemeyer, and Bruce White, who all came to our aid in the final stages of catalogue production to photograph works in private collections across the country. Our sincere appreciation goes to Michael Duncan and Jennifer Michael Hecht, who joined with Elizabeth Dunbar and the two of us to write essays that offer exciting possibilities for thinking about Robleto's practice. Thanks to Ginny Kollak and Jay Rogoff for their careful and incisive editing of these new texts.

We are very grateful to have the partnership of University of Washington Press to distribute this book and we offer our special thanks to Pat Soden, Director, for his encouragement and trust in our proposal.

Dario Robleto's work has benefited from the tireless support of art dealers across the country, several of whom worked closely with us as we prepared this exhibition and book. Our project could not have been realized without their critical assistance. Thanks to Kerry Inman and Patrick Reynolds at Inman Gallery, Houston, Texas; Randy Sommer and Bob Gunderman at ACME., Los Angeles; Bruno Delavallade and Rene-Julien Praz at Praz-Delavallade, Paris; and Chris D'Amelio and Lucien Terras at D'Amelio Terras Gallery, New York. Many collectors and museums generously lent their Robleto works to us and in doing so entrusted us with the safety of these often fragile works. Special thanks to the Blanton Museum of Art, The University of Texas at Austin; Edward Folse; Charlotte and Bill Ford; Gregory Higgins; Julie Kinzelman and Christopher Tribble; Nicole Klagsbrun; Jeanne and Michael Klein; Nicole Liarakos; Los Angeles County Museum of Art; Abby Messitte and Derek Eller; Museum of Contemporary Art San Diego; Collections of Peter Norton and Eileen Harris Norton; The Linda Pace Foundation; Dario Robleto; Allison and Ed Shearmur; Garret Siegel; Nancy and Stanley Singer; Heidi L. Steiger; Rebecca and Alexander Stewart; Brad Nagar and Reid Sutton; Julie and John Thornton; Ulrich Museum of Art, Wichita State University; Peter and Linda Zweig; and several private collections.

Lastly, we join with Elizabeth Dunbar and the staffs at both of our museums to offer our greatest thanks to Dario. Experiencing one of Dario's sculptures inspires a flow of actions and emotions, from curiosity and investigation to incredulity and trust. His poetic objects can tap our fantasies and memories with explosive results. Engaging what we know of history, science, music, and faith, Dario provides us with openings that allow our hearts and imaginations to connect with memories and the past in moving and lasting ways.

Ian Berry, *Associate Director and Susan Rabinowitz Malloy '45 Curator*
The Frances Young Tang Teaching Museum and Art Gallery, Skidmore College
Saratoga Springs, New York

Robin Held, *Chief Curator and Director of Exhibitions and Collections*
Frye Art Museum, Seattle, Washington

This catalogue accompanies the exhibition *Dario Robleto: Alloy of Love* organized by The Frances Young Tang Teaching Museum and Art Gallery at Skidmore College and the Frye Art Museum.

Elizabeth Dunbar, guest curator

FRYE ART MUSEUM
May 17–September 1, 2008

THE FRANCES YOUNG TANG TEACHING MUSEUM AND ART GALLERY
September 27, 2008–January 25, 2009

FRYE ART MUSEUM
704 Terry Avenue
Seattle, Washington 98104
www.fryemuseum.org

THE FRANCES YOUNG TANG TEACHING MUSEUM AND ART GALLERY
Skidmore College
815 North Broadway
Saratoga Springs, New York 12866
www.skidmore.edu/tang

Page 4:
Sometimes Billie Is All That Holds Me Together, 1998–1999 (detail)
Private Collection
For full caption, see page 26

Designed by Barbara Glauber and Erika Nishizato/Heavy Meta, New York
Printed in Italy by Conti Tipocolor

Photographs by Ansen Seale except the following:
Pages 4, 15, 20, 27, 128, 129, 131, 133, 134: Robert Wedemeyer
Pages 11, 12, 13, 18, 23, 28, 56, 57, 58, 59, 62, 63, 65, 69, 71, 73, 77, 84, 85, 88, 89, 92, 95, 96-97, 101, 103, 104, 106, 107, 154, 155: Thomas R. DuBrock
Pages 37, 38, 39: Kerry Inman
Pages 40, 41: © Bruce M. Wright, 2008
Pages 54, 66, 78: Rick Gardner
Pages 80, 81: Pablo Mason
Page 182: Courtesy of Arthouse, Austin, Texas
Pages 246, 247, 253, 254, 255: Courtesy of the Frye Art Museum